IMAGES
of America

MIDDLEBURG

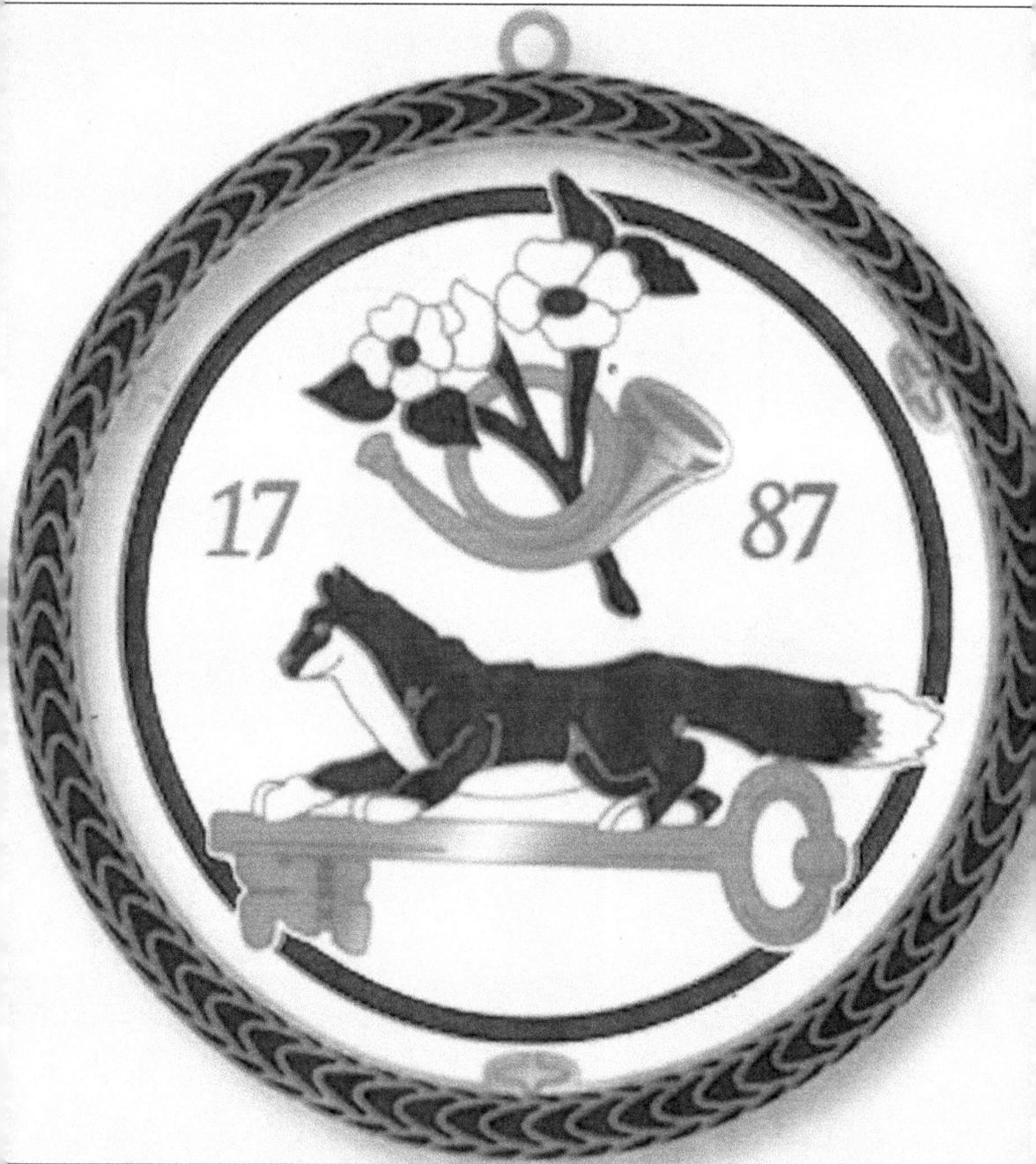

This is the town seal of Middleburg. (Town of Middleburg.)

IMAGES
of America

MIDDLEBURG

Kate Brenner and Genie Ford

ARCADIA
PUBLISHING

Published by Arcadia Publishing
Charleston, South Carolina

Library of Congress Control Number: 2012934337

For all general information, please contact Arcadia Publishing:
Telephone 843-853-2070
Fax 843-853-0044
E-mail sales@arcadiapublishing.com
For customer service and orders:
Toll-Free 1-888-313-2665

Visit us on the Internet at www.arcadiapublishing.com

This book is dedicated to the people of Middleburg, Virginia, with gratitude for the love, dedication, and generous spirit that make it such a unique and special place. Kate would also like to thank Genie for being her champion, mentor, and ultimate role model.

CONTENTS

ACKNOWLEDGMENTS

The authors would like to thank the staff at the Library of Congress Prints and Collections room for their friendliness, patience, and shared excitement in the research. We would also like to thank the Thomas Balch Library and librarian Mary Fishback, a veteran Arcadia author. We also appreciate the staff at the Pink Box in Middleburg for their assistance and for sharing their fascinating stories. We thank the Library of Virginia and the John F. Kennedy Presidential Library for their contributions. Special thanks to Tyler Gore for sharing his pictures and memories. He is a treasure.

Thanks go to Eugene Scheel, an astounding mapmaker, brilliant historian, and expert in all things historical in Loudoun County.

All the Middleburg residents who cheer on the preservation of their town's history were vital in producing this book and preserving a truly unique village. Their pride in the town is responsible for the conservation of such a colorful and fascinating history. So much gratitude is owed to them for enthusiastically sharing their stories and support in this project.

Thanks to Mimi Stein for her humor, friendship, and support and for loving Middleburg so much.

Kate Brenner would like to give special thanks to Laura Troy for sharing her wonderful photography skills and her company and friendship in hunting and putting the puzzle together. Also, thanks to Bart Gamble for his encouragement and never letting me forget to be proud of myself. Thank you to Kathy jo Shea and Jilann Brunett of Second Chapter Books in Middleburg for their grounded support and their wonderful stories.

Genie Ford would like to thank Jim Bridgeman for his endless patience and support. She would also like to thank Punkin Lee, for being such a shining example to all of us and for helping to preserve the history of Middleburg, Cindy Pearson for her commitment, and all the members of the Middleburg Business and Professional Association for their devotion to our village.

INTRODUCTION

With dreams of wealth and happiness in their heads and a helpful gift of 556 acres of land, William Powell and his bride, 16-year-old Eleanor Peyton, crossed the Potomac to begin their life among the lush fields and valleys of Loudoun County.

Their son, John Leven Powell, known to all simply as Leven, purchased a small gristmill and a two-story stone house on the banks of Hunger Run and set about establishing a small village that would become Middleburg. He named the enterprise Sally Mill after his wife, and Sally Mill Road remains today. Leven Powell was ambitious and hardworking. In only three years, he purchased 500 acres from another stalwart local figure, Joseph Chinn, received an appointment as a judge of Loudoun County, and expanded his business empire.

Chinn was also an interesting character. He was one of four sons born to Esther Ball and Rawleigh Chinn. Esther Ball was the sister of Mary Ball Washington, George Washington's mother. Rawleigh was a philandering man and had three additional sons out of wedlock with his wife's younger sister. However, when he was granted 3,300 ares of land, he honored his children, legitimate and illegitimate, by dividing the tract seven ways. The only requirement regarding this 500-acre gift was that "each [son] must bear children." Joseph Chinn's parcel would become Middleburg after Leven Powell settled it.

In 1774, the colonies were stirred by thoughts of revolution and Powell helped write the famed *Loudoun Resolutions*, demanding freedom from British oppression. When these demands were not met, war arrived on his doorstep. He enlisted, along with 2,000 others from Loudoun County, which sent more young men to fight than any other county in Virginia.

Leven Powell served with General Washington at Valley Forge until illness forced him to return home, as a colonel. After the war, he became a delegate in Williamsburg and later represented Virginia in the sixth congress of the new United States.

In 1787, the town of Middleburg was officially founded on 50 acres of the land Powell had purchased earlier from Joseph Chinn. It was originally called Powell Town, and at its heart was the old Chinn's Ordinary, now known as the Red Fox Inn. Powell declined to have the town named after him and instead called it Middleburgh, because it was halfway between the great port of Alexandria and Winchester, which was then the last stronghold of civilization for settlers heading west.

While he refused to have the town named after him, Powell did name all the streets in the new village after men he admired, many of whom shared his convictions as staunch Federalists supporting a strong central government. Pendleton, Jay, Marshall, Hamilton, Madison, Pinckney, and Washington, as well as Federal and Liberty, are all streets in Middleburg today.

In its first 100 years, Middleburgh was an important stopping point on the Ashby Gap Road, the vital artery transporting goods, livestock, and people from Alexandria to Winchester. The little town on 50 acres was the ideal place to stop and rest before continuing on what was surely an arduous journey across Paris Mountain and into Winchester.

In its second 100 years, Middleburg's prosperity would rise and fall, with a long decline after the Civil War, when the population dwindled to just 298 inhabitants. All that changed in 1904 with the arrival of the Piedmont and Orange Hunts. Harry Worcester Smith and some New York friends leased the Colonial Inn—now the Noble Beveridge House—and brought foxhunting to Middleburg. Although there was still suspicion of anyone or anything northern, when the price of horses rose and the visitors spent generously in town, the mistrust was easily overcome. The Middleburg Hunt was organized in 1906, and the town soon gained an international reputation for breeding, showing, and racing Thoroughbred horses.

In the ensuing decades, Middleburg's population stabilized at about 600 and the town undertook a significant commitment to preserving its many 18th- and 19th-century buildings and homes. The town was also remarkable for its tolerance, eccentricity, and laissez-faire attitude toward the rich and famous. Movie stars and presidents were seduced not only by Middleburg's horses, hounds, and history, but also by its respect for the privacy of its more renowned residents and visitors.

Middleburg was the setting for many dramatic events in history. Numerous battles of the Revolutionary and Civil Wars were fought on the town's streets. But if Leven Powell returned to Middleburg today, much of what he saw would be familiar. Many of the same buildings and houses still stand, including his home on Sally Mill Road. The Red Fox Inn is still a charming, gracious, and welcoming stop on the journey westward, and the single traffic light in town does nothing to dispel the sense of history.

The town has welcomed presidents and princes, movies stars and senators, and yet it remains essentially unchanged. That is the real magic of Middleburg, and long may it rein!

One

HALFWAY TO THE WEST

Before Middleburg was even a glint in anyone's eye, it was known as Chinn's Crossroads, with only a simple rustic inn nestled at the edge of the frontier. Over the centuries, this inn has had many names, but the first was Chinn's Ordinary. It was built in 1728, and the first of many famous visitors was perhaps George Washington himself, a young man and surveyor at the time, who came to meet a few relatives at the tavern. Joseph Chinn and his wife, Priscilla, constructed Chinn's Ordinary. The name is derived from the simplicity of accommodations—simple food and minimalistic sleeping quarters. Joseph's brothers settled around the ordinary, and the little hamlet became known as Chinn's Crossroads. The homes of three of the Chinn brothers still stand today. (Library of Congress.)

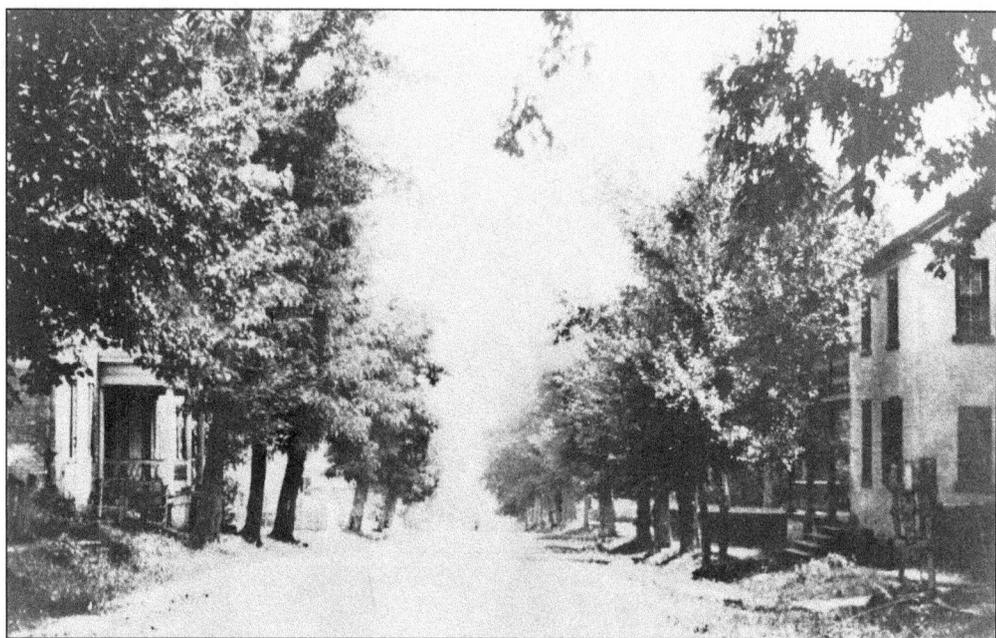

Before 1900, Washington Street was a rough road pitted with hoofprints and carriage ruts. (The Pink Box.)

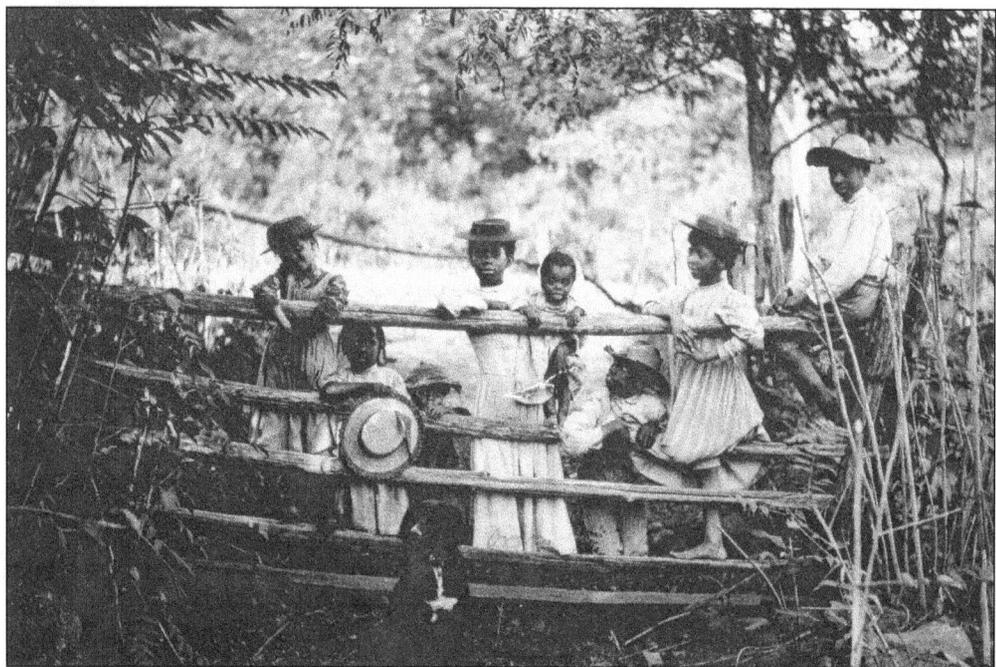

On October 19, 1864, African American children stand on a fence watching as photographer Frances Johnston's stagecoach passes by on her way to photograph the route ridden by Gen. Philip Sheridan. They are standing next to the Ashby's Gap Turnpike (now Route 50), which was constructed in 1810 as a public-private partnership to carry produce from Upperville to Aldie and on to Alexandria. With the construction of the Ashby's Gap Turnpike, Middleburg became a market town for surrounding farms. (Library of Congress.)

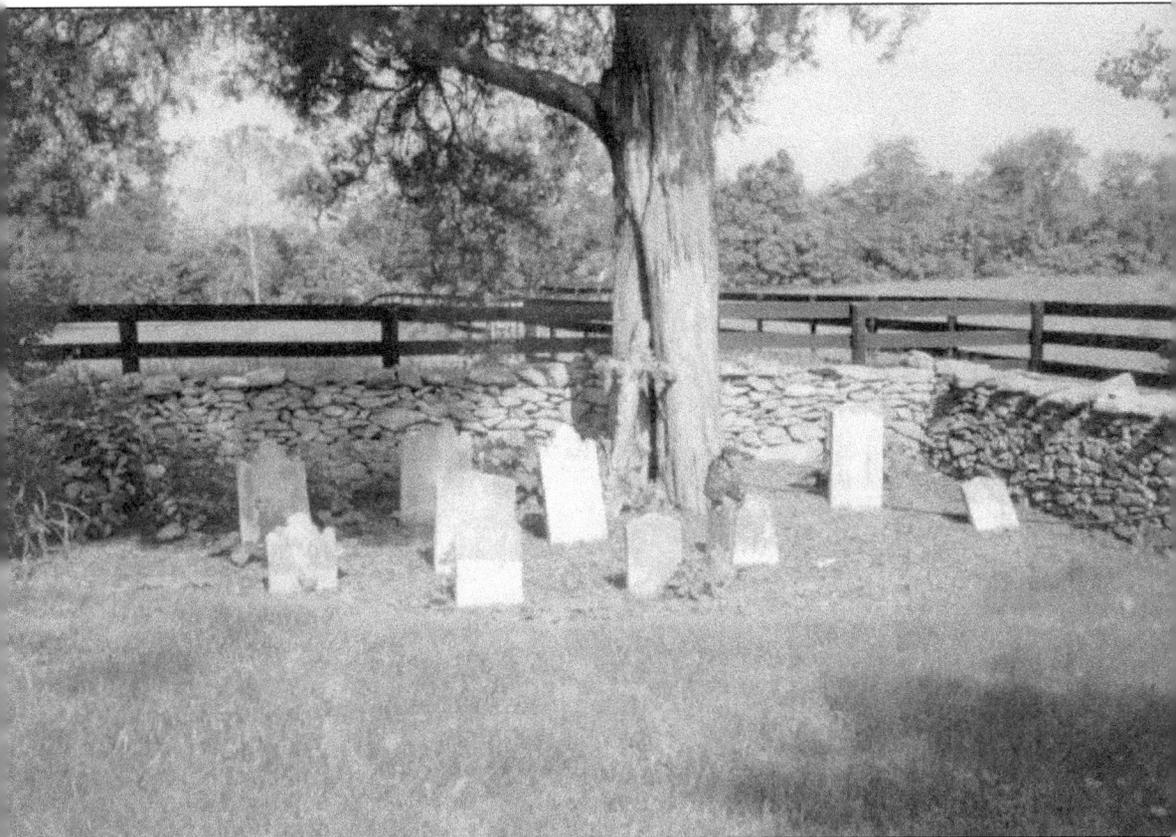

Charles and Sarah Chinn are buried in this tiny graveyard nestled within the gardens on what was once their farm, now known as Bittersweet Farm, about two miles west of Middleburg on Route 50. (Audrey Bergner Collection.)

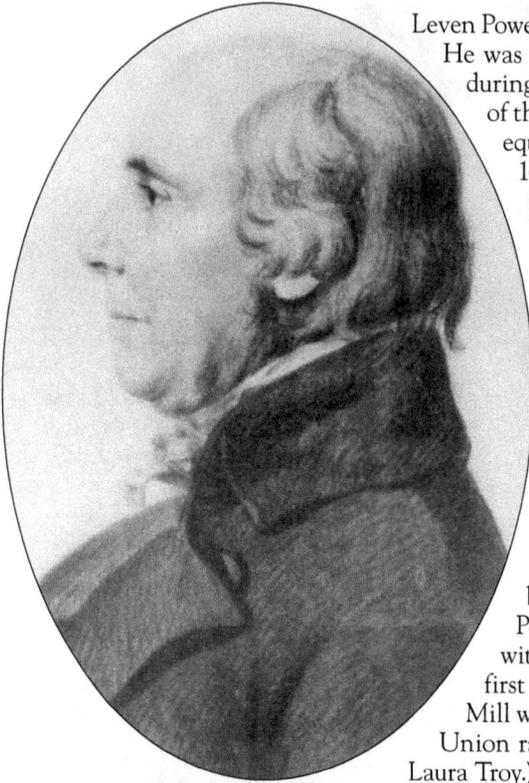

Leven Powell is considered Middleburg's founding father. He was one of Northern Virginia's leading citizens during the Revolutionary War and the early years of the new nation. At the outbreak of the war, he equipped and enlisted his own regiment as the 16th Virginia Regiment of the Continental Line, in which he served as a lieutenant colonel. He accompanied Gen. George Washington on the Valley Forge campaign until ill health forced him to return to Virginia and resign his commission in 1778. (Alderman Library.)

Powell's first home was the Sally Mill House, the remains of which stand today near its successor. He named the house in honor of his bride, who also happened to be his first cousin. Powell led his town into economic prosperity with the development of mills, and one of the first was constructed on his property. The Sally Mill was plundered and burned in one of the many Union raids during the Civil War. (Photograph by Laura Troy.)

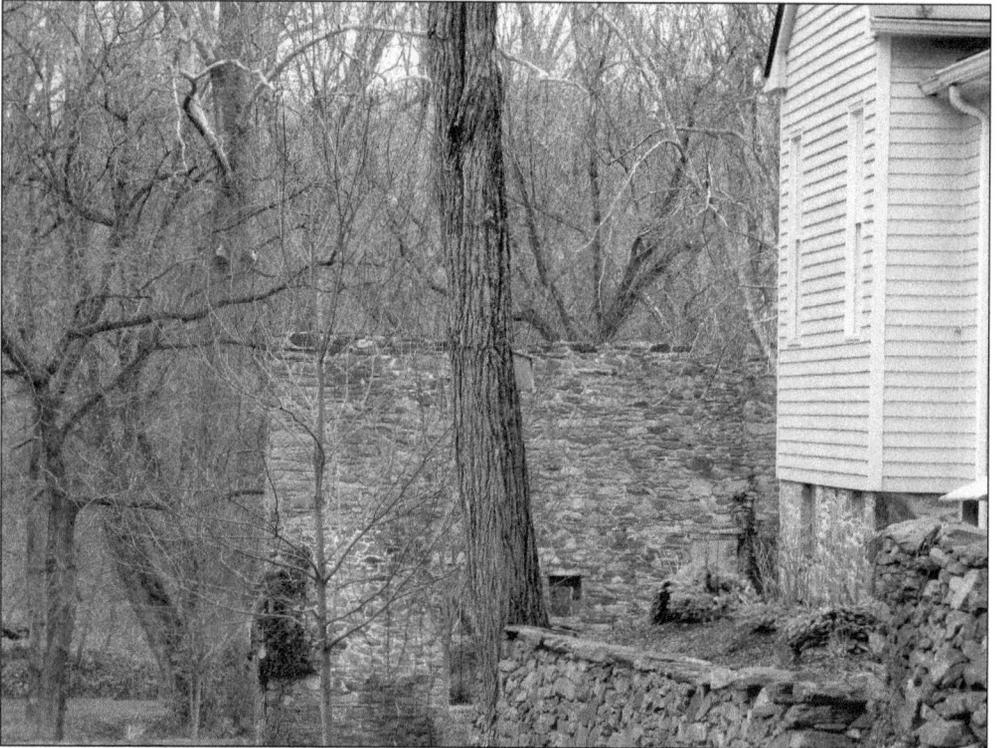

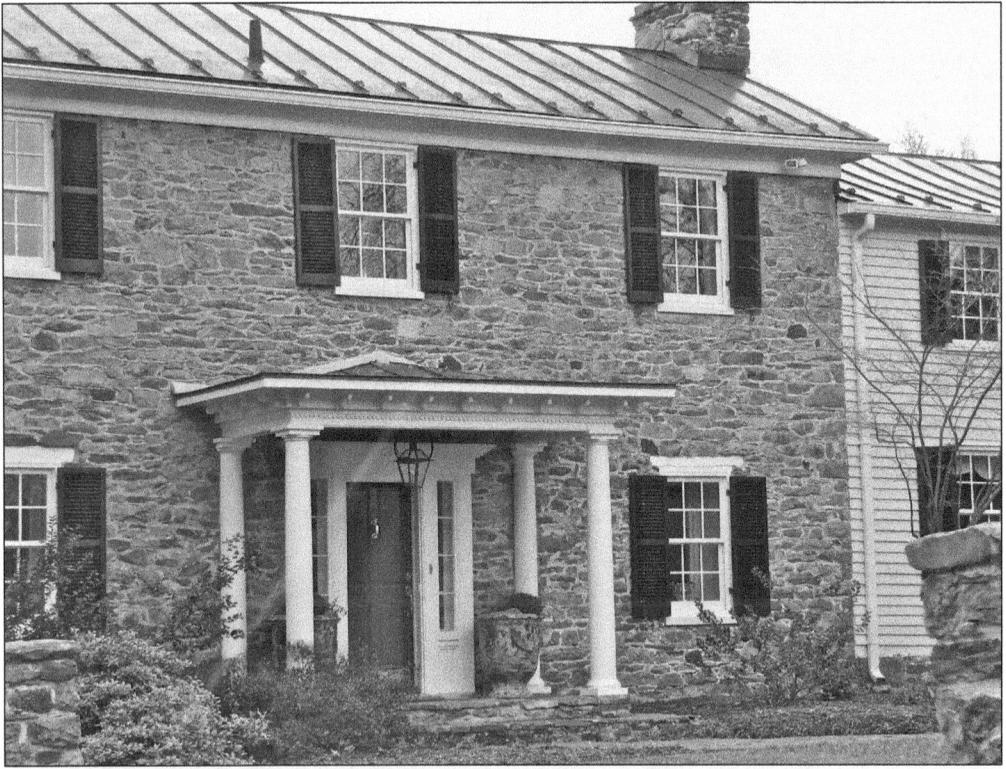

The Sally Mill House was previously owned by Trowbridge and Margaret Littleton, who expanded and preserved the old property. Though the mill has long since vanished except for one remaining stone wall. (Photograph by Laura Troy.)

Greystone, also known as Rock Hill, was built in 1807 by Minor Winn Jr., who inherited the property from his father. There is an inscription to that effect on the exterior chimney of the house. It is believed that the two-story porch was added in the late 19th century. This is the house as it stands today. (Photograph by Kate Brenner.)

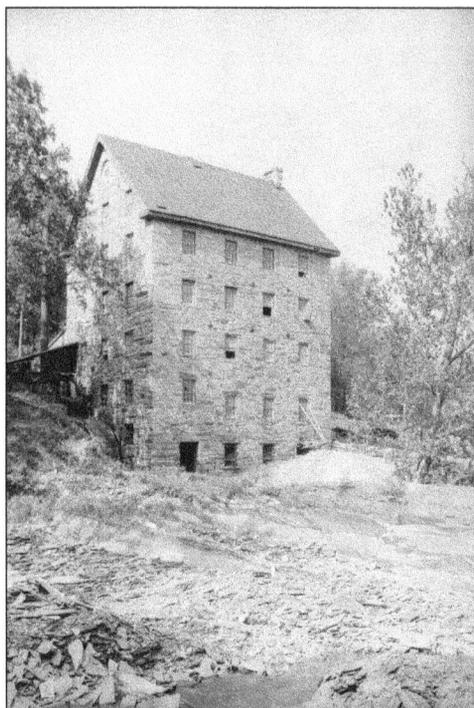

Beverly's Mill, known by the name Chapman's Mill as well, was also built by Burr Powell in the late 1700s. The land where these structures stood was part of a 1,000-acre tract left to Burr in trust for his daughter. He was a noted stonemason. Chapman's Mill is currently under restoration and can be seen from Route 66 a few miles east of the exit for The Plains. Burr Powell was considered a colorful character, and stories abound about his strength and philosophy. (Library of Congress.)

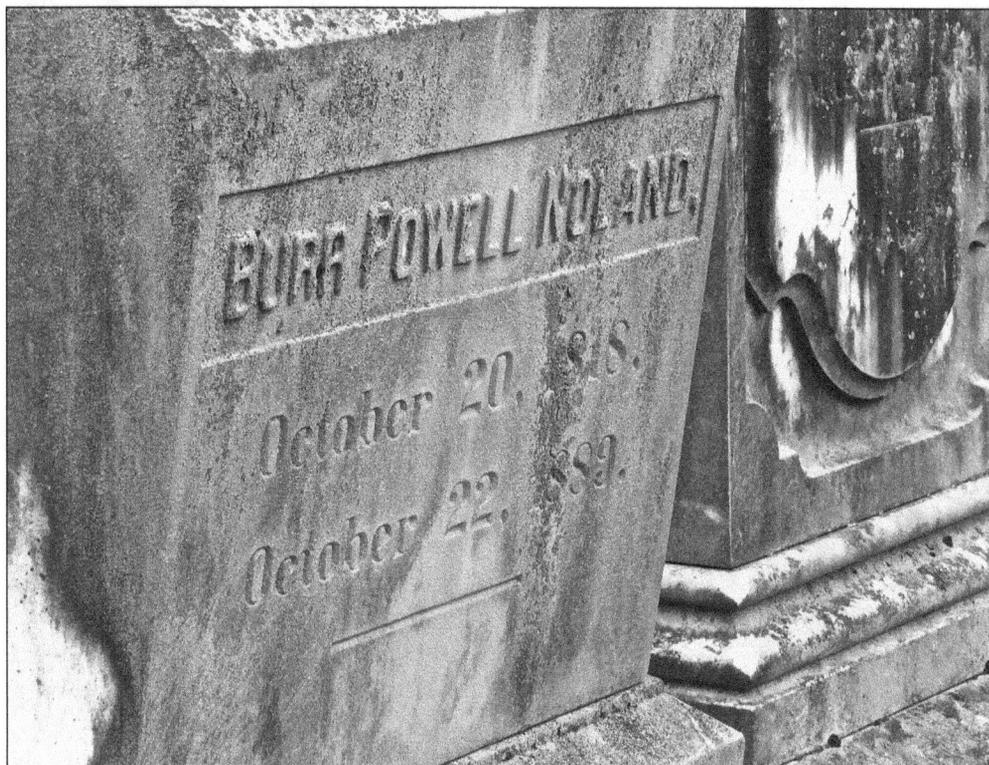

Burr Powell is buried in the Mount Sharon Cemetery behind the Baptist church on Federal Street. (Photograph by Laura Troy.)

This map of the Virginia Piedmont area was made by Jedediah Hotchkiss shortly after the Civil War. It is a finely detailed map in pen and ink and pencil mounted on cloth. Hotchkiss had been a cartographer for Gen. Stonewall Jackson, and his work was so extraordinary that he became known as the "Mapmaker of the Confederacy." In his post–Civil War life, he worked for Confederate general Robert E. Lee at Washington College. (Library of Congress.)

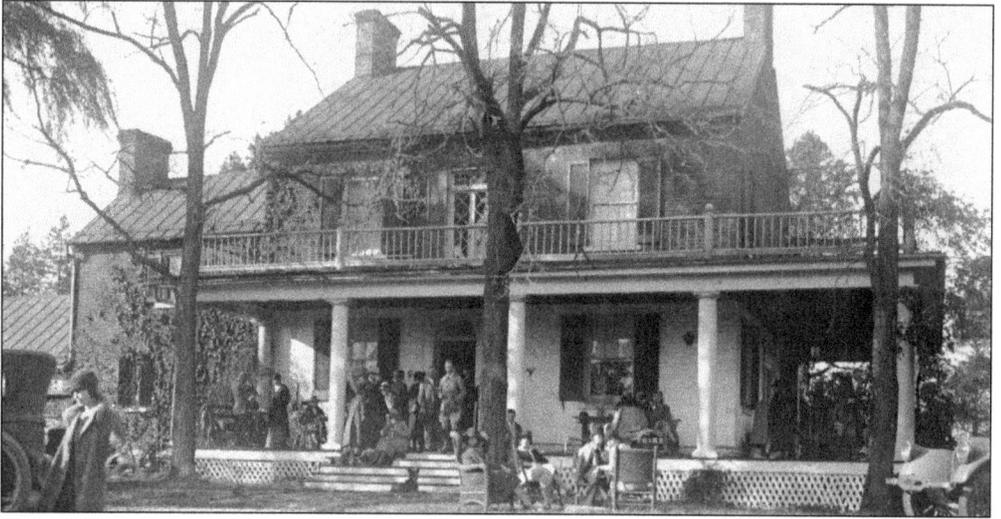

Vine Hill was built in 1804 by Richard Cochran and served as a private residence until it was sold to George L. Ohrstrom Jr. in 1968 to house the National Sporting Library and Museum and the *Chronicle of the Horse*. Its name derives from the vineyard of 4,000 grapevines on the property in the 19th century. The collection in the library, which was first—and perhaps appropriately—housed in a barn, was founded by Alexander Mackay-Smith and George L. Ohrstrom Sr. Mackay-Smith was known around the world as a scholar on sporting subjects and was the library's guiding influence until his death at the age of 95. He served not only as curator and as a member of the board of directors, but from its inception was also the greatest fan and user of the collections. (The Pink Box.)

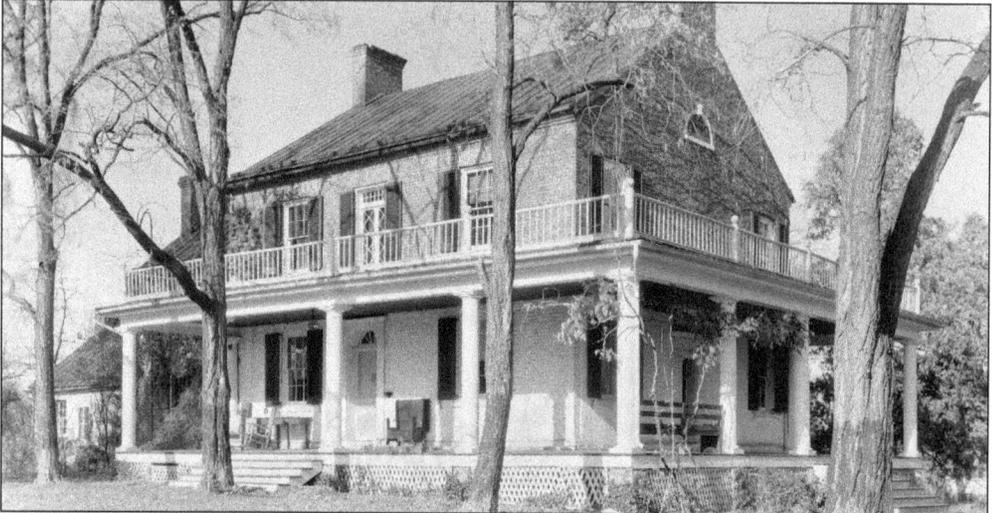

Vine Hill is seen here in 1925. A financial boon after 1900 allowed the construction of the stately homes and mansions that make Middleburg so exciting today. Julia Whiting bought a nearby house known as The Hill in 1927 for $30,000. She was a feisty young woman when she moved to Middleburg from Washington, DC. Perhaps one of the first "townies," as such transplants are known, she was notorious for her raucous displays of devotion to the town. She initiated a "Clean up Middleburg" campaign, which went unsupported by the town council. To show her indignation, she proceeded to collect a large amount of trash, which she promptly dumped on the mayor of Middleburg's front stoop. (Library of Congress.)

Vine Hill is now the home of the National Sporting Library and Museum, which is dedicated to preserving and sharing the art and culture of equestrian and field sports. (Photograph by Laura Troy.)

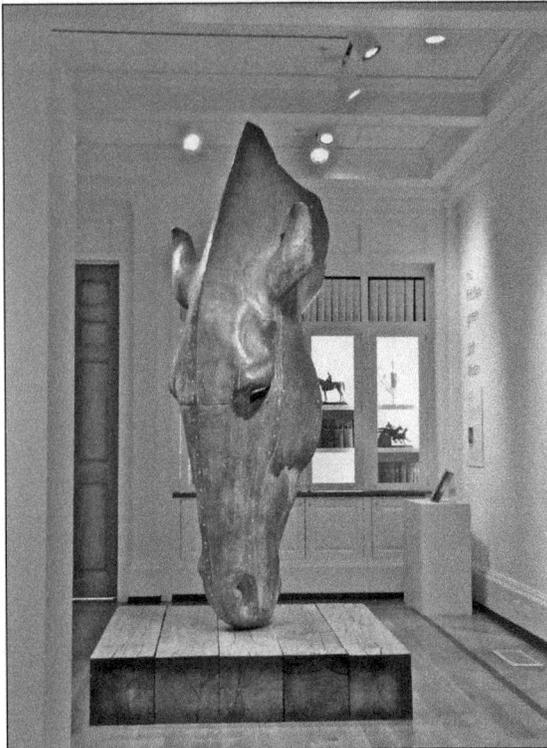

An oversized sculpture by Nic Fiddian-Green titled *Still Water* was exhibited at the National Sporting Library and Museum in 2012. (Photograph by Laura Troy.)

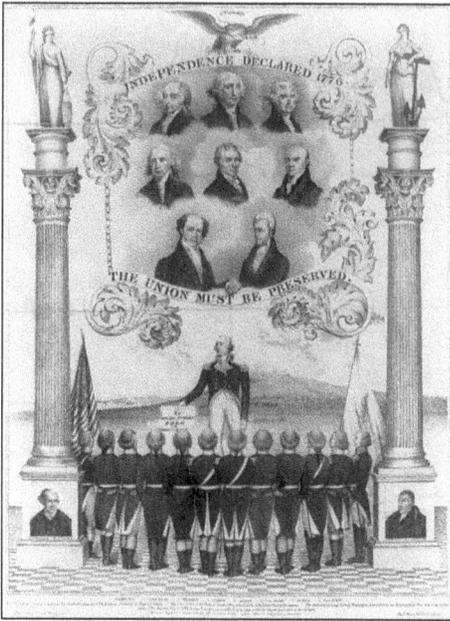

In the words of historian James W. Head, "It can be shown that Loudoun County was most forward in resisting the arbitrary aggressions of the British government and that the valor and patriotism she evidenced during the Revolution was equal to that of her sister counties." In this memorial commemorating the American Revolution titled "Independence Declared," beneath the bust portraits, is a scroll with Andrew Jackson's famous toast, "The Union Must Be Preserved." Below stands George Washington in uniform holding a scroll inscribed with, "We declare ourselves free and independent." (From an 1839 lithograph by Thomas Moore; Library of Congress.)

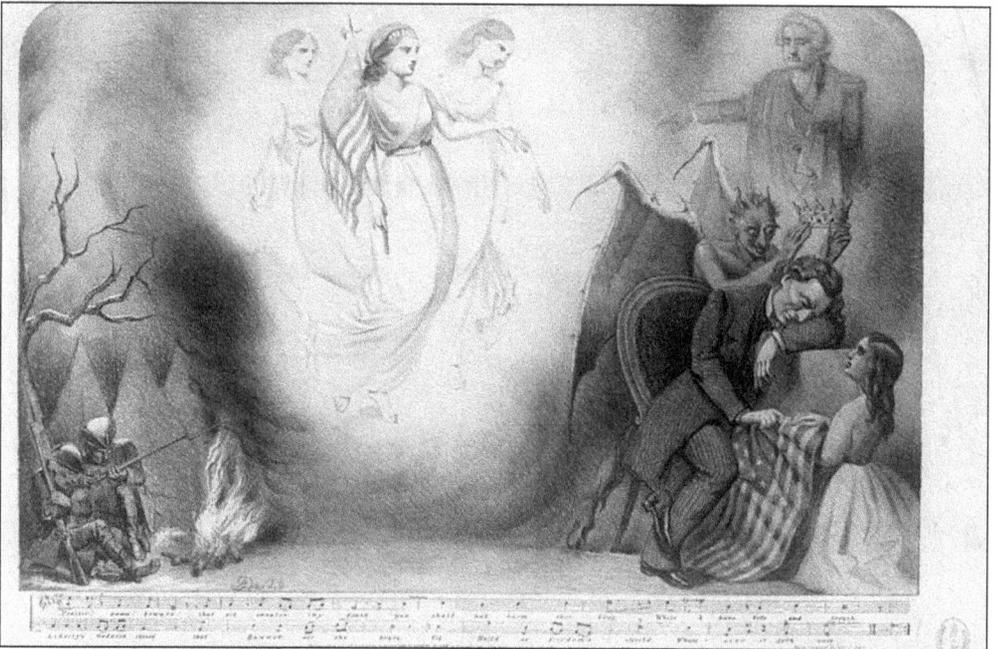

Loudoun at the time of the Revolution was one of the most populated counties in the state of Virginia. Although the war never came to Loudoun's soil, her volunteer rate, according to the returns of 1780 and 1781, numbered 1,746—far in excess of the numbers reported by any other Virginia county. In the background of this 1864 Benjamin Day lithograph, the specter of George Washington looks on while a man is crowned king by Lucifer. Washington points toward Liberty, and two female attendants (center) appear in an aura of light. Liberty has a halo of stars and holds another American flag. On the far left, two Revolutionary War soldiers huddle next to a campfire over song lyrics reading, "Your vet'ran sires, Encamp'd at Valley Forge, Exposed to winter's storms." (Library of Congress.)

This is a portrait of Capt. Matthew Rust, one of the authors of the *Loudoun County Resolves*, which were in essence a declaration of independence made in June 1774. The original *Loudoun County Resolves* disappeared sometime in the past 230 years. Nearly all of the Lee papers, which may have included the *Loudoun County Resolves*, were destroyed in the great 1895 fire at the University of Virginia, where they had been archived. The original *Loudoun County Resolves* had been found in 1826 among the papers of Leven Powell. (Library of Congress.)

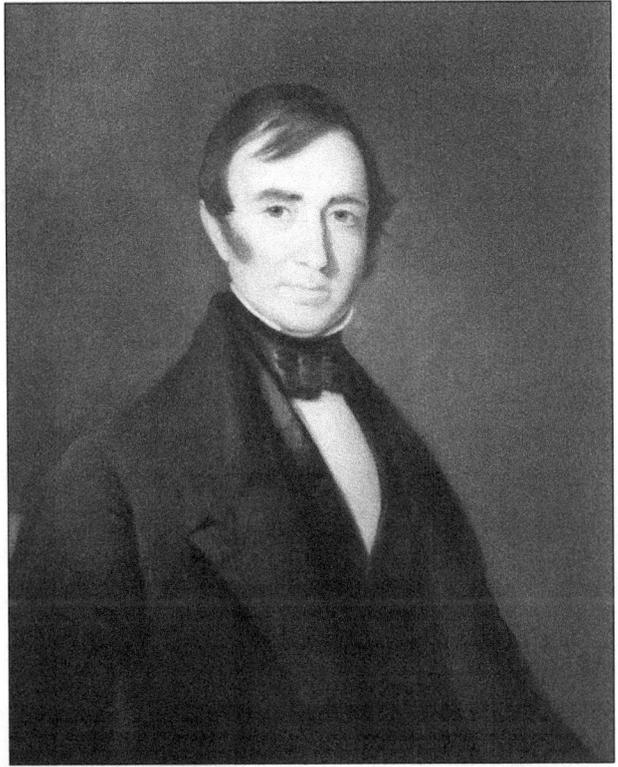

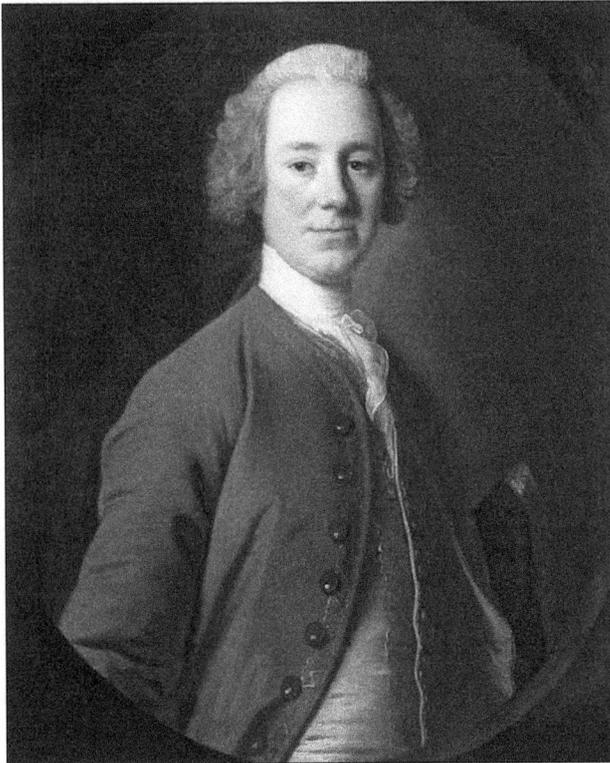

On February 17, 1756, John Campbell, the fourth Earl of Loudoun, was appointed captain of the province of Virginia, and on March 20, he became commander in chief of the British forces in America. He was an officer utterly lacking in initiative, ability, courage, or intelligence. After numerous and ungraceful tactical errors throughout the entire war in America, Parliament ordered him to return home. The Loudoun family motto, "I Byde My Time," remains in Loudoun as an almost forgotten legacy. (Library of Congress.)

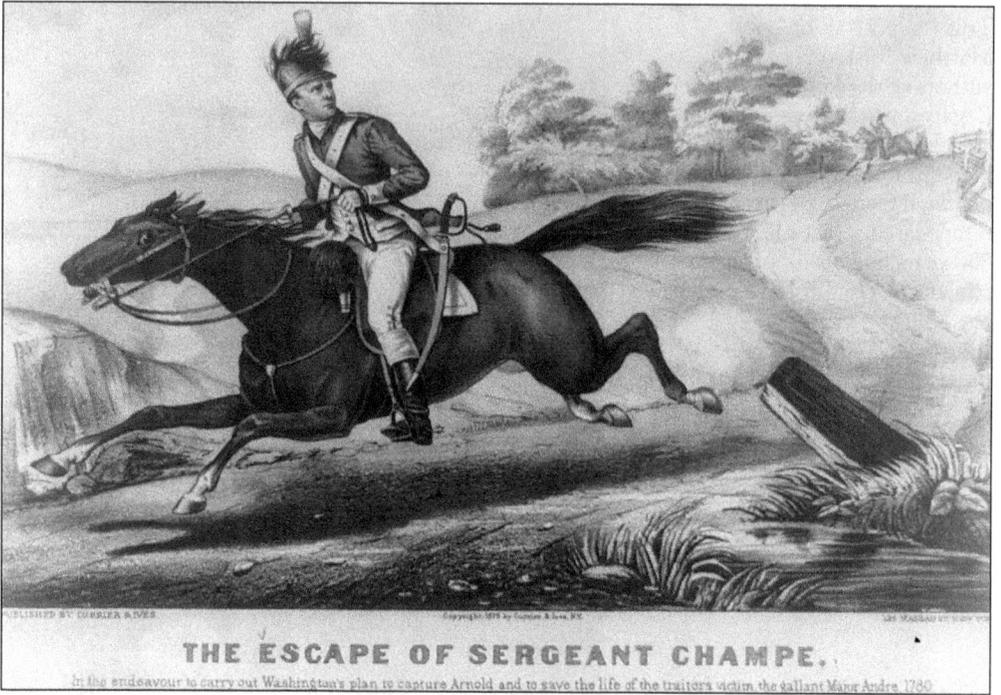

THE ESCAPE OF SERGEANT CHAMPE.

In the endeavour to carry out Washington's plan to capture Arnold and to save the life of the traitor's victim, the gallant Major Andre, 1780

John Champe was the star of his own Revolutionary War thriller, almost taking down the traitorous Benedict Arnold, who abandoned his loyalties to the Americans and deserted to serve the British. Champe's mission, given by George Washington, was to feign desertion from America and infiltrate Arnold's regiment, kidnap him, and bring him back to be tried as a traitor. He was forced to travel with Arnold as his recruiter, all the while maintaining the image of loyalty to his despised enemy. He finally escaped and deserted into the Appalachian Mountains, rejoining the American Army. (Library of Congress.)

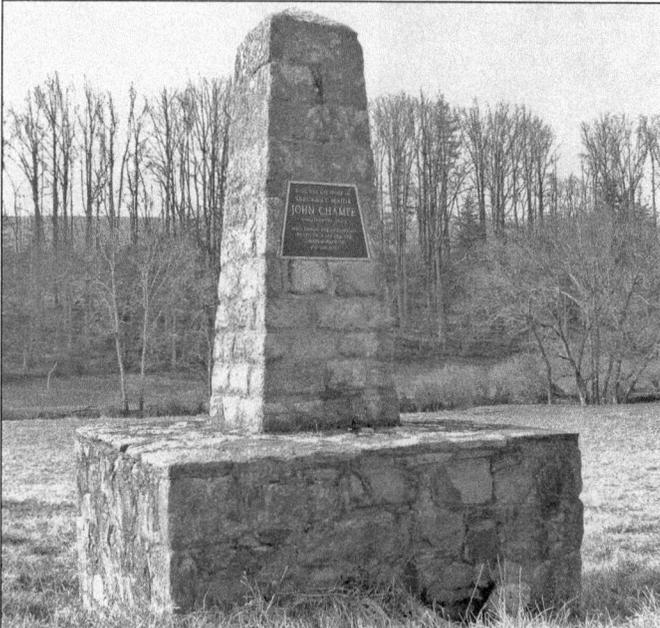

Champe returned after his wartime adventures to settle near Middleburg with his family. His home was just off Route 50 on his namesake Champe Ford Road. An obelisk stands in his honor where his homestead had been. (Photograph by Laura Troy.)

Two

War Comes to Middleburg

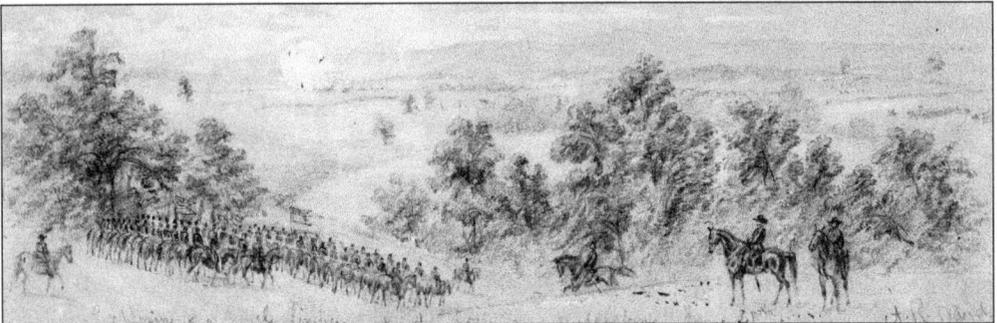

The atrocities of war struck hard at Middleburg when the Civil War arrived on the town's doorstep. Bloody battles were fought—and legends grew—as the war raged all around the tiny village. This 1863 Alfred Waud drawing shows a battle near Middleburg. (Library of Congress.)

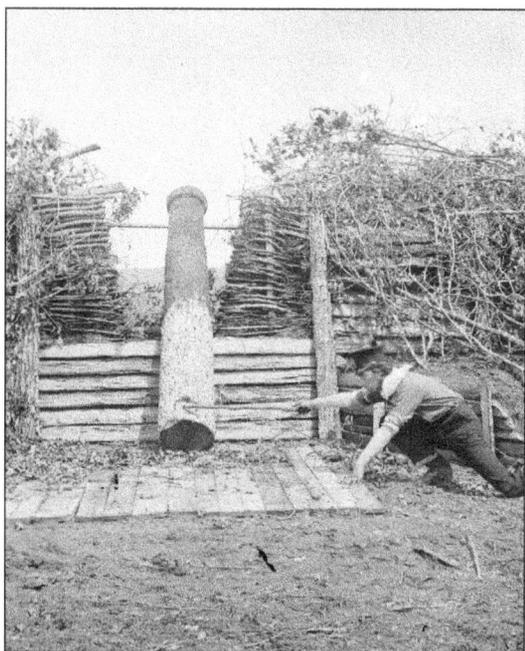

This Quaker gun was a deception tactic used in 18th- and 19th-century warfare. Although resembling an actual cannon, the Quaker gun was simply a black wooden log used to deceive an enemy. The name derives from the Quakers, who have traditionally held a religious opposition to war and violence. Middleburg was first drawn into the sectional controversy when pro-slavery folks in Loudoun unsuccessfully petitioned the state legislature in 1850 for the formation of a new county, with Middleburg as the proposed county seat. The Loudoun Quakers concentrated at Goose Creek adamantly criticized slavery, but the pro-slavery residents became still more defensive of it. On May 23, 1861, citizens of Middleburg voted 115-0 in favor of secession from the Union, which Leven Powell had done so much to memorialize in his plan for the town. (Library of Congress.)

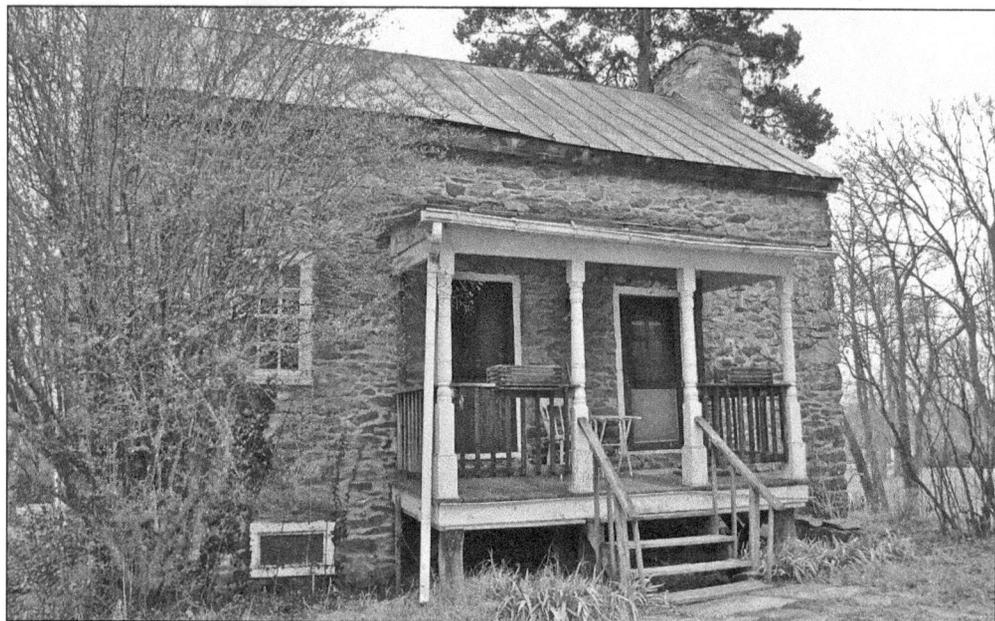

Built around 1770, Mount Defiance was thought to have earned its namesake during a dispute between the "fathers" of Middleburg, Powell and Chinn. After a battle over 700 acres, which ensued through two generations, the Chinn family built a home named Mount Recovery, honoring the reacquisition of a portion of their land. Their previous home, which had been lost to the Powells during the litigation, had been named Mount Defiance by the Powells in a smug expression of their sentiment towards the Chinns. Later, during the war, Mount Defiance regained its pugilistic label when it became a center of defense during the Battle of Middleburg in 1863. Confederate general J.E.B. "Jeb" Stuart defended this post with 3,200 men until being driven out by Federal troops. (Photograph by Laura Troy.)

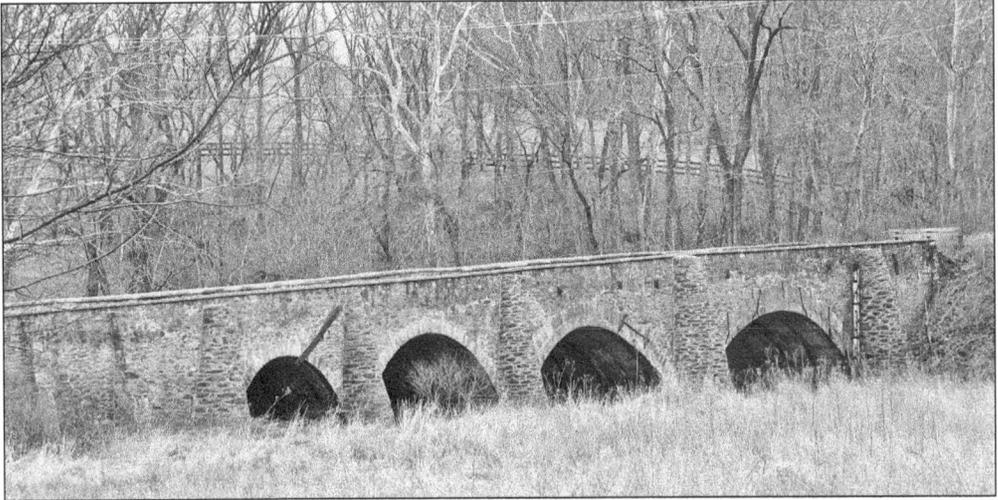

Goose Creek Bridge was built in 1801 and is now a preservation site. The bridge was the scene of a fierce cavalry battle on June 21, 1863; many men and horses died here. It was rebuilt by the Fauquier and Loudoun Garden Club on land donated by Sen. John Warner. The bridge carried traffic until 1957. It is dramatic and set in a landscape that has changed little in 200 years. It also played a key role in a mystery by Ellen Crosby, *The Merlot Murders*. (Photograph by Laura Troy.)

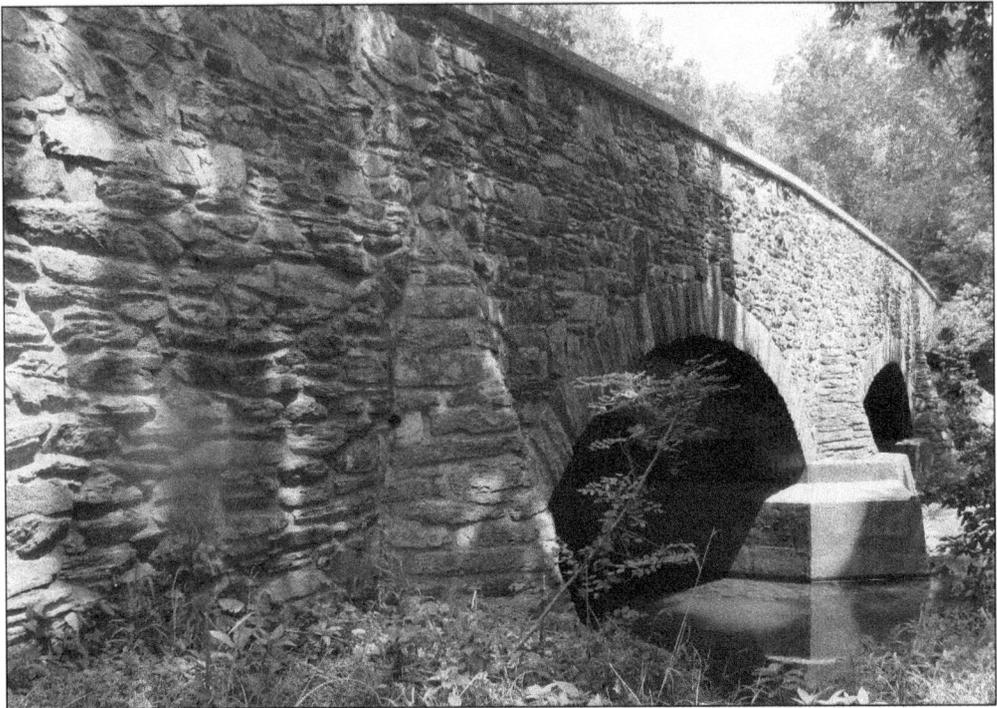

Hibbs Bridge is a beautiful, double-arched stone bridge built between 1810 and 1830 on Snickers Gap Turnpike (now Snickersville Turnpike). The Hibbs family operated mills, and one son rode with Mosby's Rangers, despite the fact that the Union army used the Hibbs residence as a headquarters. A different kind of attack occurred in the 20th century, when a plan arose to demolish the bridge. Local residents rallied, and eventually, in 2007, a restored Hibbs Bridge was reopened to traffic. (Photograph by Kate Brenner.)

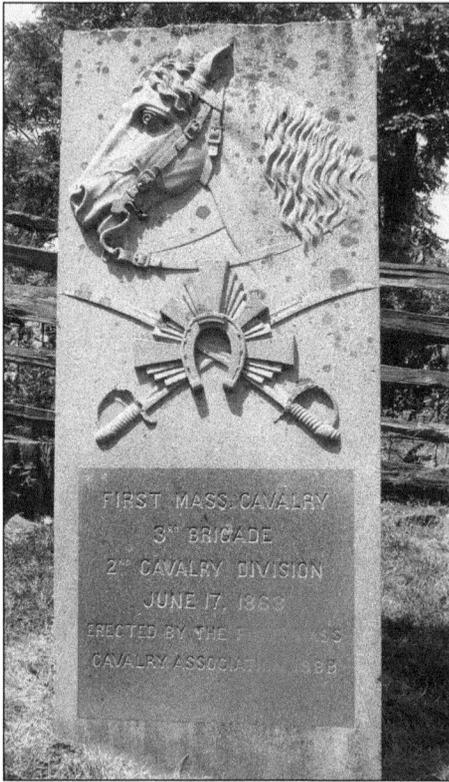

Snickersville Turnpike is one of the most beautiful roads in Loudoun County. At a sharp bend in the road is an evocative Civil War monument commemorating a spot where, in June 1863, some of the heaviest fighting before Gettysburg took place, at the Battle of Aldie. As historian Bob O'Neill writes, "The narrow bend in the road quickly became a dusty, confused killing ground." A Northern surgeon is reported to have said that this was "by far the most bloody cavalry battle of the war." The road and fields have changed very little over the past 150 years. (Photograph by Kate Brenner.)

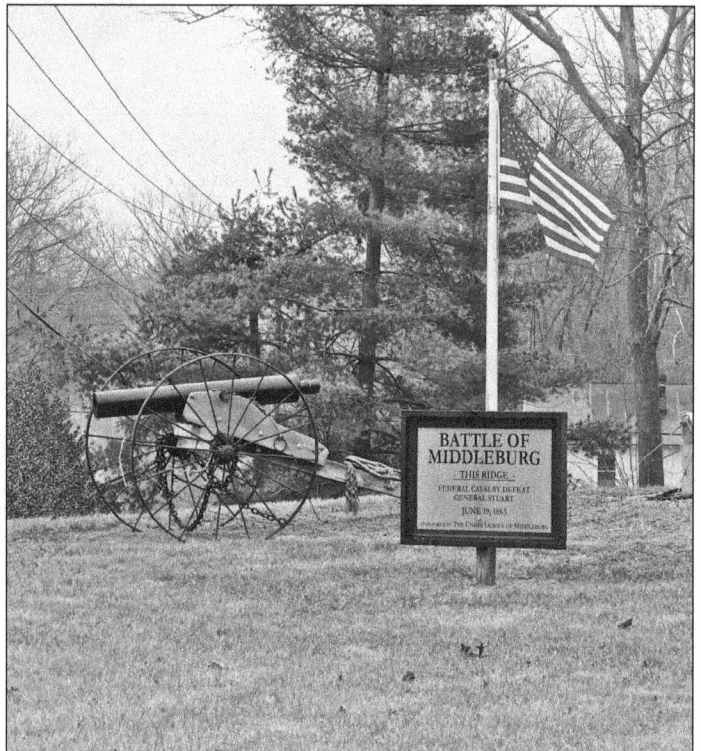

On June 19, 1863, Confederate forces led by General Stuart faced off in a bloody battle known as the Battle of Middleburg. The two armies played cat and mouse along what is now Route 50. Stuart was attempting to prevent Union armies from moving troops through the Shenandoah Valley on their way to the epic Battle of Gettysburg. (Photograph by Laura Troy.)

24

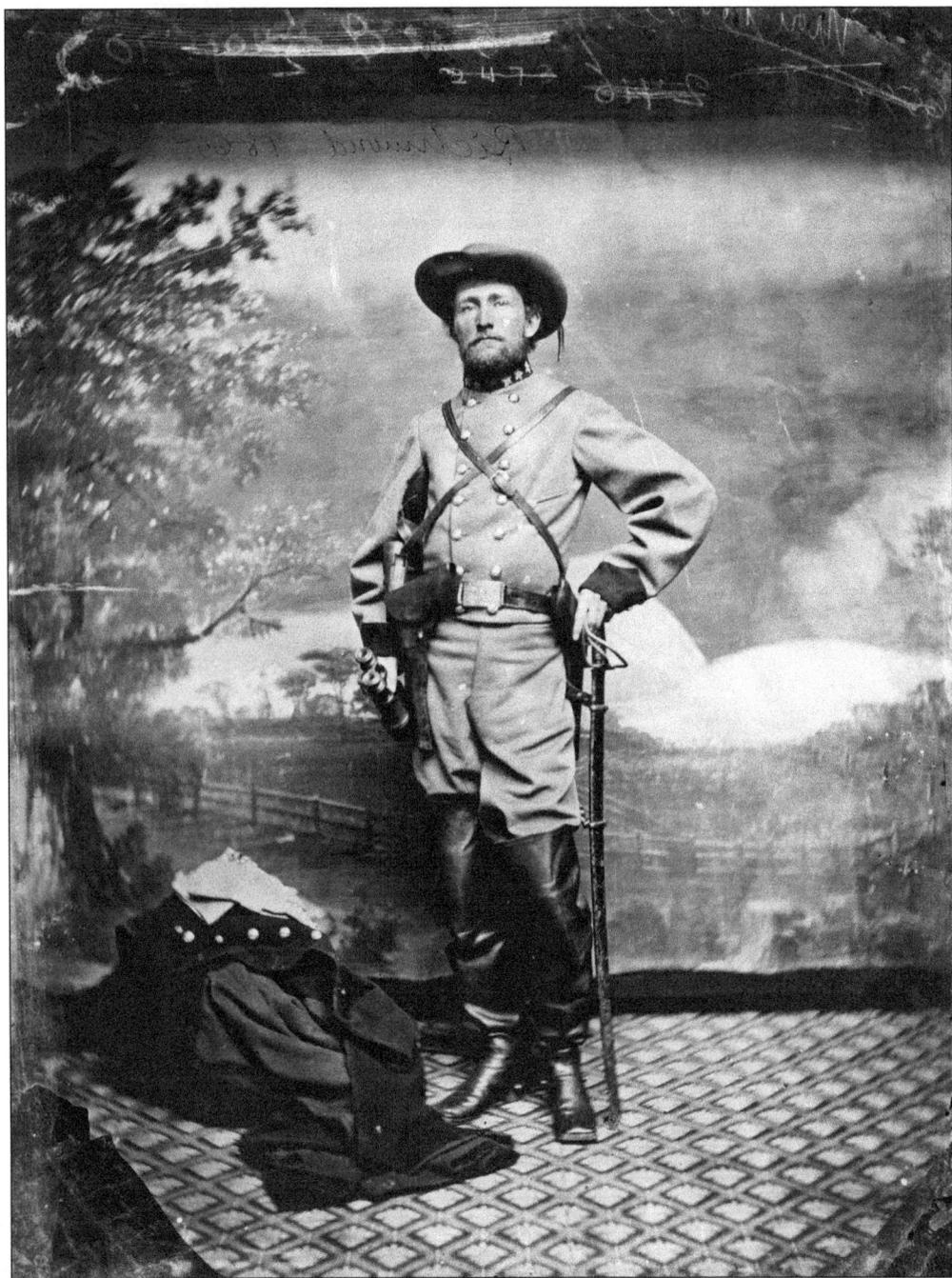

The Gray Ghost, John Mosby, the famous Confederate wartime player, began his crusade in Middleburg. Mosby and his rangers formed a legendary band of cavalry men as he set out to prove that a small number of skilled men and fine horses spread over a large, unsettled area could launch disastrous attacks on larger bands of formal troops. With the aid of safe houses and provisions for his rangers from locals, Mosby crushed any doubts about his theory as he pummeled Union troops for 28 months with his guerilla-like warfare. He earned his title from his sudden appearances, frightening Federal troops, and his equally swift departures. (Library of Congress.)

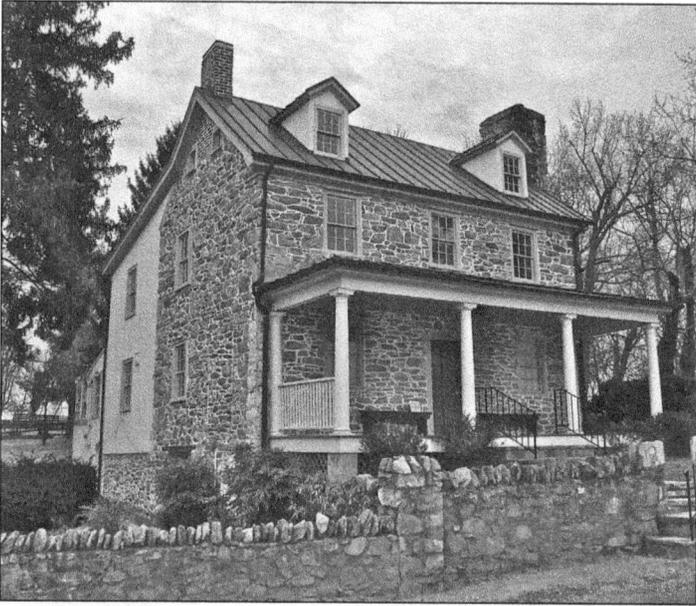

Company A of Mosby's 43rd battalion was formed here, at the Caleb Rector House, just outside Middleburg. These men would soon become known as Mosby's Rangers, notorious for their cross-country operations and blistering raids on the Union troops. (Laura Troy.)

In 1863, because of the cruelty of the raids and manhunts for Mosby by the Union troops, a petition was sent by the townspeople urging Mosby to set up base in another location. The townspeople feared their village would be burned by Union hands, but the mayor, Lorman Chancellor, supported Mosby's refusal to be displaced. Here, at the Lorman Chancellor House, Mosby had Sunday dinner before he commenced his most damaging and famous raid against the Union. Mosby stated in reference to his plot, "I shall mount the stars tonight or sink lower than the plummet ever sounded." The Norman Chancellor House, the mayor's home during the Civil War and the current mayor's family home, still stands at the corner of Washington and South Jay Streets. (Laura Troy.)

After dinner on March 9, 1863, Mosby and his rangers crept to the Fairfax Courthouse, where Union general Edwin Stoughton was already snoring in his bedclothes, sleeping off a drunken stupor. Mosby snuck into the bedroom and roused the drowsy general, lifting his nightshirt and giving him a hearty slap on the behind, saying, "Get up, general, and come with me! Do you know who I am? Did you ever hear of Mosby? He has caught you!" That night, Mosby also managed to capture 58 horses, two captains, and 30 prisoners without a shot fired. In a time when honor and dignity defined a person's caliber, this capture was most humiliating and insulting to the Union's reputation. Mosby's Rangers even made the front page of *Harper's Weekly* in September 1863 for destroying a Union wagon train. (Library of Congress.)

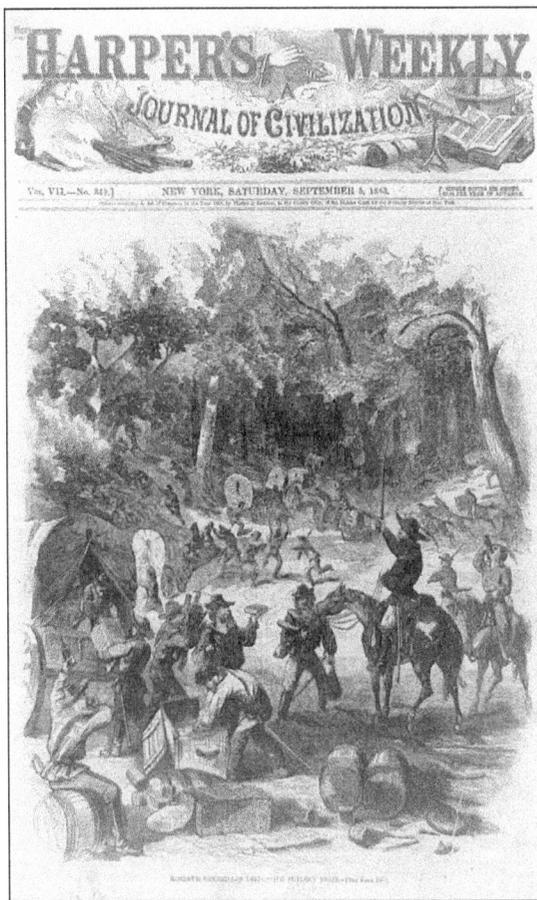

A realistic Civil War reenactment takes place just outside of the Red Fox Inn on the streets of Middleburg. (The Pink Box.)

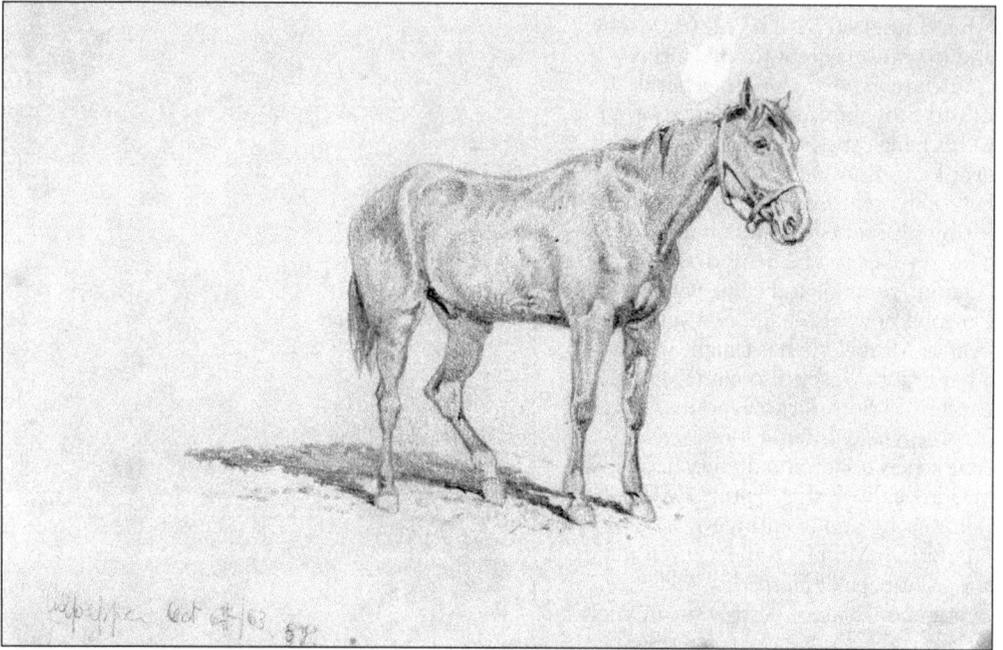

Middleburg's equine resources were vital contributions to the Virginia cavalry. Because of Middleburg's obsession with sport horses, foxhunting, and horse racing, many strong horses and riders were available, groomed and ready for battle. Both soldier and steed were trained in speed and jumping, both important to evading the enemy. Cavalry riders were responsible for their valuable mounts, which were held with in high regard and with a great deal of emotional attachment. This 1863 painting of a cavalry horse by Edwin Forbes shows the demeanor necessary for a warhorse: calm and tractable but alert and ready for action. (Library of Congress.)

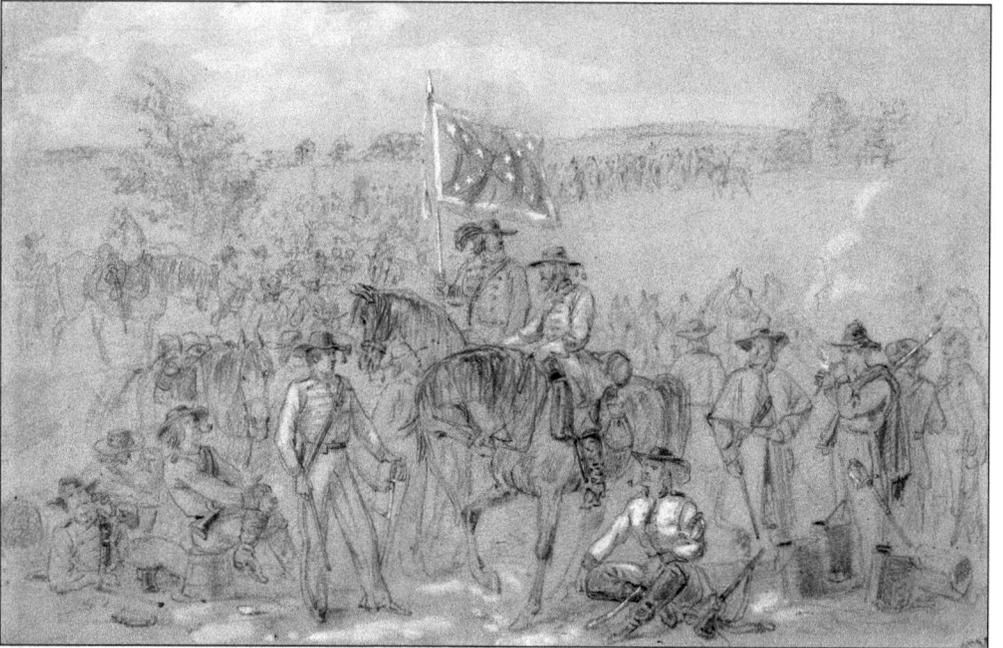

Alfred Waud painted this 1862 work of the 1st Virginia Cavalry. (Library of Congress.)

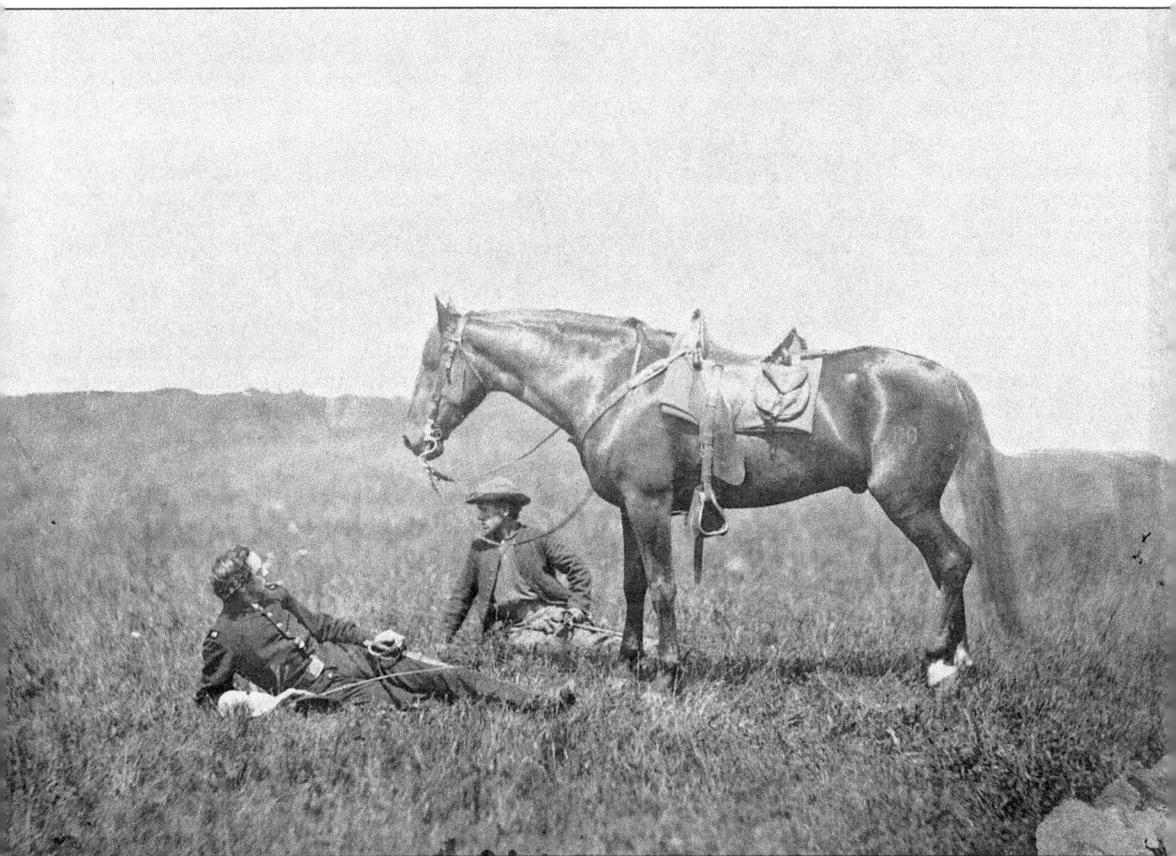

Capt. Harry Page (left) lounges in a Virginia meadow with a fellow soldier and his relaxed mount. (Library of Congress.)

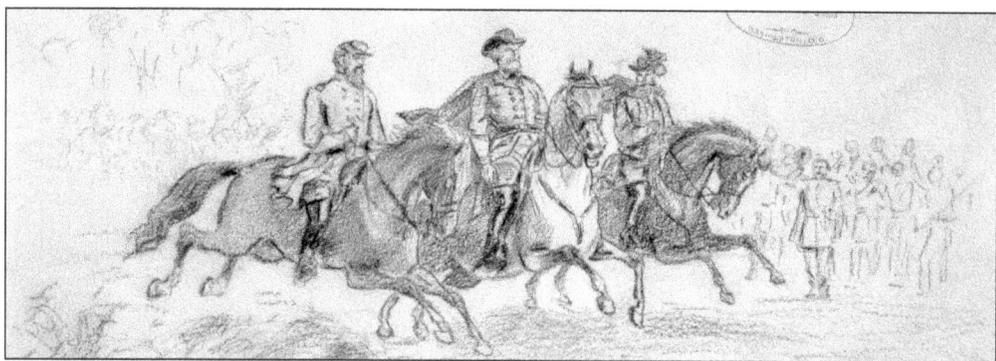

Generals Robert E. Lee, "Stonewall" Jackson, and Jeb Stuart ride through a cheering reception in this drawing by F.C. Burroughs titled *Three Heroes*. In his book *The Cavalry Battles of Aldie, Middleburg and Upperville*, Bob O'Neill describes a battle scene: "The narrow bend in the road quickly became a dusty, confused killing ground from which there was little chance of escape. Men were punched out of their saddles by sharpshooters who could practically touch their targets. Once down in the road the wounded endured a greater horror as terrified and wounded horses plunged and reared, trampling those underneath . . . Hemmed in by the deep cut as well as the walls and fences and pressed by their comrades behind them the Yankees could not avoid the deadly fire that dropped them by the score." (Library of Congress.)

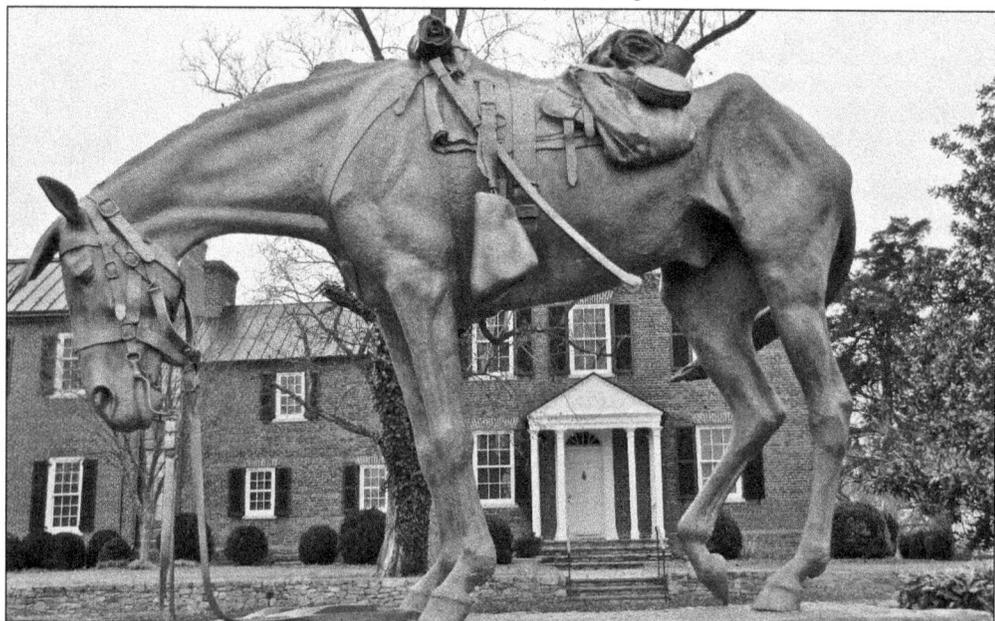

Middleburg's pedigreed horses were vulnerable to theft and the Federal troops took advantage of this weakness. The insults against the Union by Mosby and his rangers caused Gen. Ulysses S. Grant to order a series of retaliations against him. Because Middleburg was the heart of "Mosby's Confederacy," it received the brunt of these attacks. This officer's account of the raids against the townspeople reveals the brutality, "They ranged through the beautiful Loudon Valley and a portion of Fauquier county, burning and laying waste. They robbed the people of everything they could destroy or carry off—horses, cows, cattle, sheep, hogs, etc., killing poultry, insulting women, pillaging houses, and robbing even the poor negroes." This evocative statue in front of the National Sporting Library and Museum honors the thousands of horses that perished during war. It was created by Teresa Pallman and donated by Paul Mellon. (Photograph by Laura Troy.)

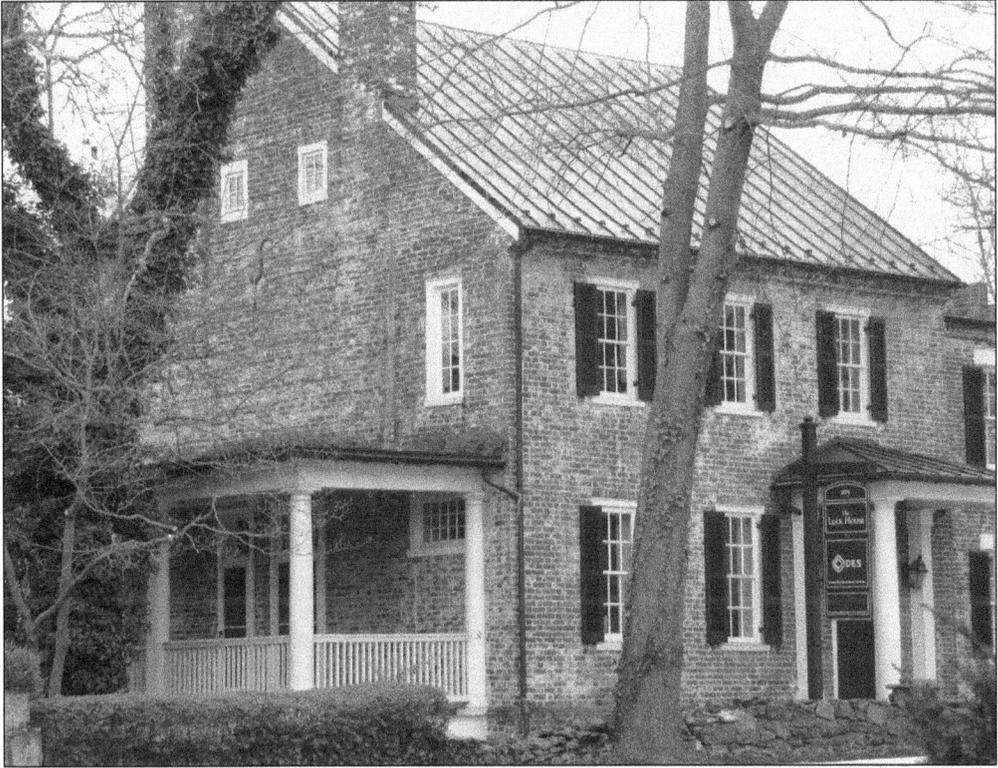

The town physician, William Cochran, was an important Middleburg figure during these times. The doctor's wife, Mary Catherine Cochran, kept a detailed diary of the shocking treatment by the Union troops. One entry reads, "Soon the Yankee soldiers were swarming round us climbing fences, creeping into ham houses, stables, carriage-houses, like the frogs of Egypt coming into our ovens and kneading troughs. They searched our houses for arms; they broke open our stables and took every horse worth stealing, took corn and hay, where they found it; saddles, bridles, harness were all appropriated." William and Mary Cochran resided in the Luck House, which still stands in Middleburg today. (Photograph by Laura Troy.)

Here, a horse and rider meander down the street past the Luck House. (The Pink Box.)

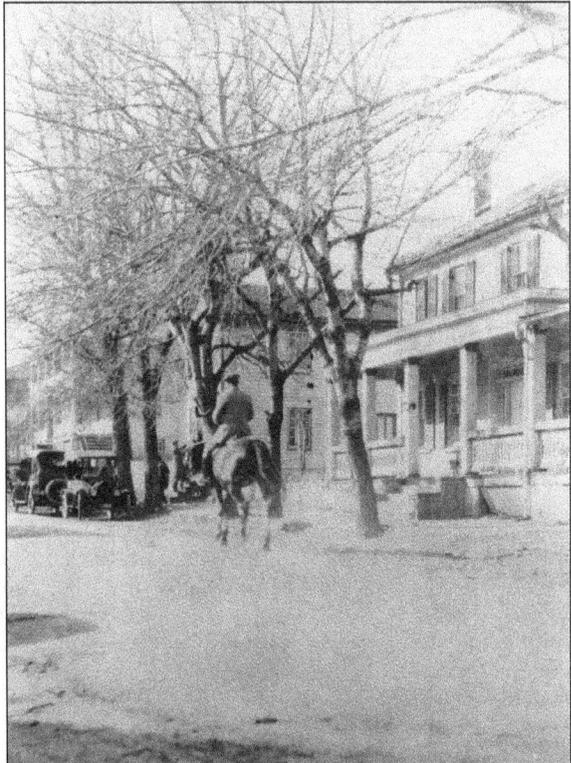

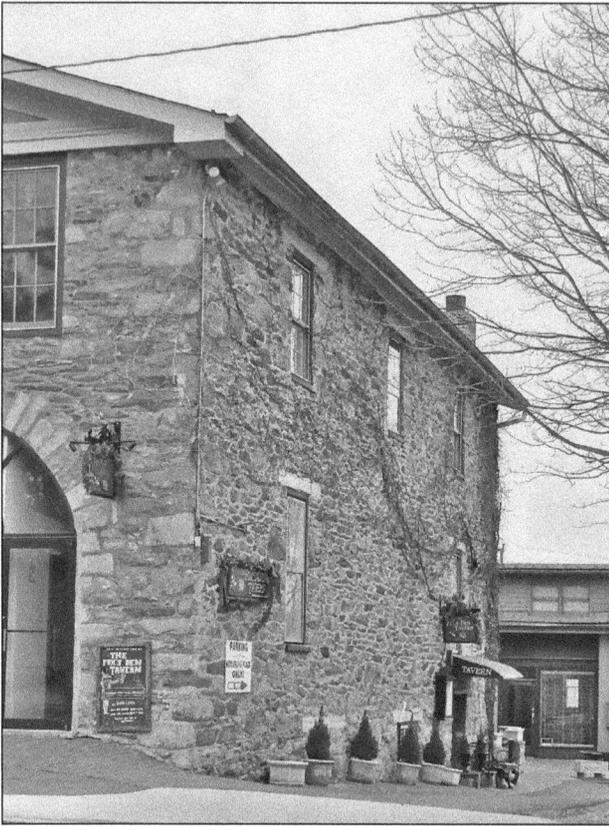

During Federal raids, the townspeople would hide their precious horses any way possible—even in taverns. Mosby was rumored to have hidden his horse in Middleburg's Hidden Horse Tavern, becoming its namesake. Mary Cochran's diary entries give insight into the intense rage felt regarding horse theft: "We were roused by the familiar cry of 'Yankees' . . . Our fine gray mare, who has so often found safety before, was consigned to the cellar . . . A knock on the door . . . 'Will you have someone conduct me to [search] your cellar?' I knew the mare was there but determined to be civil till they got her. I opened the door and there she stood . . . I forgot propriety and going to the dining room window, seeing her in the midst of some hundred Yankees, I told them I hoped she'd break the neck of every man that mounted her."

The large stone tavern thought to have hidden Mosby's horse during Union raids is now known as the Fox's Den Tavern. Guests are served in the same large cellar where Mosby's horse would have quietly stood, waiting for danger to pass. (Photograph by Laura Troy.)

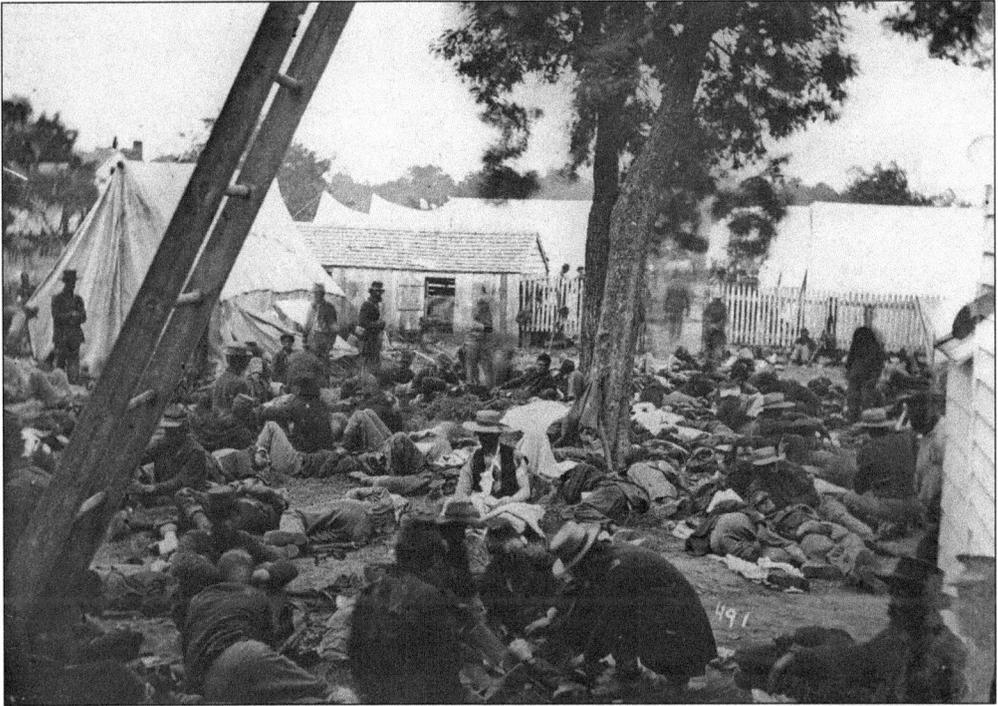

This chilling photograph shows a field hospital in Savage Station, Virginia, with wounded soldiers lying on the ground awaiting treatment. (Library of Congress.)

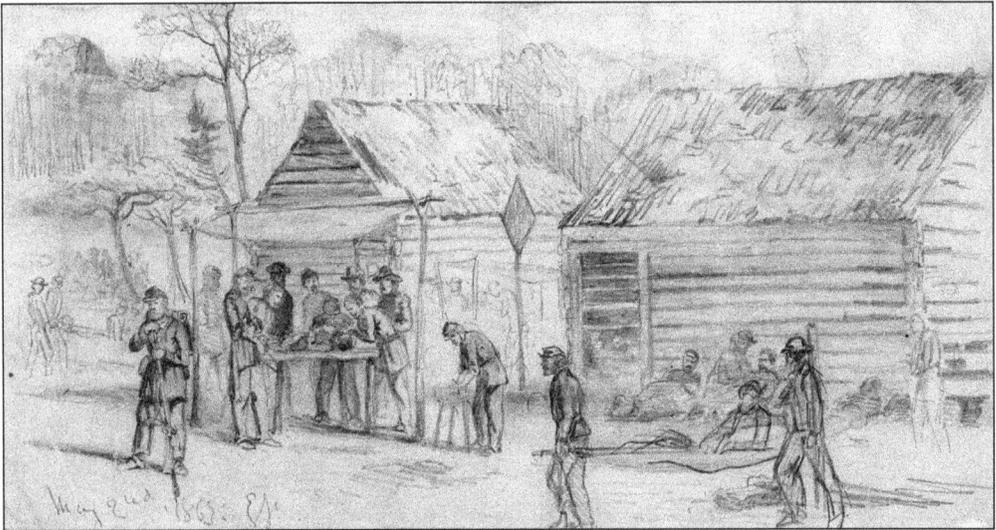

Artist Edwin Forbes captures the crude facilities that served as hospitals during the war. Despite the desperation, the townspeople of Middleburg did not lose hope. Middleburg's theme of alliance and unity within the town was very much alive during this time. Mary Cochran's diary demonstrates this when she recalls fellowship during her struggle to help the wounded: "I saw the rations for 200 men and I know 10 men could have eaten it . . . A great many have died. The bodily labor necessarily fell upon the townspeople, but the country people sent in constant supplies of food, ready cooked. Long rows of hillocks in our cemetery attest that Death reaped his harvest." (Library of Congress.)

When 1,200 wounded soldiers were brought from the Battle of Wilderness to Middleburg for treatment, other accommodations besides the physician's home were necessary. When Catherine Broun, wife of the town's leading merchant, Edwin Broun, observed the transformation from town to hospital, she said, "The horrors of war are upon us." The churches in town, such as the Free Church and the Middleburg Methodist Church, were converted to hospitals as well as the homes and even the front yards of the townspeople. Catherine Broun described the horrors that lay in the streets of Middleburg as "the most pitiable objects that one could possible conceive of" adding, "Their surgeon is sick. Have not had any medical attention for two or three days. The stench is terrible." (Library of Congress.)

The diary Catherine Broun kept while living at Sunny Bank Farm has given invaluable insight into the town's Civil War history. Their farm, just a mile outside of Middleburg, was a quiet country retreat with a quaint farmhouse and 178 acres of Piedmont farmland. During the leaner times in the mid-19th century, the Brouns mostly resided here on their farmland to protect their reserves. (Photograph by Laura Troy.)

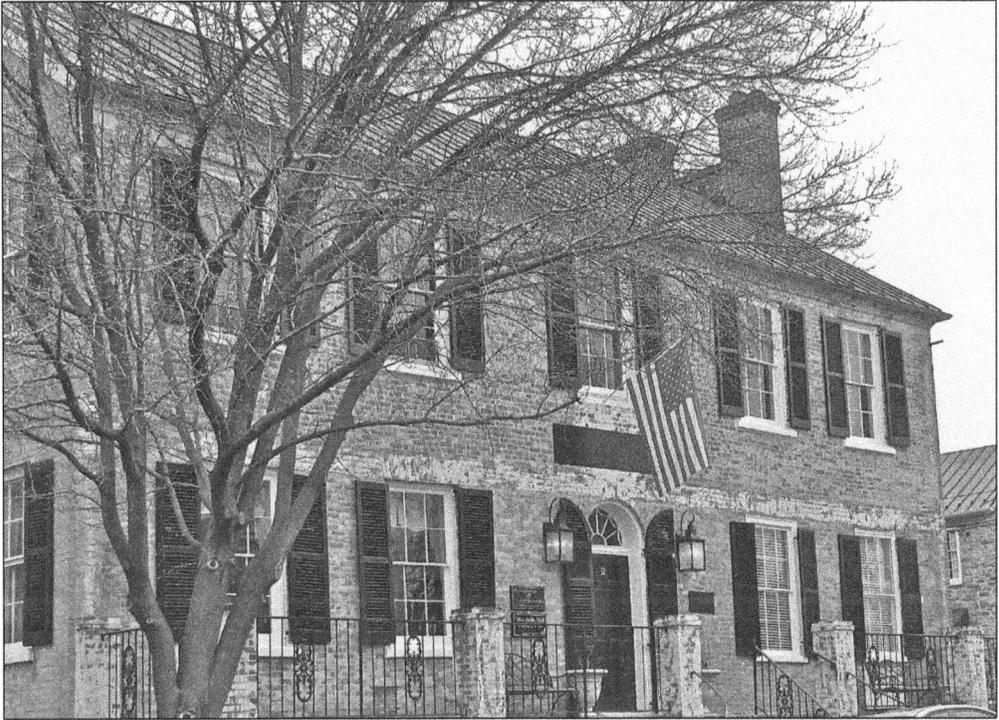

The Noble Beveridge House, sometimes referred to as the Colonial Inn, was Catherine Broun's Middleburg home. It was built in 1830 and had a double-decker porch. It has been home to everything from mortally wounded Civil War soldiers to a bank. (Photograph by Laura Troy.)

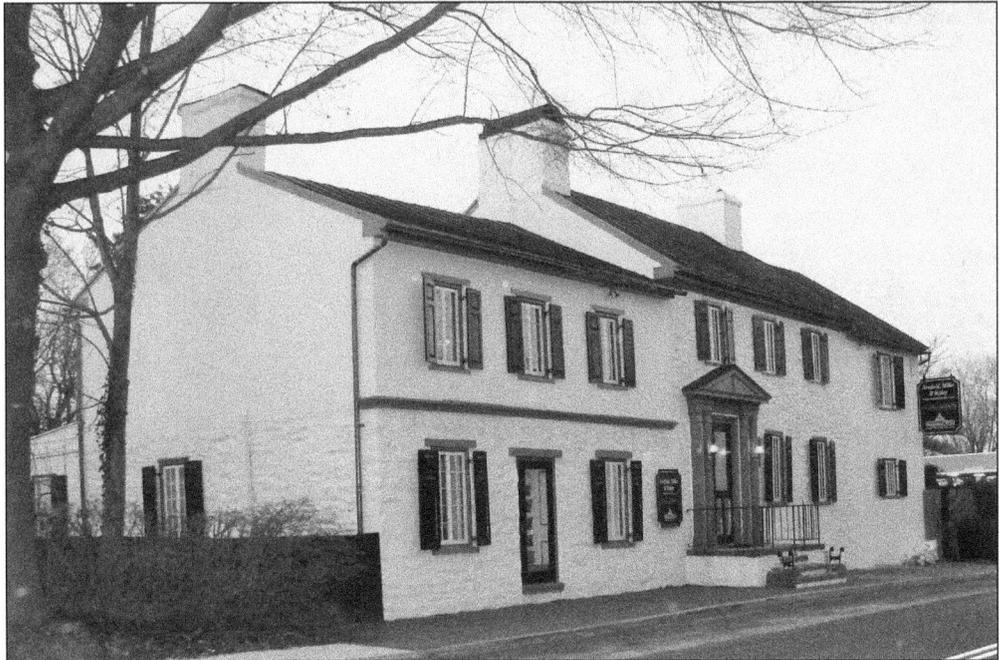

The Boyd-Broun House was also home to the Broun family. It was purchased in 1820 and remained in the family until around 1860. (Photograph by Kate Brenner.)

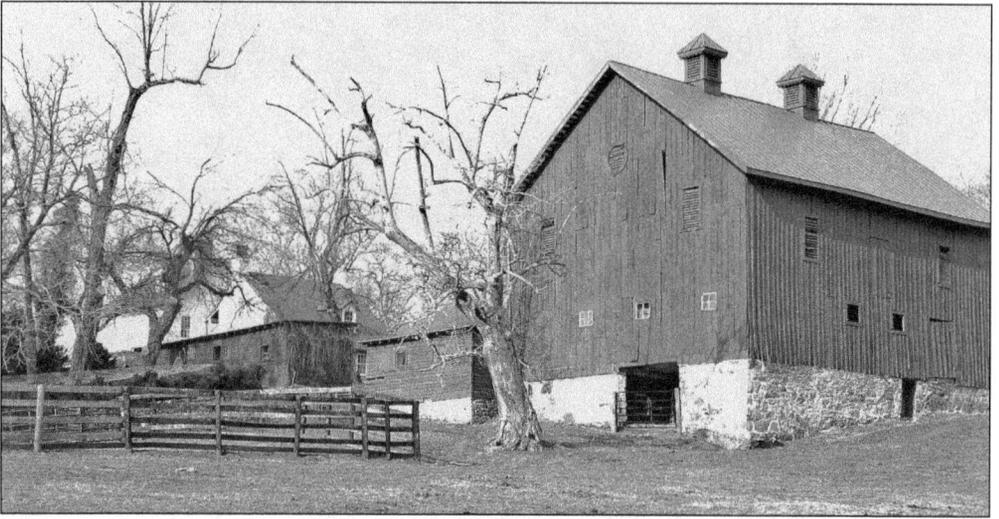

Rock Hill had a brief role in the Civil War. Family history holds that the farm was the site where Mosby's Rangers divided up the money from their 1864 Greenback Raid, when Mosby derailed a train near Duffield's Station in West Virginia. The men made off with the federal payroll of $173,000. Rock Hill was first built by Thomas Humphrey in 1797 on land he had acquired from his service in the Revolutionary War. In the midst of the suffering of the Civil War, Middleburg offered its homes to tend to more than 1,000 wounded and dying men. The people banded together and shared their resources, though they initially had little to spare even for their own families, much less for strangers. Middleburg's comradeship signified the unities formed during the war; a sharp contrast to the rampant cruelty of external troops. (Library of Virginia.)

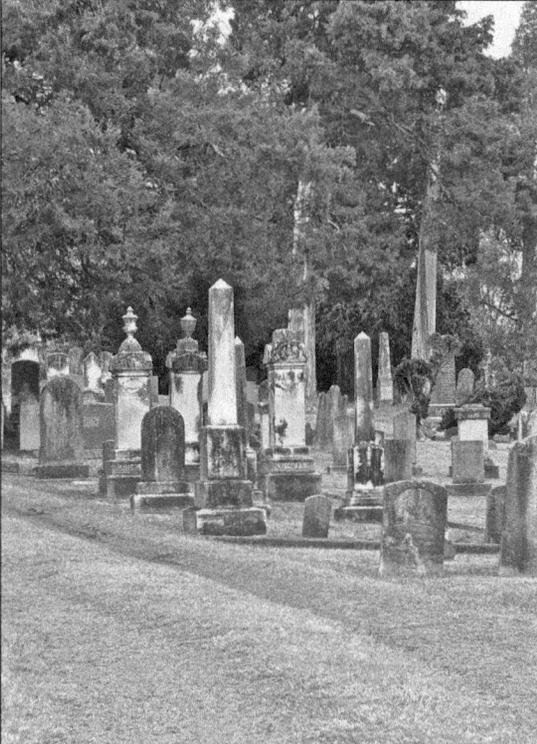

Middleburg buried its dead at the Mount Sharon Cemetery, which was purchased from Marietta F. Powell for $520 in 1850. Sharon is a Hebrew word for "countryside" and biblically represents man's eternal state of peace. (Photograph by Laura Troy.)

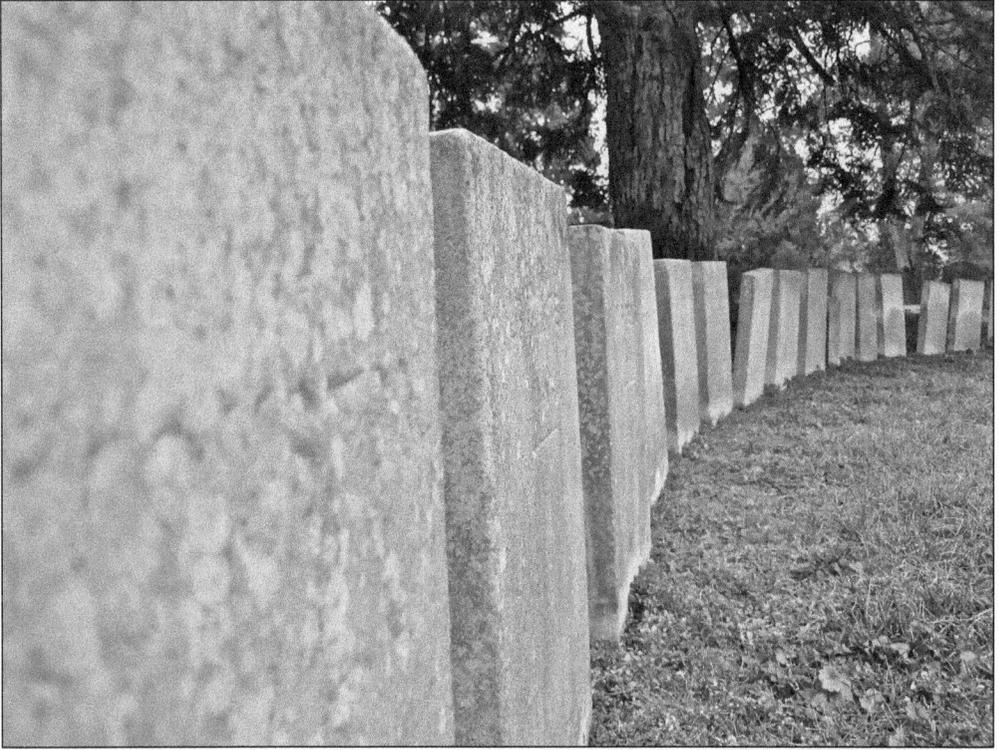

Dozens of headstones surround the main monument in a circle. Most of them are blank in honor of the unidentified bodies buried beneath them. (Photograph by Laura Troy.)

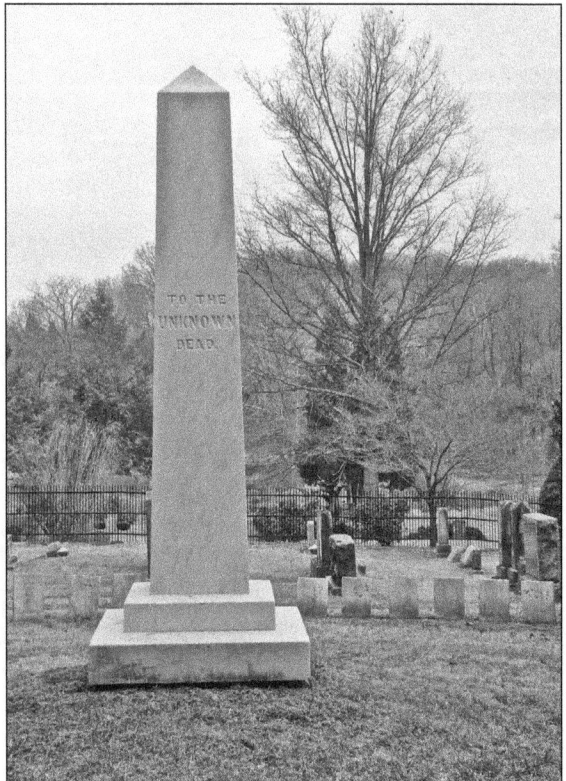

With so many of the dead unidentified, this monument was made to honor the large group of unknown soldiers. It has been suggested that this was the first monument of this kind in the colonies. (Photograph by Laura Troy.)

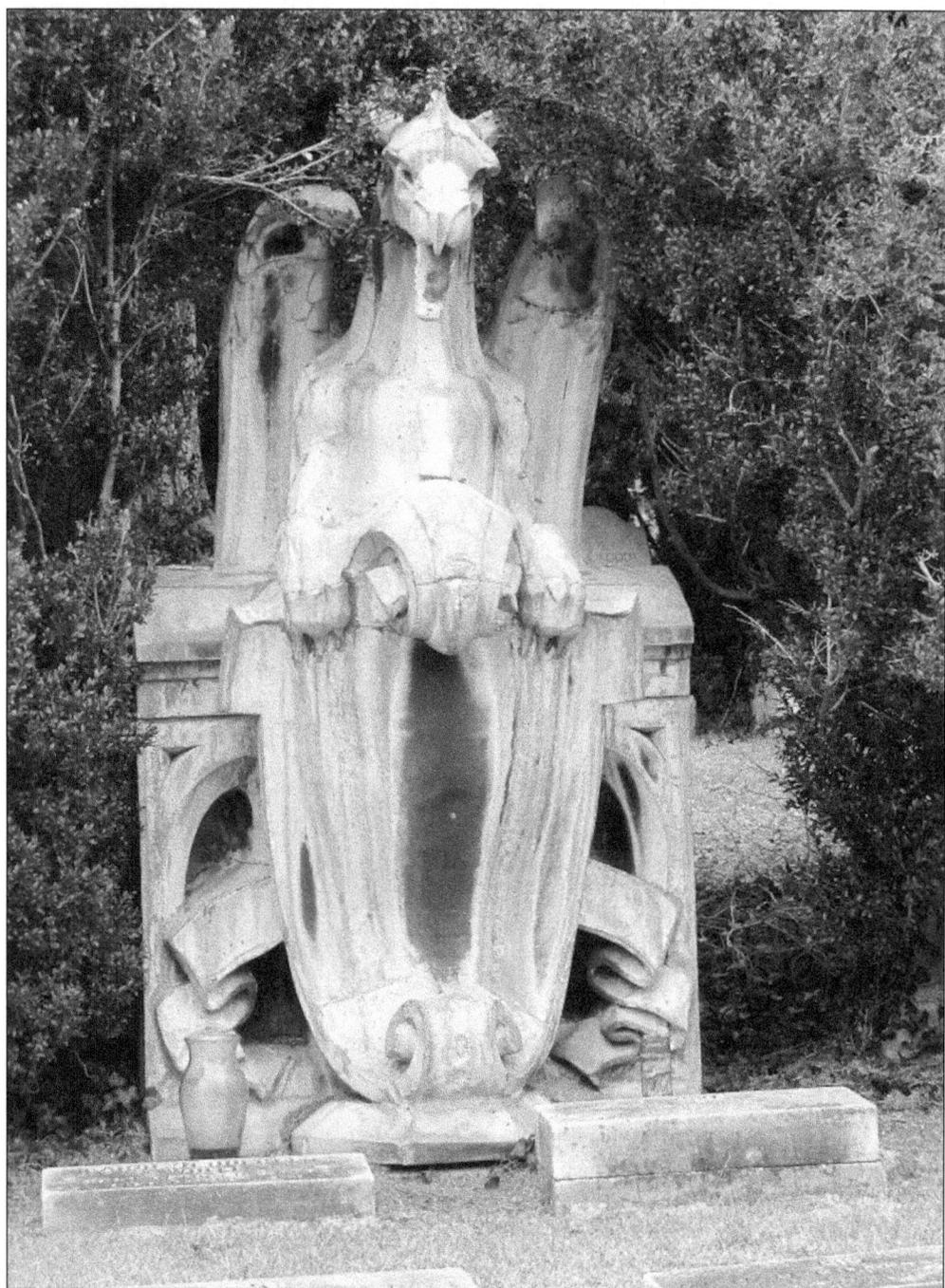

The Mount Sharon Cemetery is a tranquil place with beautiful landscaping, a serene duck pond, and even a few surprises, like this dragon sculpture peeking out of a hedge of boxwoods. There is also a Rodin sculpture in the cemetery. (Photograph by Laura Troy.)

The wounds of war take a long time to heal, but in this 1886 photograph, the sons and grandsons of Confederate veterans pose together in Middleburg. (The Pink Box.)

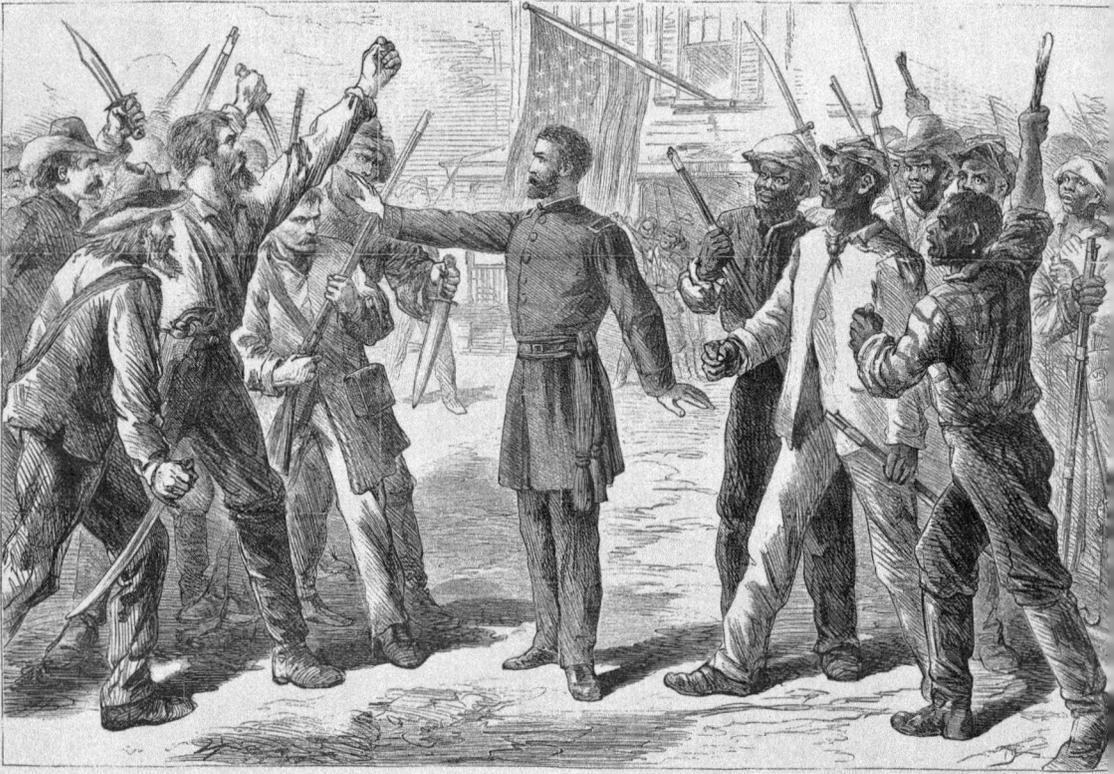

THE FREEDMEN'S BUREAU.—DRAWN BY A. R. WAUD.—[SEE PAGE 467.]

At the conclusion of the war, the US War Department established a Freedman's Bureau in Middleburg at the Asbury Methodist Church, where a black congregation had already begun to worship. The bureau remained active in the town, ministering to the material needs of the freedmen until 1872 and leaving the name Bureau Corner, which Middleburg's northeast quarter is still known as. The construction of Middleburg Methodist Church, which had begun in 1858 following the split in Asbury's congregation, was completed in 1868 to serve as a house of worship exclusively for whites. This Alfred Waud depiction from *Harper's Weekly* shows the difficulties of the post–Civil War era of reconstruction. A man in the middle of two angry mobs—one white and one black—represents the Freedman's Bureau's attempts at pacification. (Library of Congress.)

Three

FAME AND FORTUNE IN MIDDLEBURG

A NEW ERA in Middleburg

Announcing the Opening of
Perfect Sound and Talking Pictures

MIDDLEBURG
HOLLYWOOD
THEATRE

Bringing To You
All the Latest
First Run Pictures

Featuring All Your Favorite
Stars

This Theatre Will Bring to You from
Time to Time Some of Your Favorite
Stars in Person

Matinees Every Saturday
at 3 P. M.

Shows Changed Every
Monday, Wednesday, Friday
and Saturday

NORMA SHEARER JOAN CRAWFORD CLARK GABLE RAMON NOVARRO MARION DAVIES JACKIE COOPER

Middleburg has always attracted its share of the rich and famous—and occasionally infamous. When *Gone With the Wind* made its debut in the Middleburg Hollywood Theater, Clark Gable graced the opening with his presence in the audience. (The Pink Box.)

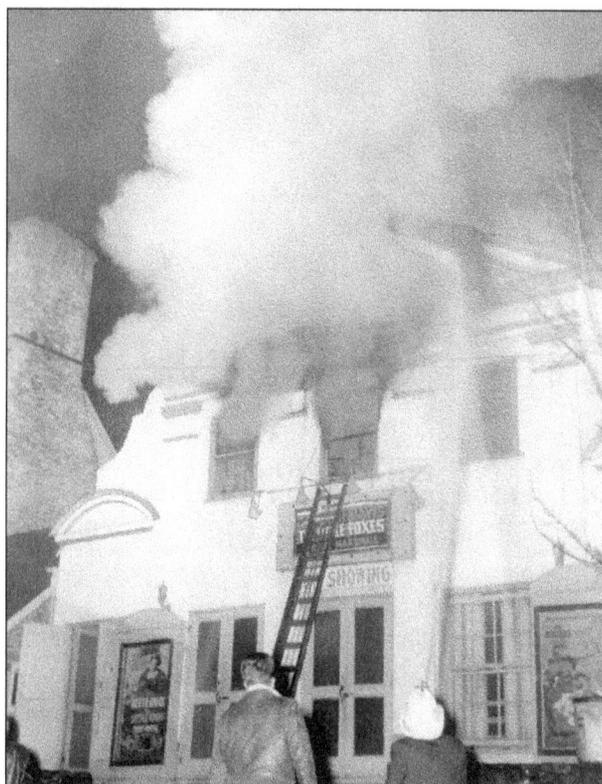

The Middleburg Hollywood Theater, successor to the Red Fox Theater of the 1920s, burned in the 1950s, courtesy of a dropped cigar in the restroom. Fighting the fire are firemen Leon Nachman (right, in white hat) and Warren Jenkins. The Red Fox Theater had been a casualty of the Great Depression, but in 1932, it was reopened by Liz Whitney, who coproduced *Gone With the Wind* with her husband, Jock Whitney. That film's arrival at the theater was a black-tie event. The theater boasted the latest of the talking pictures, and its 30¢ evening admission was higher than all area prices. It was the first air-conditioned building in either Loudoun or Fauquier County. Deteriorating structural and health violations closed the theater in the late 1950s. (The Pink Box.)

The steps of the theater were all that remained after the fire. The presence of celebrities in the 1930s helped establish Middleburg as a "safe house" for fame; the town always exhibited discretion and courtesy to the famous people who visited. (Photograph by Kate Brenner.)

Tab Hunter, Hollywood's golden boy in the 1950s and 1960s, was an avid horseman. His first starring role, at the tender age of 19, was opposite Linda Darnell in the romantic South Seas adventure *Island of Desire*. He also starred in the Academy Award–nominated *Damn Yankees*. In addition, he had a pop hit called "Young Love," which stayed at the top of the charts for 12 weeks in 1956. He was well known in Middleburg and often rode in the surrounding countryside. (The Pink Box.)

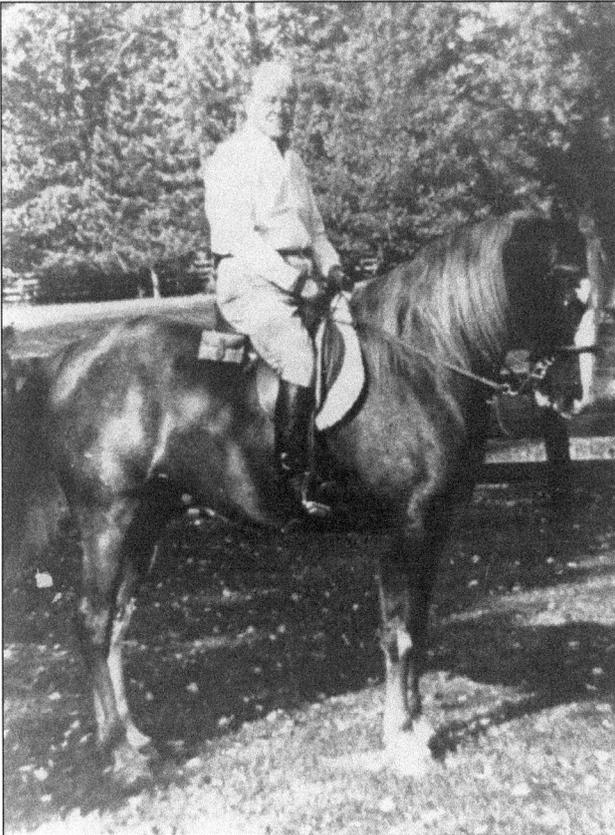

Jack Kent Cooke spent his teenage years in California, sold encyclopedias during the Depression, and went on to become one of the most successful entrepreneurs of the 20th century. The former owner of the Washington Redskins, Cooke was one of the most unique characters to reside in Middleburg, owning a large Thoroughbred operation called Kent Farms. He bred and raced a number of successful horses, most notably Flying Continental, who won the 1990 Jockey Club Gold Cup. His son John Kent Cooke bought Boxwood, the former home of Gen. Billy Mitchell. There is now a thriving vineyard at Boxwood. When he died in 1997, Jack Kent Cooke included Middleburg in his will, promising his book collection to the Middleburg Library. (The Pink Box.)

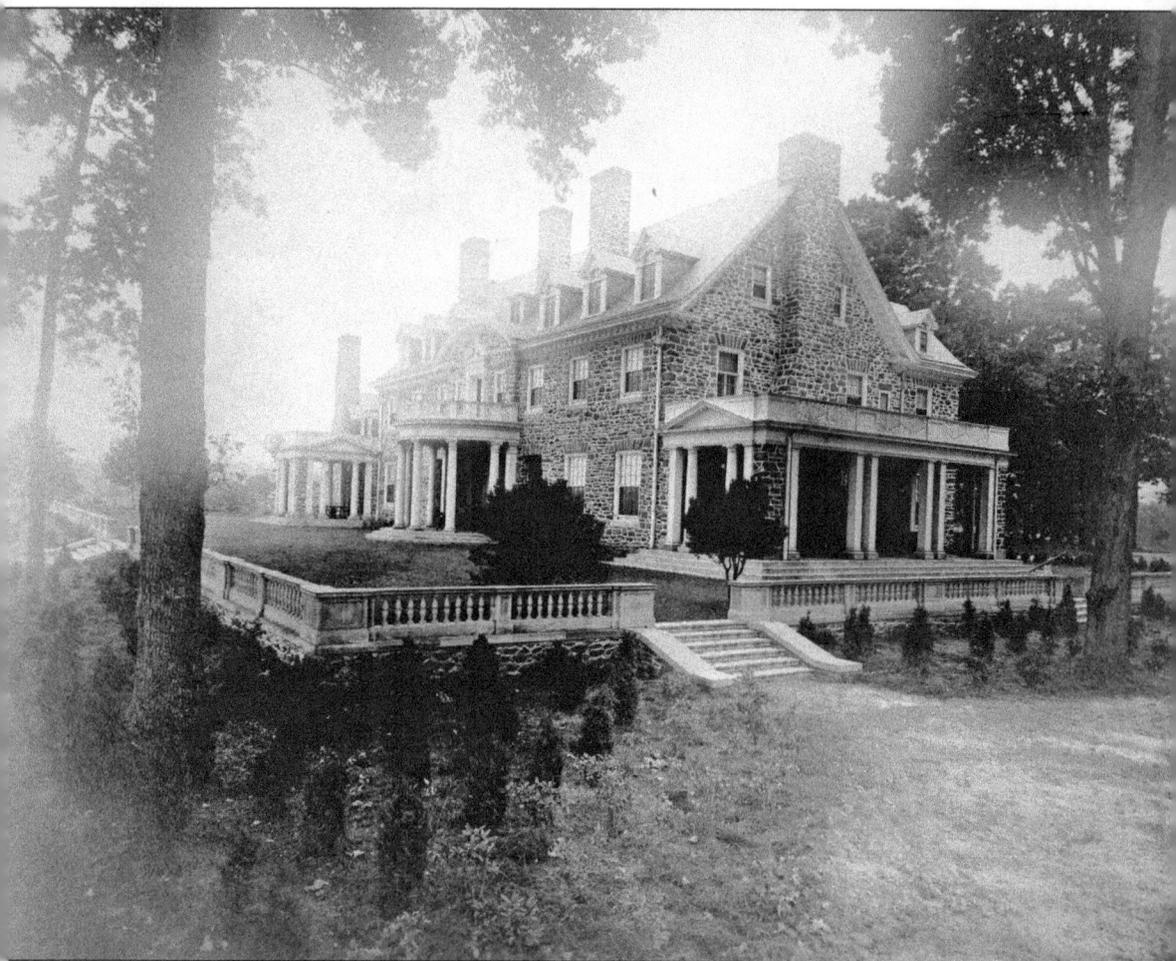

The original plantation house of Ayrshire Farm was built around 1821 by land speculator Bushrod Rust. Purchased in 1847 by George S. Ayre, it was comprised of the south 290 acres of the present farm. Ayre continued to add adjoining acreage to the farm but lost it to creditors in 1880. Anthony Lawson purchased the property for a dairy and beef cattle enterprise, temporarily renaming the farm Brookland. It was the home of Gen. J.A. Buchanan around 1920, when this photograph was taken. In *The Civil War In Fauquier*, Eugene Scheel writes, "The colonel [Mosby] seemed particularly fond of the views at Ayrshire." On June 27, 1863, the estate was the site of a skirmish when Jeb Stuart engaged Union forces during the Battle of Upperville. Portions of Alfred Hitchcock's *Topaz* were filmed at Ayrshire. (Library of Congress.)

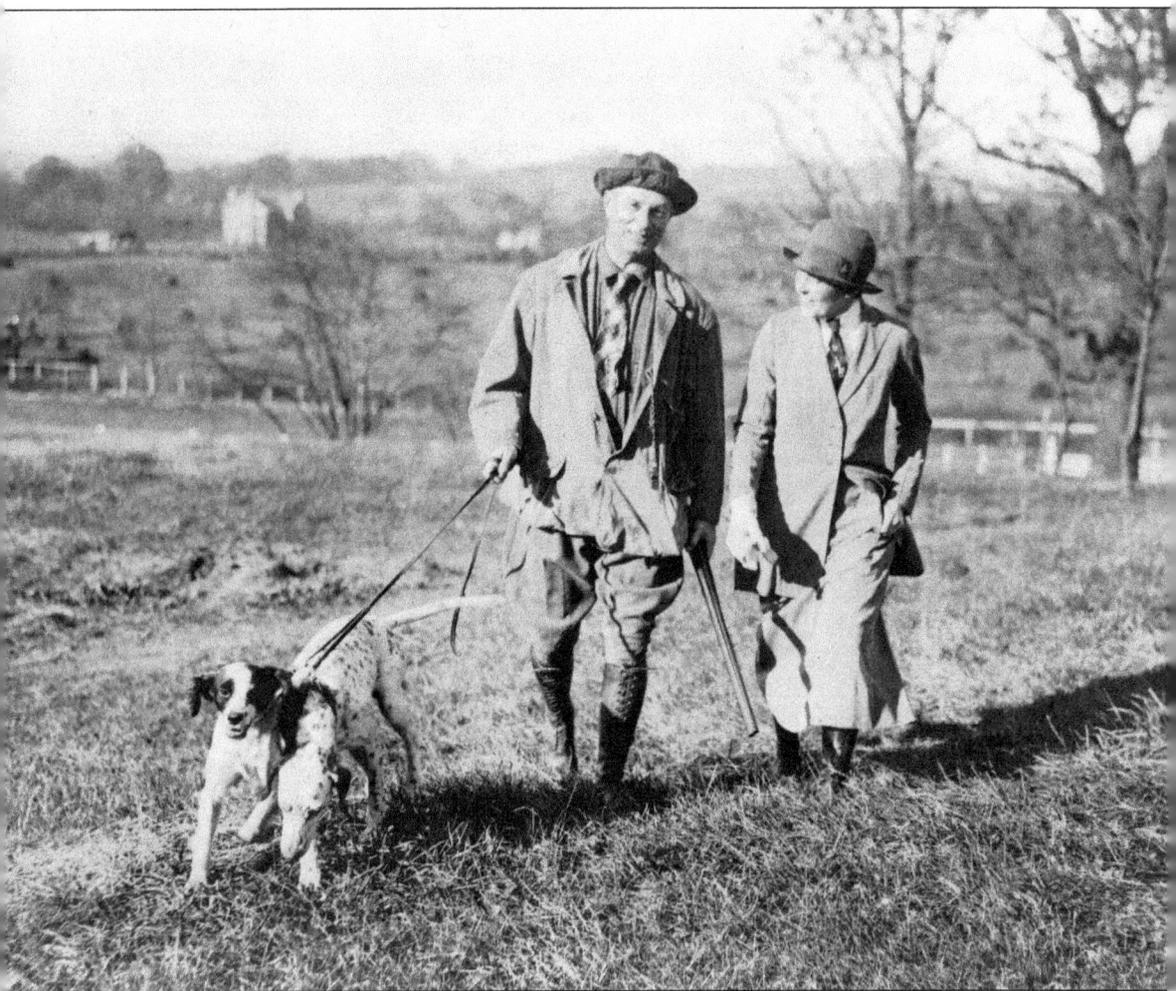

Gen. Billy Mitchell, regarded as the father of the US Air Force, and his wife, Elizabeth, walk their hounds together near their home, Boxwood, in Middleburg. Mitchell moved to Boxwood Farm in 1926 and lived there until his death. (Library of Congress.)

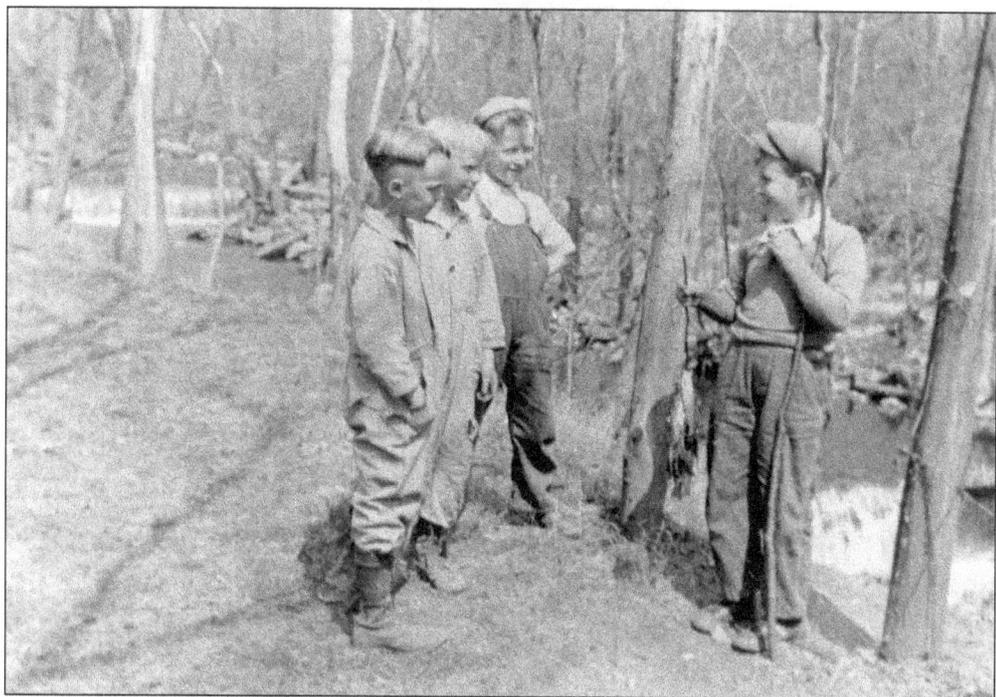

Middleburg was a great place to grow up for Bill Mitchell, the son of Gen. Billy Mitchell. Here, he proudly shows off his catch of fish to friends. (The Pink Box.)

Boxwood, the former home of Gen. Billy Mitchell and the current home of John Kent Cook, is seen here. (Photograph by Kate Brenner.)

Paul Mellon, a philanthropist and owner/breeder of Thoroughbred racehorses, made a lasting impact on the Middleburg area. He is one of only five people ever designated an Exemplar of Racing by the National Museum of Racing and Hall of Fame. He was co-heir to one of America's greatest business fortunes, the Mellon Bank estate, and donated land and funds to construct the Middleburg Agricultural Research and Extension Center, the Middleburg Training Track, and the National Sporting Library and Museum. Mellon's first and last love was horses; he was joint master of foxhounds of the Piedmont Hunt and won the famed 100-Mile Ride three times, demonstrating to everyone his determination and skill. He is seen here as a young man at the Rolling Rock Hunt. (*Life* magazine.)

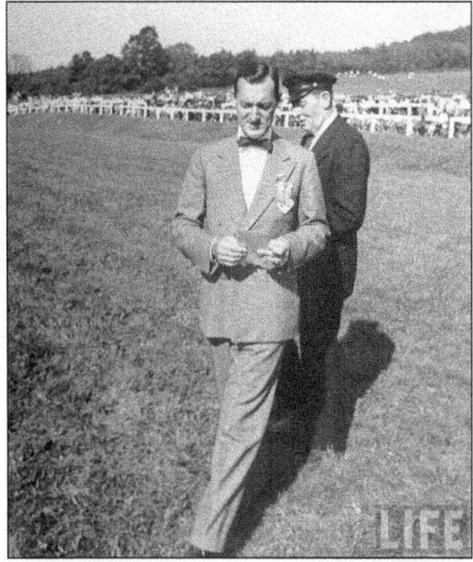

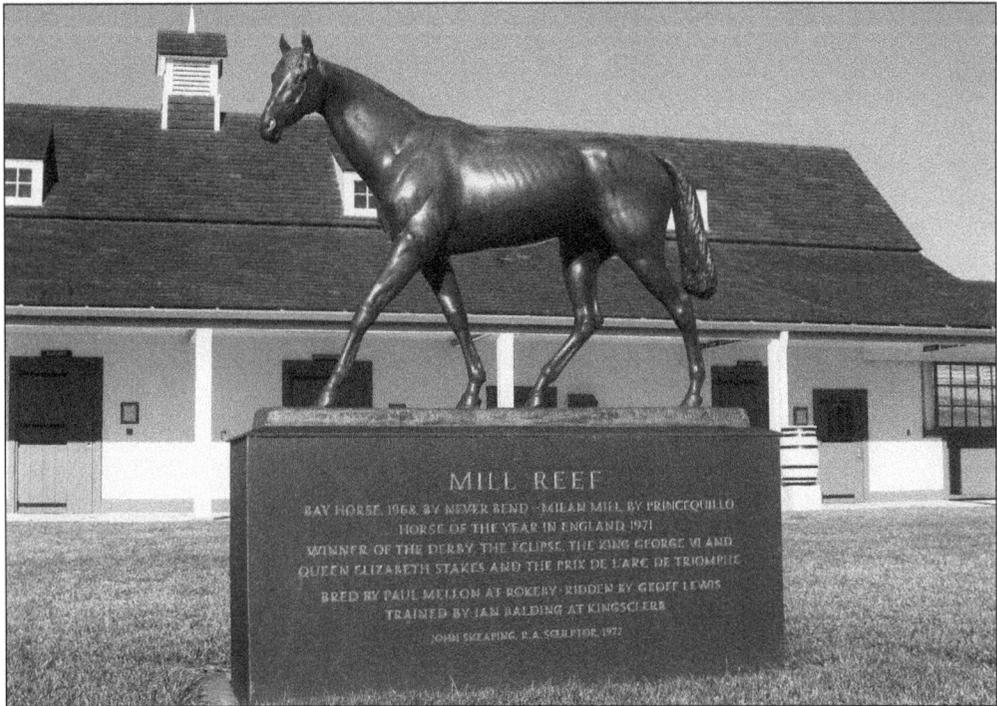

Mellon owned many Thoroughbred horses at his Rokeby Stables, including Kentucky Derby winner Sea Hero. Two of his horses, Arts and Letters and Fort Marcy, were named American Horse of the Year, in 1969 and 1970 respectively. Both are inductees in the National Museum of Racing and Hall of Fame. He also owned two European champions, Mill Reef and Gold and Ivory. Mill Reef was listed as the eighth-rated horse in the world for the 20th century in *A Century of Champions* by John Randall and Tony Morris. Mellon won the Eclipse Award for Outstanding Breeder in 1971 and again in 1986. This large bronze statue by John Skeaping is of Mill Reef, but it also honors Mellon's achievements in the horse industry. It sits in the courtyard of the L-shaped racing stables at Rokeby. (Photograph by Karen Nutini.)

ARTS AND LETTERS
1966 — 1998

HORSE OF THE YEAR
BELMONT STAKES

Arts and Letters is buried and memorialized at Gainesway Farm in Kentucky, a top-tier Thoroughbred breeding facility. (Gainesway Farm.)

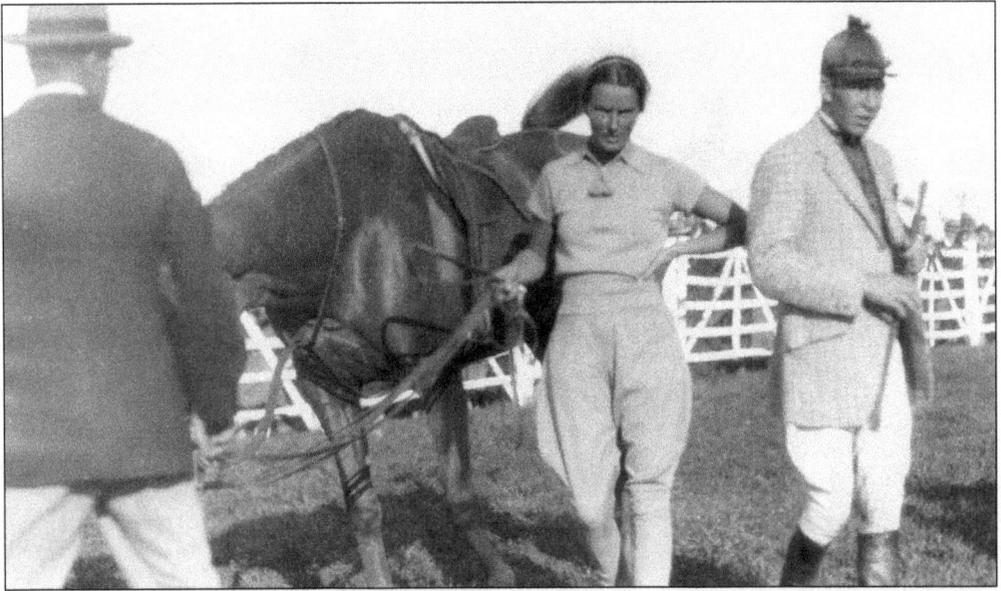

Llangollen, on 1,100 acres at the foot of the Blue Ridge Mountains, is one of the most exquisite farms in the Middleburg area. Formerly the home of well-known horsewoman Liz Whitney Tippett, many successful Thoroughbred horses were raised on the property. Through her social standing and involvement with horses, Liz met and married John Hay "Jock" Whitney, a member of the extremely wealthy Whitney family of New York. Jock Whitney's grandfather, father, and uncle were all heavily involved in Thoroughbred horse racing. For their 1930 marriage, he bought his bride Llangollen farm, a large and historic property off Trappe Road west of Upperville. Liz Tippet (center) is seen here after riding around the Llangollen racecourse on a hot summer day. (The Pink Box.)

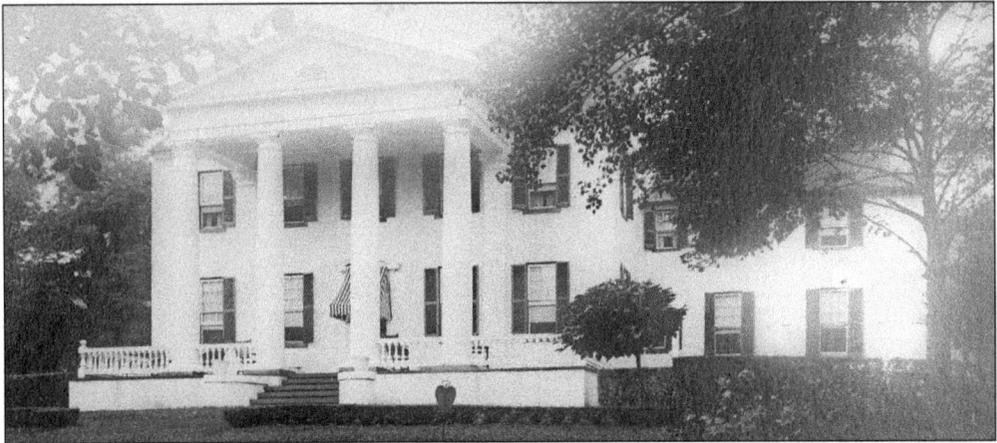

General Lafayette was entertained at Llangollen on his second visit to America. In the American Revolution, Lafayette had served as a major general in the Continental Army under George Washington. In her 2005 book *The Middleburg Mystique*, local author Vicky Moon wrote of Llangollen, "If the walls could talk here, they'd tell of the wild hunt balls thrown by [Tippett] . . . And of the time she brought her favorite horse into the great room or the 35 dogs that lived here full time. (The most beloved ones were kept in her deep freezer when they passed on.) And of the well-known visitors: Doris Duke, Elsa Maxwell, Eddie Arcaro, Prince Aly Khan . . . Bing Crosby, ambassadors and politicians from Washington." (Library of Congress.)

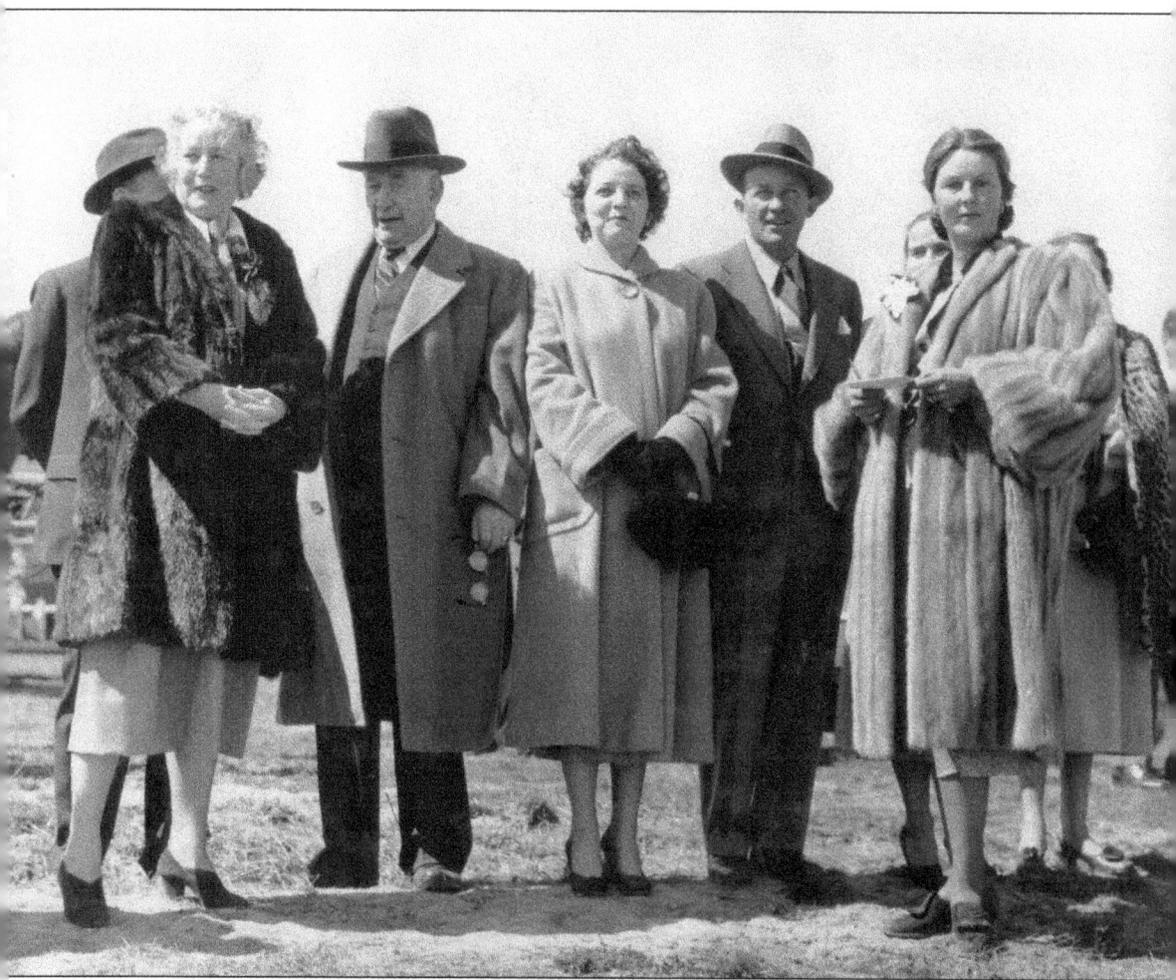

From left to right, Ellie Wood Keith, Alben Barkley, an unidentified woman, Bing Crosby, and Liz Tippett pose at the Piedmont Hunt racecourse at Llangollen in the 1930s. (The Pink Box.)

Liz Tippett and Bing Crosby are seen here at Llangollen. The estate was originally part of a 10,000-acre land grant on which a two-story manor house was built in the late 1770s. Liz Tippett lived here for six decades, and in 1989, it was sold to Roy L. Ash, who saved it from destruction. In 2007, it was sold to a corporation controlled by American businessman Donald P. Brennance, whose daughter Maureen oversees the property and formed the VIPolo Club. (The Pink Box.)

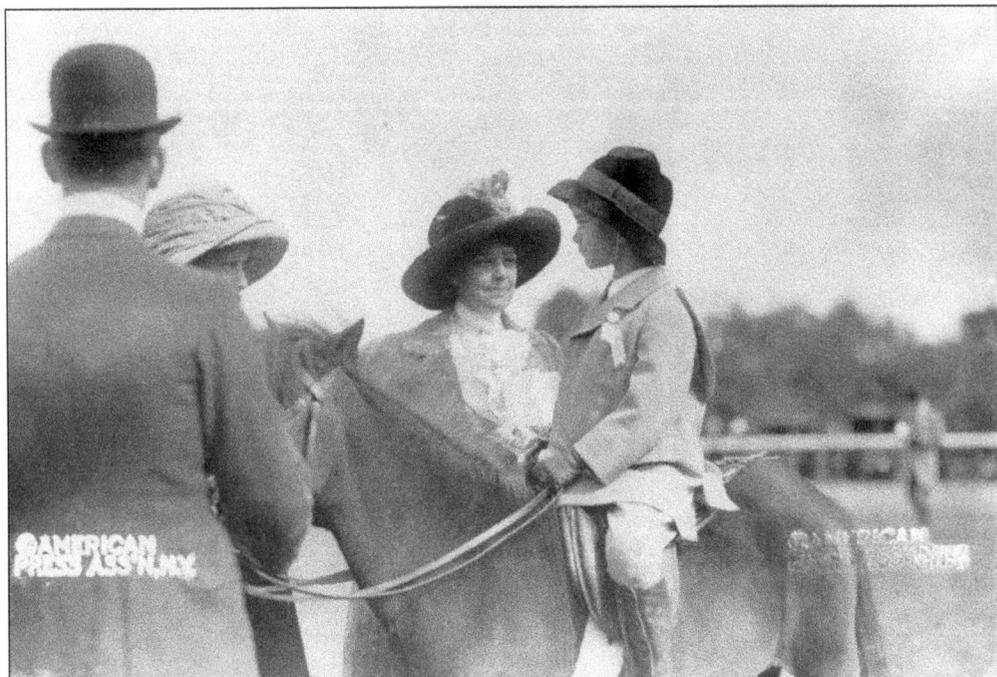

John Hay "Jock" Whitney was the publisher of the *New York Herald Tribune* and later was the US ambassador to Britain. Here, a very young Jock Whitney rides a pony in a horse show. He and Liz Tippett divorced in 1940, but she went on to marry three more times and made Llangollen the center of the hunt set scene. She married Col. C.J. Tippett in 1960 and died in 1988. (The Pink Box.)

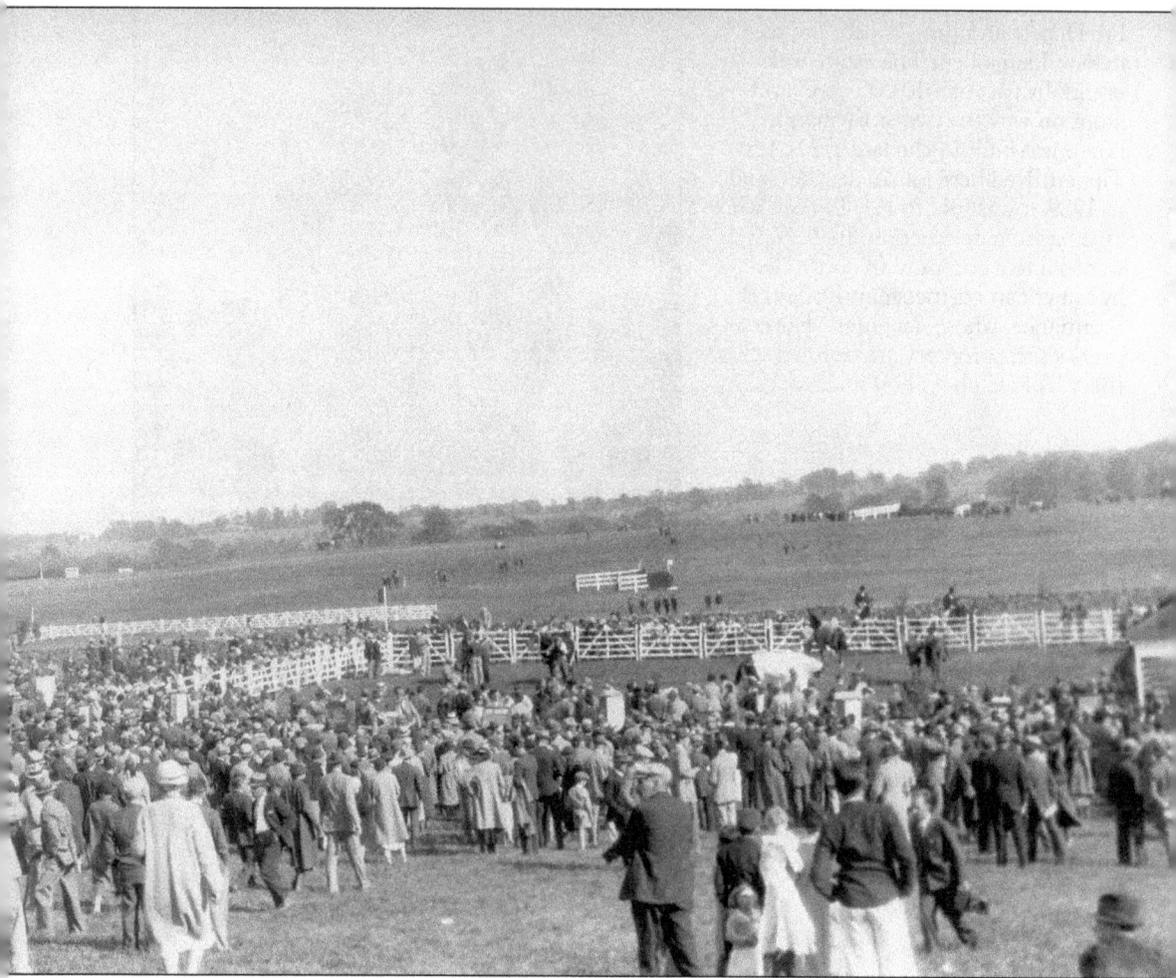

Spectators gather at the Piedmont Hunt racecourse at Llangollen for this race in the 1920s. (Nancy Lee.)

Sheila Johnson started her career as a music teacher. With Robert Johnson, she cofounded the cable network Black Entertainment Television (BET). After their divorce, she created Salamander Hospitality and expanded her interests into sports and hotels and resorts. She owns Salamander Farm near Middleburg. There is a lot in a name: the origin of "Salamander" can be traced to Bruce Sundlun, who was shot down over Belgium in World War II. For several months, he evaded capture and eventually fought with the Resistance, when he was given the code name "Salamander" after the amphibian that can mythically walk through fire. Sundlun was later governor of Rhode Island and owned a 200-acre farm in Virginia that he called Salamander. When Shelia Johnson bought it from a subsequent owner, she found Sundlun's story inspiring and she also discovered that the salamander has symbolized strength, courage, and fortitude through the centuries, all traits she believes in. Sundlun gave her permission for the name Salamander Farm to be restored to the property, and Johnson also uses the name Salamander in her businesses. In August 2013, the Salamander Hotel and Resort will open in Middleburg. (Salamander Hospitality.)

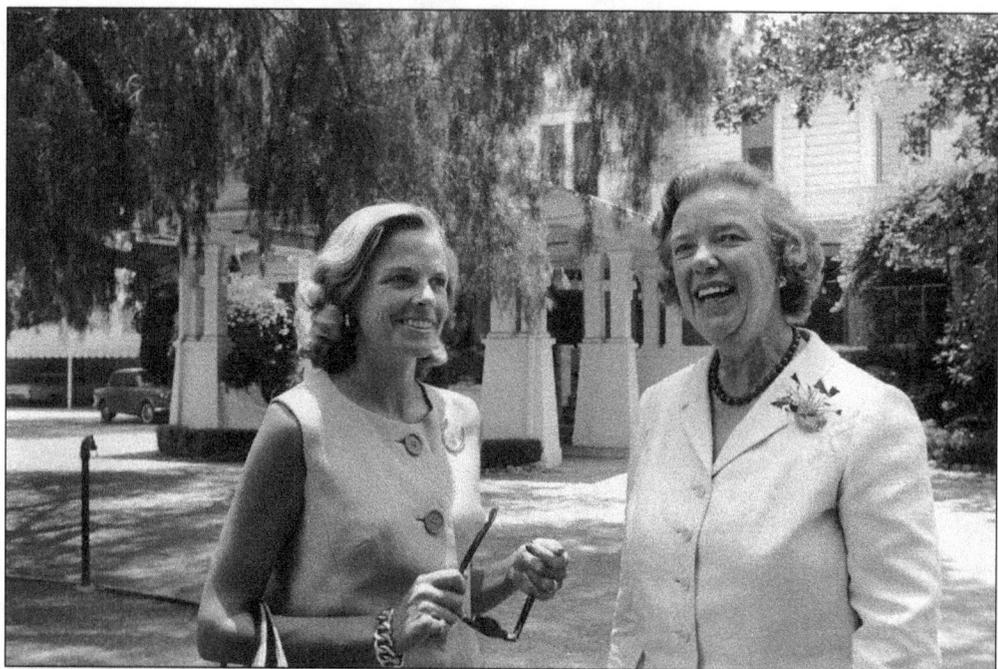

Joan Irvine Smith (right) is the great-granddaughter of James Irvine and a well-known philanthropist. She cofounded the National Water Research Institute, the Irvine Museum, and the Reeve-Irvine Research Center. Smith's love of horses led to the establishment of three world-class horse facilities in the early 1980s, known as The Oaks, in Virginia, San Juan Capistrano, and Valley Center. When the foals were two years old, they were started under saddle in the stall for a few weeks, worked in the round pen for a few weeks, and then sent to Middleburg, where Smith's late husband, Cappy Smith, operated Oaks, the third farm of 300-plus acres. (The Katie Wheeler Library.)

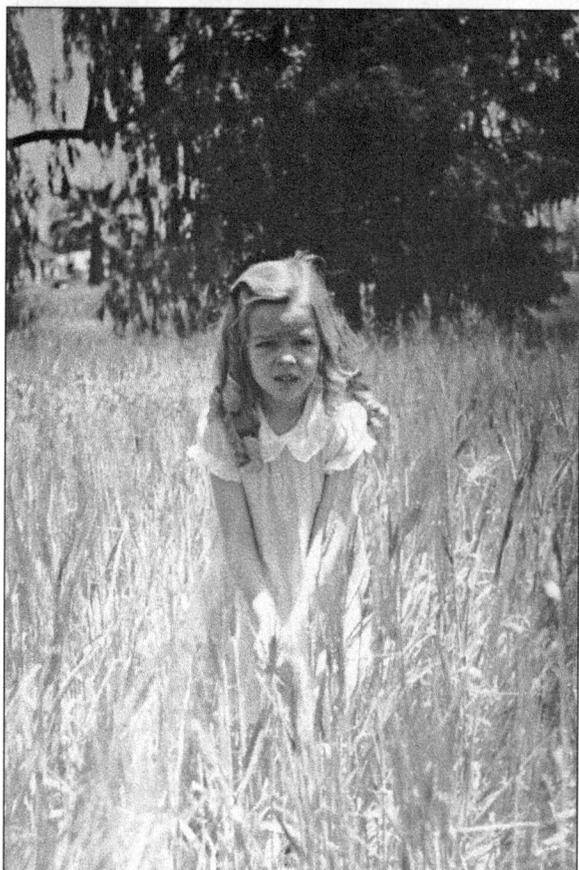

A beautiful young Joan Irvine plays in a pasture in this photograph. (The Katie Wheeler Library.)

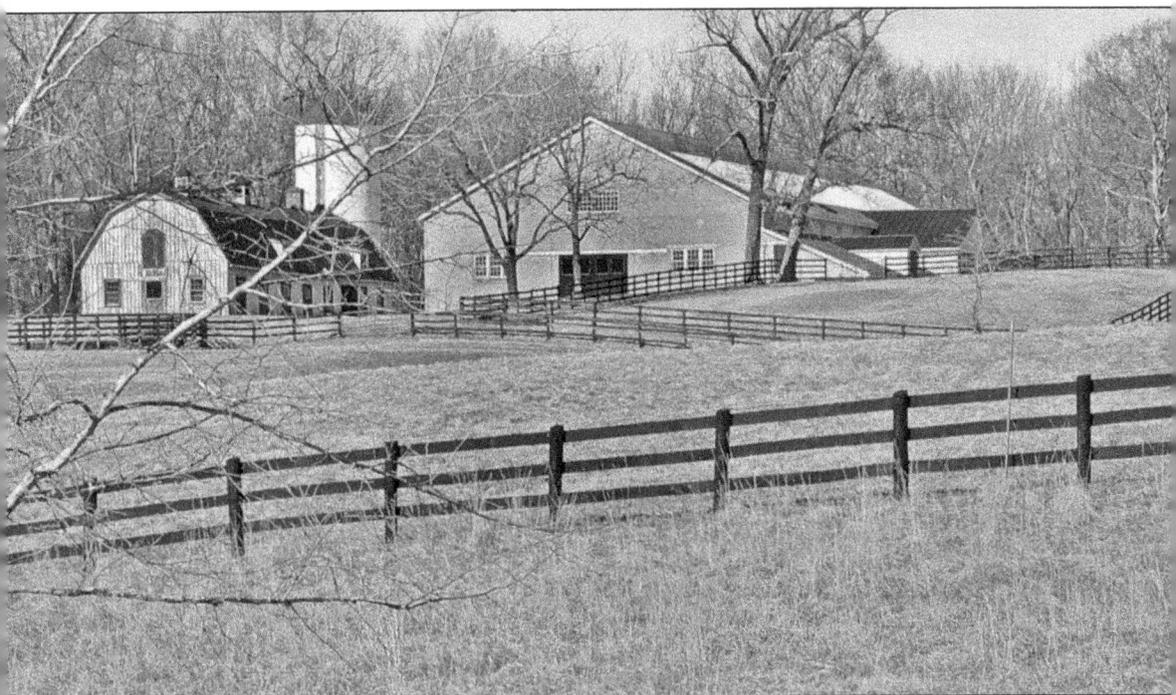

The Oaks, Joan Irvine Smith's former home, which includes these beautiful barn facilities, is just outside of Middleburg. It is now owned by John and Julie Coles. (Photograph by Kate Brenner.)

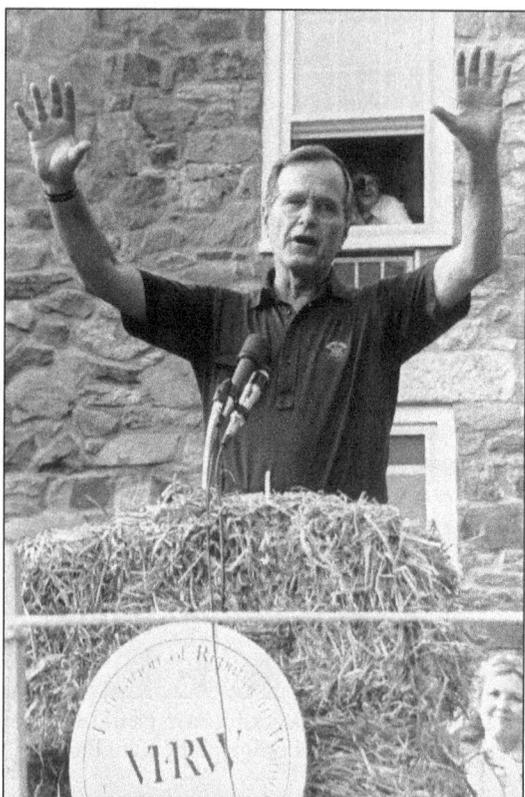

Then vice president George H.W. Bush addresses the Virginia Federation of Republican Women at Atoka Farm. (The Pink Box.)

Elizabeth Taylor (right) and Sen. John Warner (left), who were married at the time, are seen here with Nancy Reagan (center) at the Warners' Atoka Farm in the 1970s. (The Pink Box.)

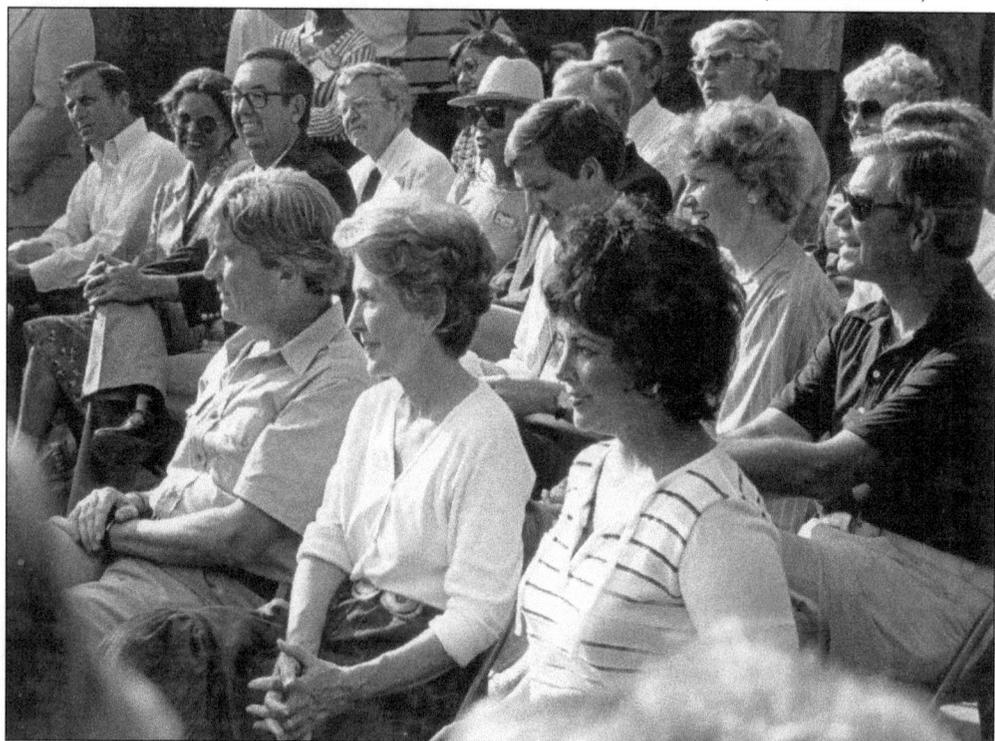

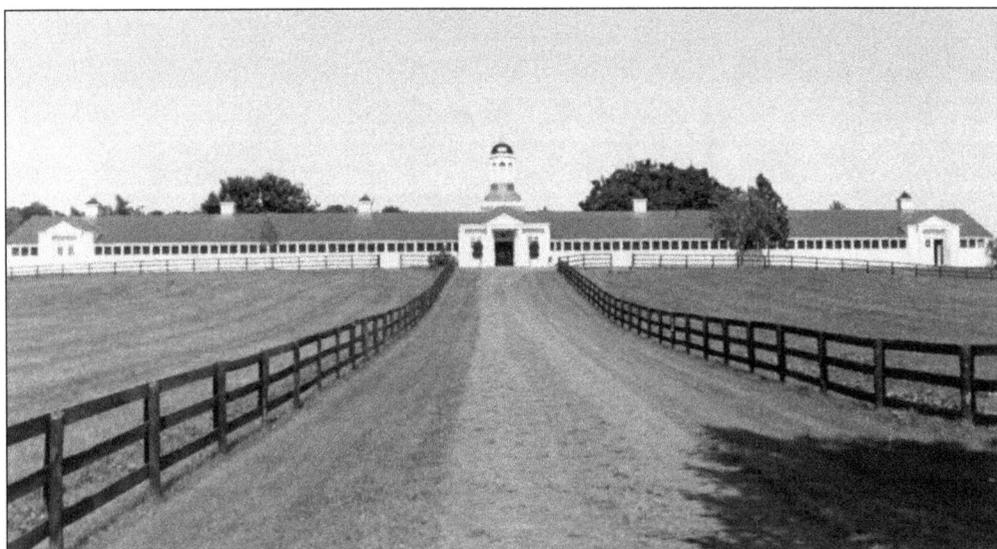

Historic Burrland, now known as Hickory Tree Farm, is a 458-acre Thoroughbred horse breeding and training farm one mile south of Middleburg. The property includes 22 buildings, 14 smaller structures, and a rural landscape of pastures and groomed paddocks. The house at Burrland was built by the Noland family in 1870. William Ziegler bought the property in 1927. The house was deliberately gutted and burned down in 1961 by then owner Eleonora R. Sears in an attempt to reduce her property taxes. (Library of Virginia.)

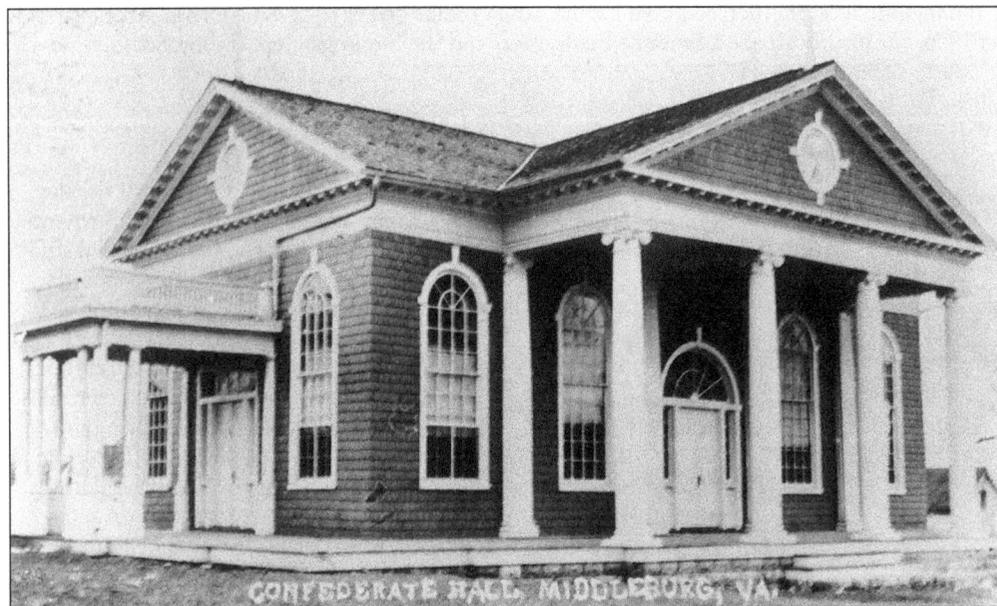

Hickory Tree Farm is now home to Confederate Hall, which was built in 1907 and moved there in 1972 by the Mills family, who purchased Burrland in 1966. They already owned a home on the adjacent Burnt Mill Farm and combined it as well as Burrland and a few other properties to create the property they renamed Hickory Tree Farm. Confederate Hall was a Classical Revival building erected for the 1907 Jamestown Exposition and moved to Middleburg to serve as a meeting place for the United Daughters of the Confederacy. In its place today is an Exxon gas station. (The Pink Box.)

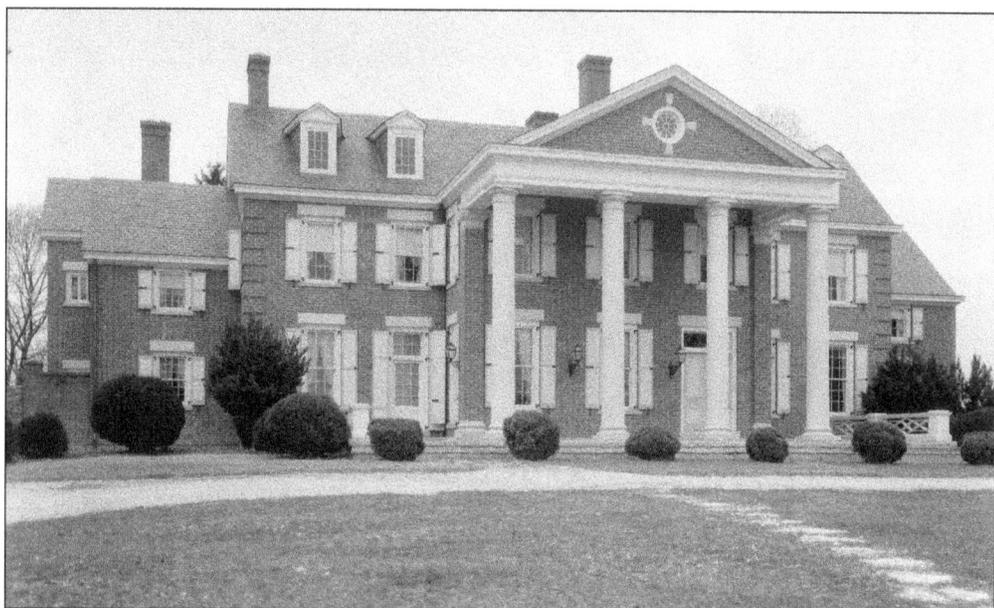

The original Burrland house is seen here. In 1926, William Ziegler purchased it from Rosalie Noland for $70,000. Although Ziegler bred show horses and polo ponies at his estate in Noroton, Connecticut, it was not until the mid-1920s that he became seriously interested in breeding and racing Thoroughbred horses. His first good horse was Our General, who won the 1924 Junior Champion Stakes. He then acquired Espino, who became one of the country's top three-year-olds in 1926, winning both the Lawrence Realization and the Saratoga Cup. (Library of Congress.)

According to accounts of the day, by 1930 Ziegler had built Burrland into one of the best-equipped stud farms on the Atlantic seaboard. Both he and his wife maintained racing stables at Burrland, with colts racing in his name and fillies carrying the scarlet and green silks of Middleburg Stable, the *nom de course* of Helen Ziegler. Three of the most successful horses during the founding years of Burrland were Polydor, winner of 19 races; Goneaway, who split the Whitney pair Wichare and Bonojur in a spirited contest of juveniles; and Spinach, who as a three-year-old earned $105,000 with victories at the Potomac Handicap, the Havre De Grace Cup, the Riggs Handicap, and the Latonia Championship. (Library of Congress.)

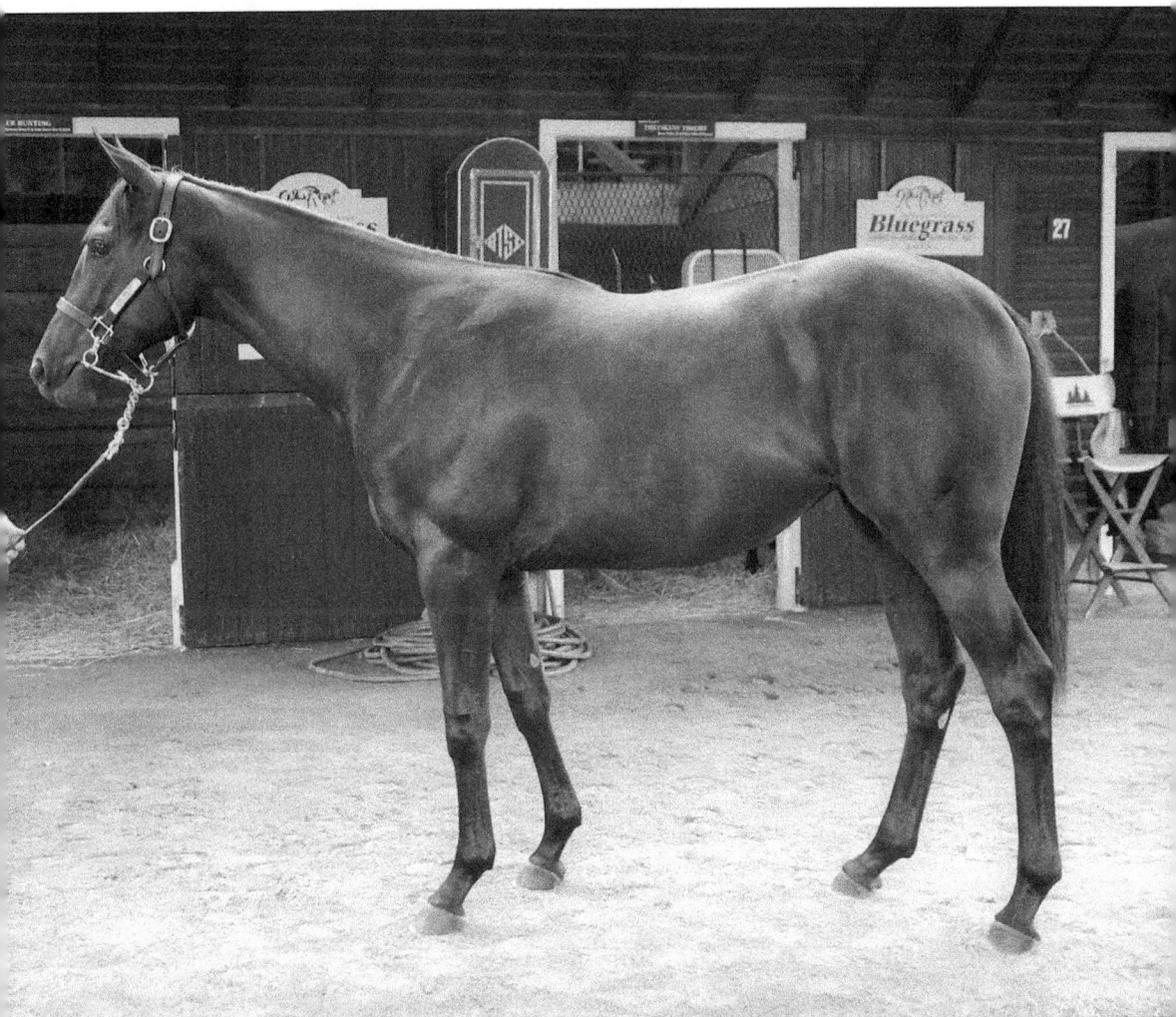

The Burrland property also boasted a competition-sized Thoroughbred racetrack. Prior to 1965, it was the main track used to train horses by local trainers in Middleburg. Thoroughbreds are still born and bred on the working farm today. This beautiful Hickory Tree filly was born on the property. (Saratoga 2011 Sale Catalogue.)

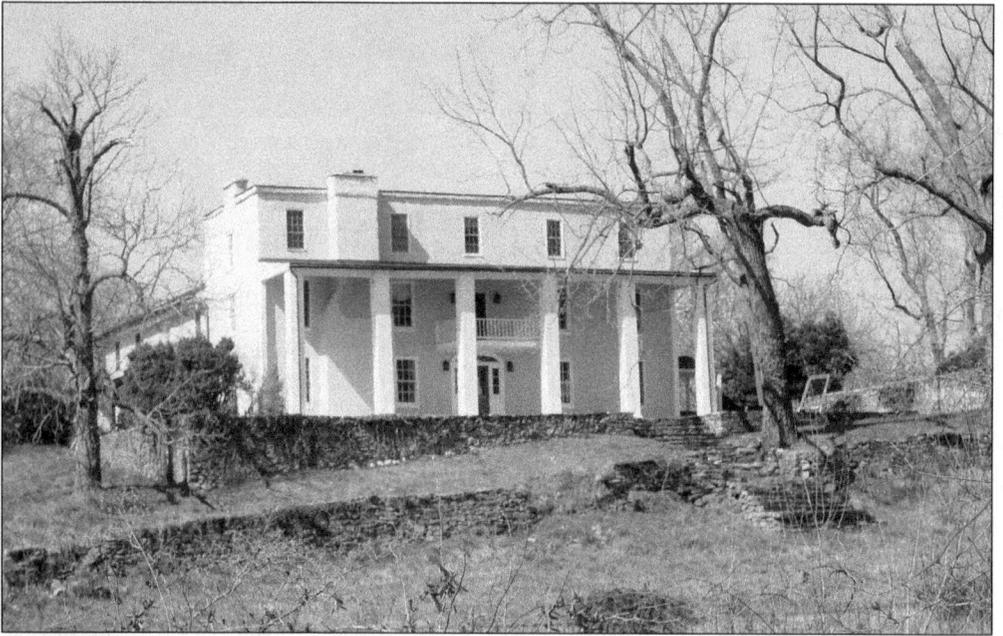

Built for Robert T. Hapstone, a prominent Baltimore businessman, Waverly stands as a symbol of prosperity rarely expressed in the Victorian architecture of Northern Virginia. At a time when the region was still suffering from the aftermath of war, dwellings such as Waverly were reserved for the most elite members of society. Waverly is a fine representative of the design talents and craftsmanship of the local building firm of John Norris and Sons. It was later owned by Tom and Elizabeth Furness and is now the home of Piedmont Vineyard. Waverly is one of the rare architectural designs offering a double-story portico. It was added in 1830 and purposely exaggerated to reflect the changing stylistic trends of the Greek Revival. It fell into disrepair but was fully restored in the 1940s. The estate operated as a dairy farm until 1973, when the Piedmont Winery was established there. (The Pink Box.)

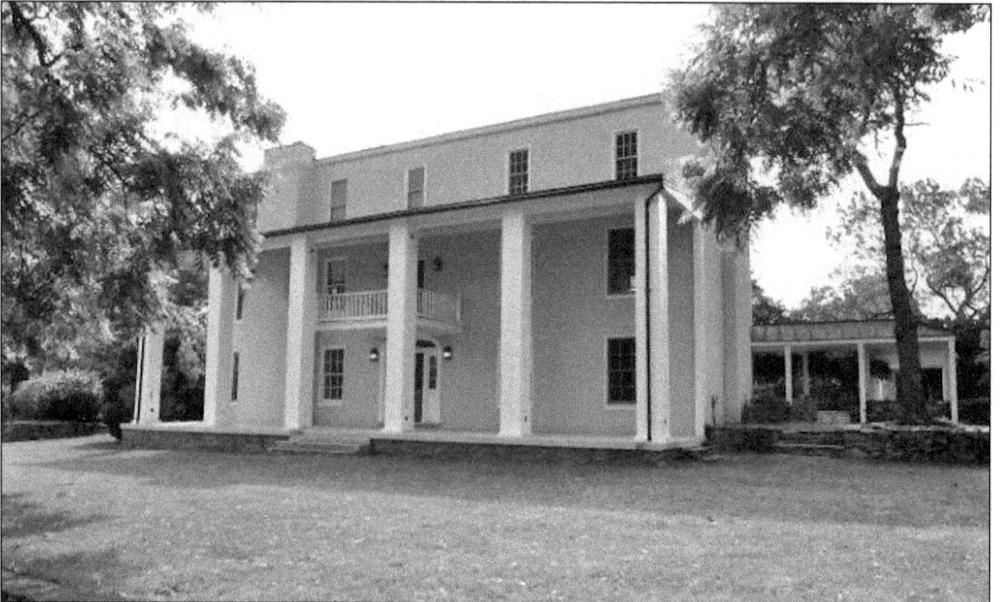

Huntland is a historically significant, 129-acre farm less than a mile from Foxcroft School, dating back to around 1837. A tall, white, stucco wall topped by brick encloses a portion of the property and a rich, secretive history lies just on the other side. Huntland was a station on the Underground Railroad and had an intricate system of underground tunnels traversed by more than 1,000 slaves making their way to freedom in Pennsylvania. The tunnel began underneath an iron gate in the stucco wall, ran under the front lawn, and ended in the east wing of the house. In this photograph, stone steps lead to a break in the wall; the iron gate sits next to a hollow where the remnants of the tunnel can be seen. (Photograph by Laura Troy.)

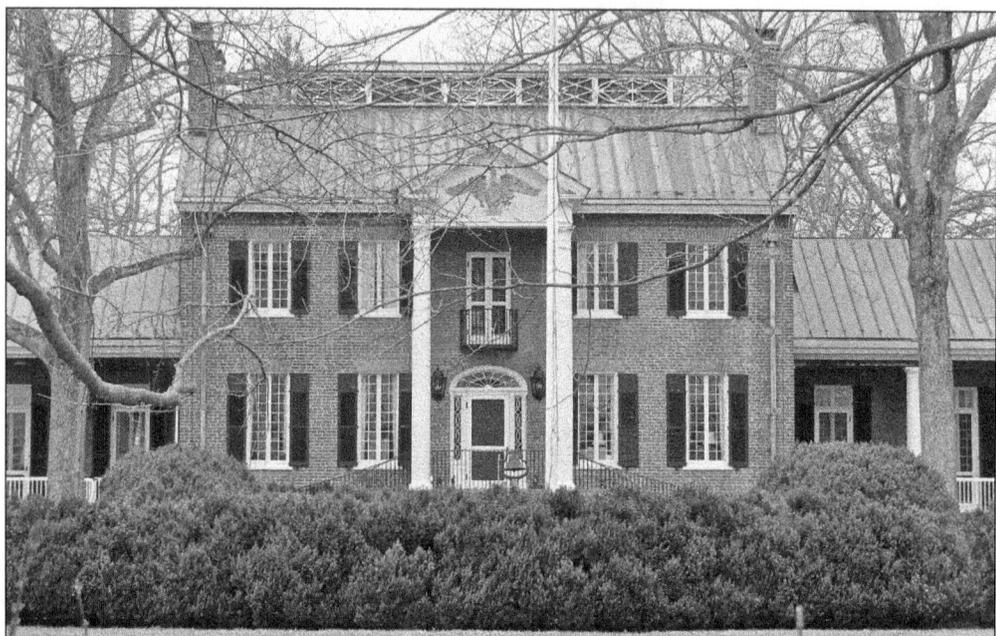

Today, the grand manor house at Huntland looms over a ring of old boxwoods and features a majestic plaque of a golden eagle on the front facade. In his 1914 book *American Adventures*, Julian Street described Huntland thusly: "In a well-kept park near Mr. Thomas's house stand extensive English-looking buildings of brick and stucco, which, viewed from a distance, suggest a beautiful country house, and which, visited, teach one that certain favored hounds and horses in this world live much better than certain human beings. One building is given over to the kennels, the other the stables; each has a large sunlit court, and each is as beautiful and as clean as a fine house—a house full of trophies, hunting equipment, and the pleasant smell of well-cared-for saddlery." (Photograph by Laura Troy.)

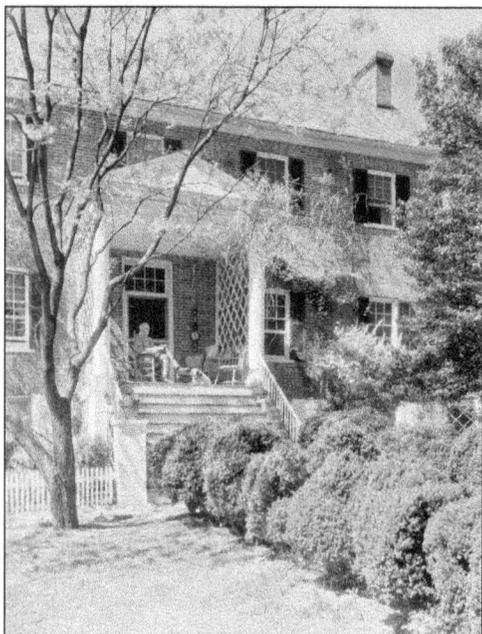

Benton is a well-preserved example of an early-19th-century Federal plantation house. The quality of the architecture reflects the skill of its builder and initial owner, William Benton, and the house symbolizes the prosperity of the region seen in the large number of farms built in the first half of the 19th century. Benton was an expert brick maker and mason who served as the foreman for the building of Oak Hill, James Monroe's Loudoun home. He is credited with making bricks for most of the brick houses in Middleburg. Except for a remodeling after 1908, when it was purchased by Daniel Sands, the house has changed very little since its construction and the woodwork of the main house remains in excellent condition. (Library of Congress.)

The McQuays were among the most important founding families of St. Louis, a nearby village, but their family history is also linked with Middleburg. Local lore says the village was named after a McQuay who had left Virginia after the Civil War to live in St. Louis. In 1891, a village lot was described as Little St. Louis. Historian Eugene Scheel refers to St. Louis as "the Black Middleburg" and describes the "St. Louis Colored Colt Show," officially chartered in 1889, as being organized and managed by Charles McQuay, who was born into slavery in 1856 to William and Catherine McQuay and was listed as a house servant on the Benton property in 1870. The St. Louis Mount Zion Baptist Church is seen here. (Photograph by Laura Troy.)

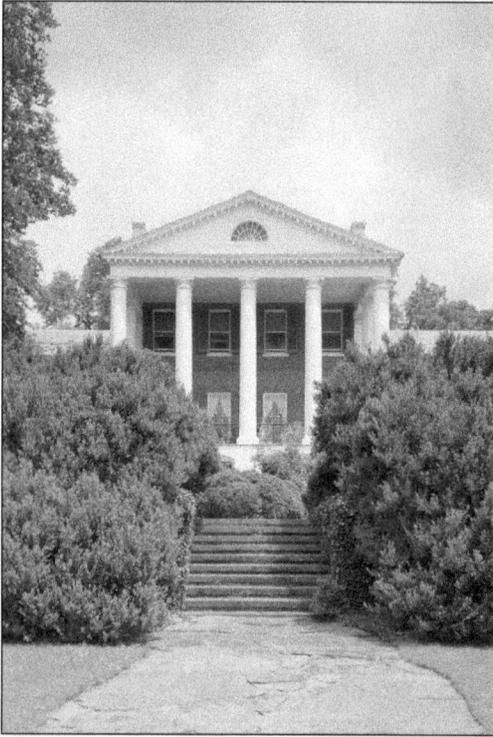

Oak Hill, the Loudoun County home of James Monroe, the fifth president of the United States, is a magnificent structure just outside Aldie. It was built between 1820 and 1823, with William Benton of Middleburg serving as the foreman. Monroe worked on the drafting of the Monroe Doctrine at Oak Hill, seen here around 1930. (Library of Congress.)

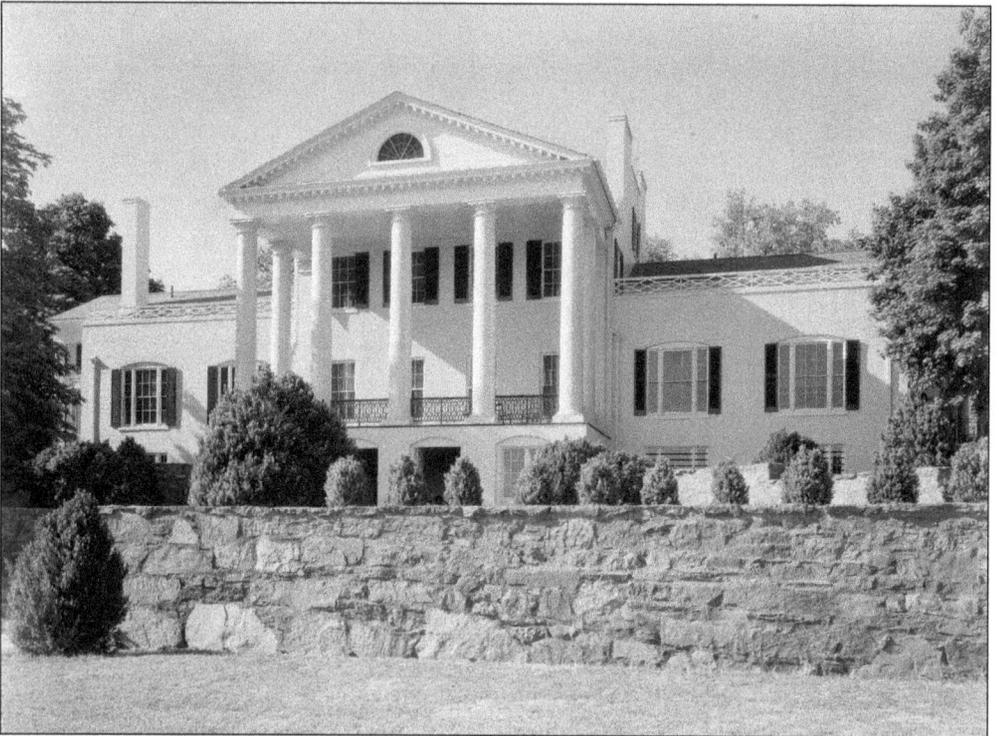

The Oak Hill estate, seen here around 1930, passed out of the family after Monroe's death but is still a private residence today. (Library of Congress.)

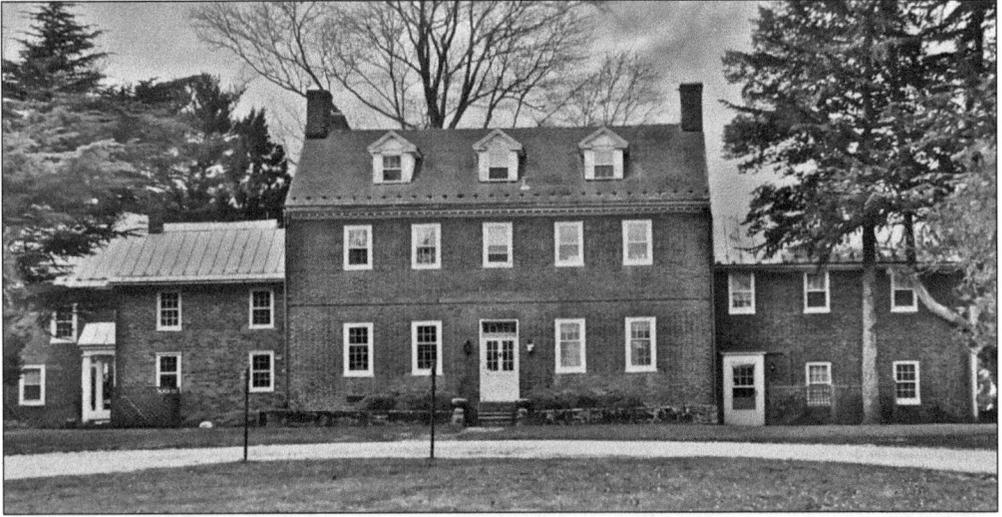

The Farmer's Delight land was originally part of the Goose Creek Tract, taken by Robert Carter in 1727. In 1741, a 1,000-acre portion of the tract, Green Leislip, was conveyed by Lord Fairfax to Dr. Charles Green. After Green's death, his widow retained the property for a time but later sold it to Thomas and Mary Owsley. The Owsleys then sold it to Jacob Reed, who sold it to Col. Joseph Lane for 568 pounds, 4 shillings in 1791. The structure forms part of the present house at Farmer's Delight and was built by Lane prior to 1803. An insurance policy of that date issued by the Mutual Assurance Society of Virginia describes it as a brick dwelling house, called Farmer's Delight, measuring 24 feet by 43 feet. The house survived the nearby Pot House Battle during the Civil War. (Photograph by Kate Brenner.)

The Leith family purchased Farmer's Delight in 1856, and they owned it until it was conveyed to Henry W. Frost Jr. in 1919. The Frosts maintained well-known racing and hunting stables during their ownership and added wings to both sides of the house. George C. McGhee, a former ambassador to Germany and ambassador-at-large, acquired the house and farm in 1948, undertaking an extensive renovation to the house, adding to the wings and laying out elaborate gardens. During McGhee's residence, Farmer's Delight was visited by dignitaries from many foreign countries as well as important US officials. Prominent fellow citizens of McGhee's native Texas, including Pres. Lyndon B. Johnson and Speaker of the House Sam Rayburn, were frequent guests. (The Truman Library.)

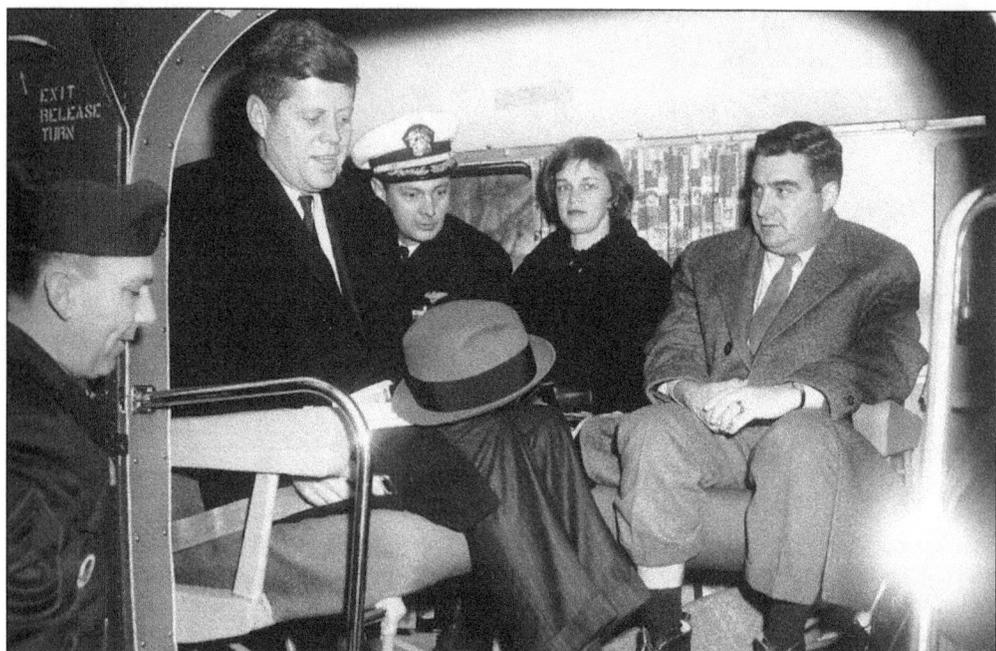

When John Kennedy was elected president in 1960, everything changed for Middleburg. President Kennedy is seen here departing the White House for Glen-Ora in Middleburg. From left to right, John G. Hays, assistant to the military aide to the president; President Kennedy; Tazewell Shepard Jr., naval aide to the president; and Nancy Salinger and her husband, press secretary Pierre Salinger, wait aboard a Marine Corps helicopter preparing for takeoff from the South Lawn at the White House. (The John F. Kennedy Library.)

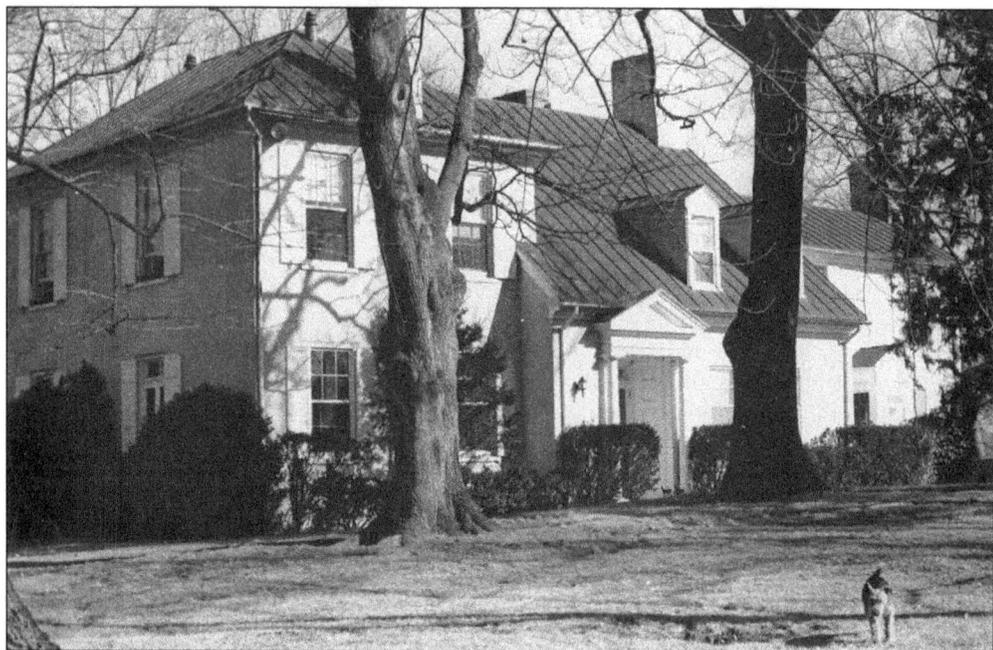

Charlie, a Kennedy family dog, stands in the right corner on the front lawn of President Kennedy's Middleburg residence, Glen-Ora, in 1962. (The John F. Kennedy Library.)

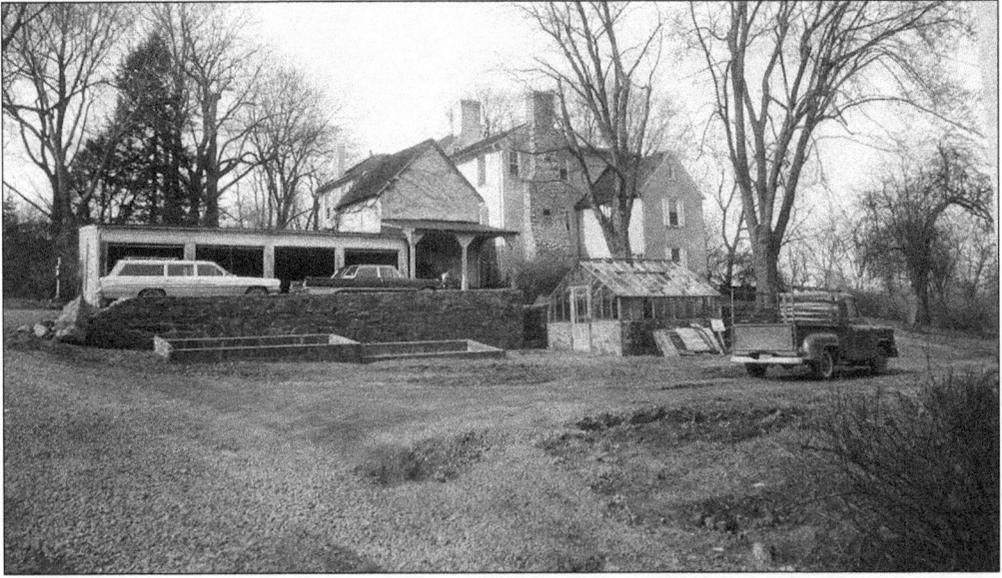

Horses and hounds brought the Kennedys to Middleburg. Jacqueline Kennedy was a fervent horse lover who loved the proximity of the Piedmont and Orange County hunts. As a young girl, she participated in many hunt meets held around Middleburg. This photograph shows Glen-Ora in the 1960s, when the Kennedys were there. (The John F. Kennedy Library.)

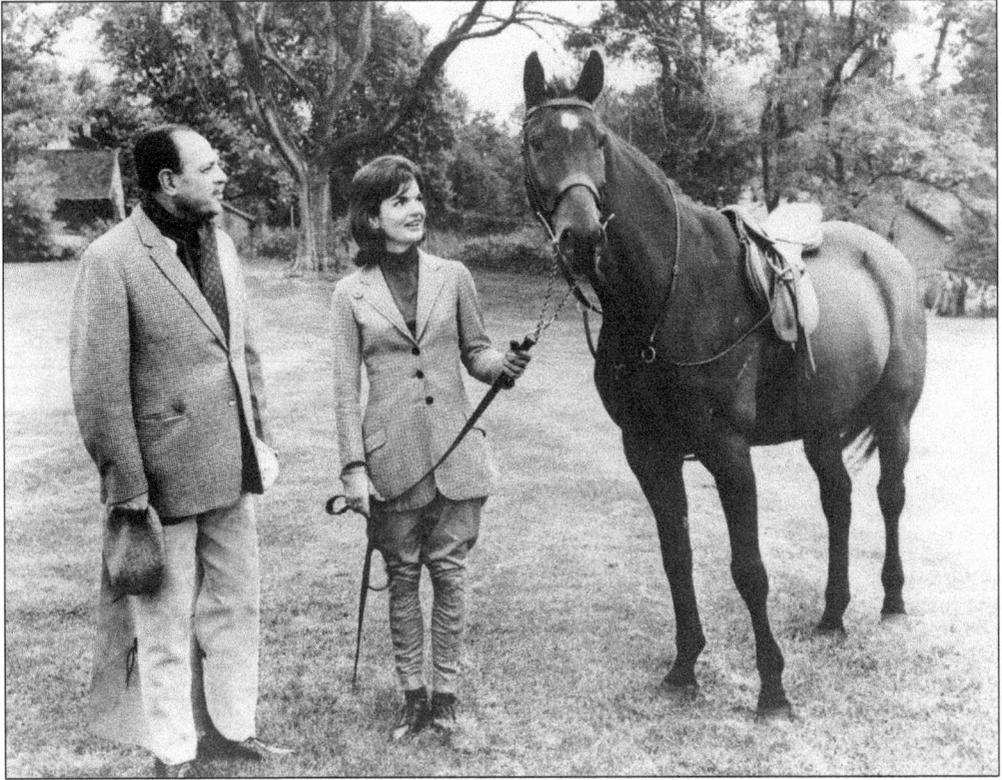

Jackie Kennedy shows Pakistan's King Ayub Kahn the fine horse he had given her as a gift at Glen-Ora. They took a ride through the countryside later that day. (The John F. Kennedy Library.)

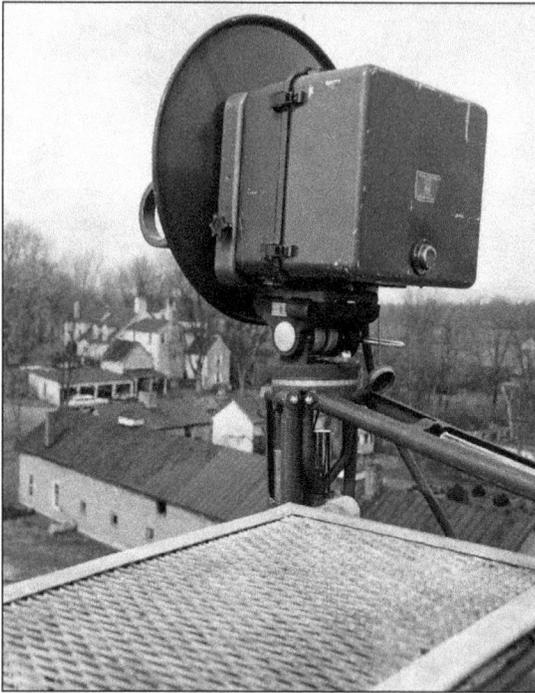

The Kennedys leased Glen-Ora in 1961 as their country retreat. Jackie referred to it as her "salvation" and considered it her home, not the White House. President Kennedy even ran sensitive operations during the Cuban Missile Crisis from Glen-Ora, and special communications equipment was installed. Though Glen-Ora was supposed to be a retreat and respite from the stress of Washington, the pressures of leadership still seemed to follow the president. (The John F. Kennedy Library.)

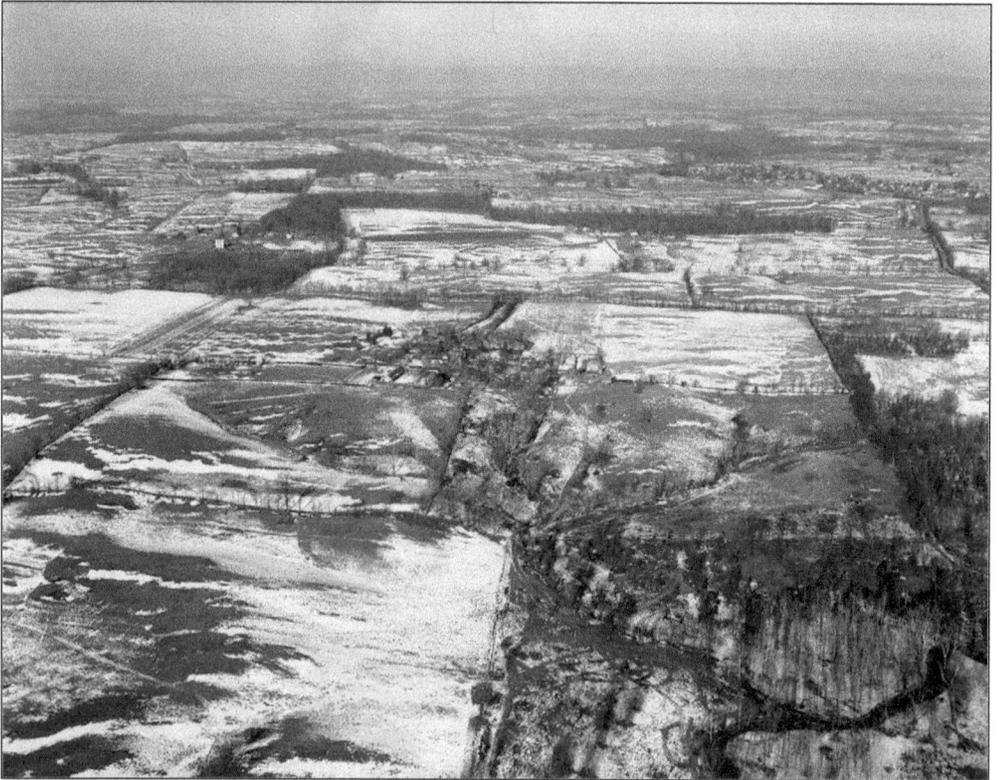

In this aerial view of Glen Ora on a snowy winter day, the village of Middleburg can be seen in the upper right-hand corner. (The John F. Kennedy Library.)

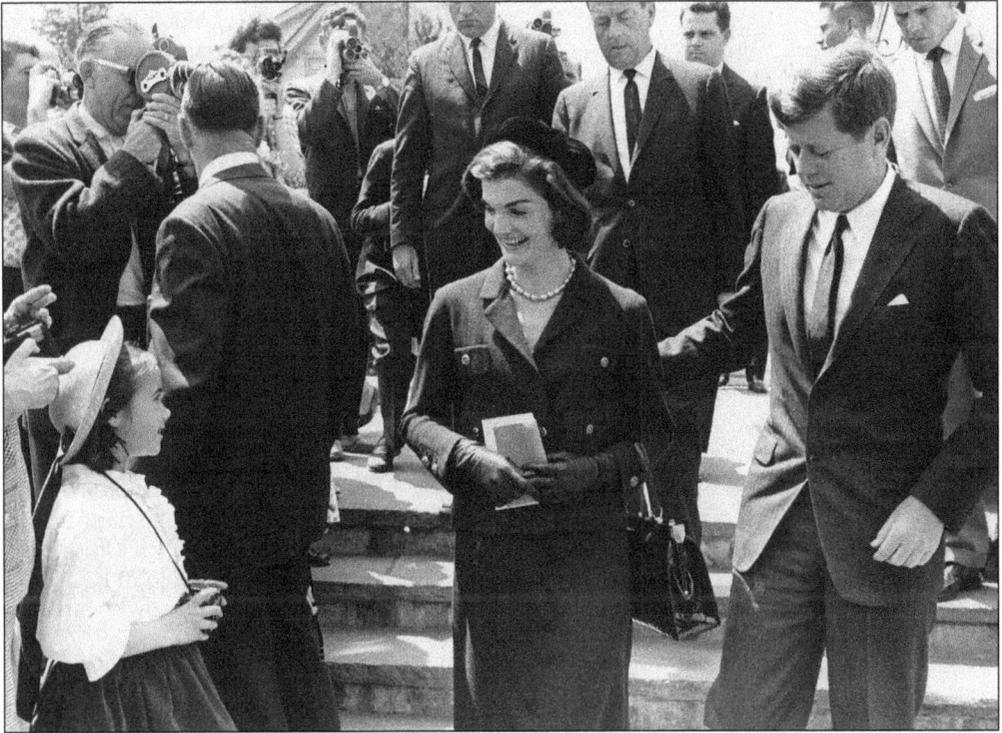

The little girl pictured here with John and Jackie Kennedy is none other than Betsy Davis, who is now the mayor of Middleburg. This photograph was taken in Middleburg in 1962. (Photograph by Howard Allen.)

Equines were always a huge part of the Kennedy's lives, thanks to Jackie. They even joined a political affair or two. In this photograph, a group of guests stands next to two Kennedy family ponies after a luncheon in honor of Harold Macmillan, the prime minister of Great Britain. From left to right are Macmillan; President Kennedy; David Ormsby-Gore, ambassador to the United States from Great Britain; Jacqueline Kennedy; and the ambassador's wife, Sylvia Thomas Ormsby-Gore. Caroline Kennedy's ponies, Macaroni (left) and Tex, stand at the right. (The John F. Kennedy Library.)

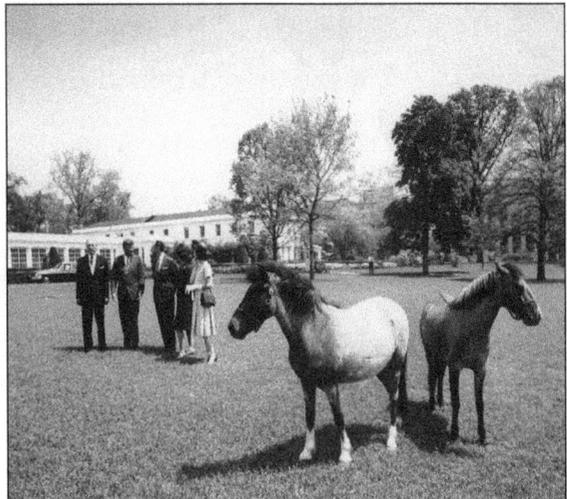

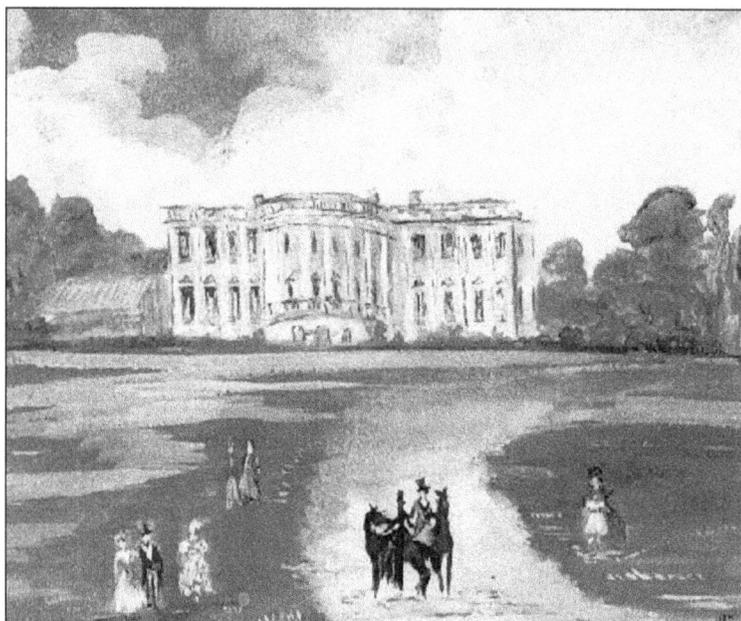

Jackie Kennedy wanted horses in every facet of her life—she even managed to insert them into her paintings. This watercolor painting of the White House with horses on a path and figures on the lawn in the foreground was painted by Jacqueline Kennedy and given to her husband as a gift. The president chose to hang it in the Oval Office. (The John F. Kennedy Library.)

This cute pony was sent by the Irish minister for external affairs, Frank Aiken, to John F. Kennedy Jr. The US ambassador to Ireland, Matthew H. McCloskey, sent the photograph to Evelyn Lincoln with a letter dated September 16, 1963, regarding the status of the horse's arrival at the White House. JFK Jr. was indeed lucky, not only to receive every child's dream of a pony, but to have it delivered by air to the front lawn of the White House. (The John F. Kennedy Library.)

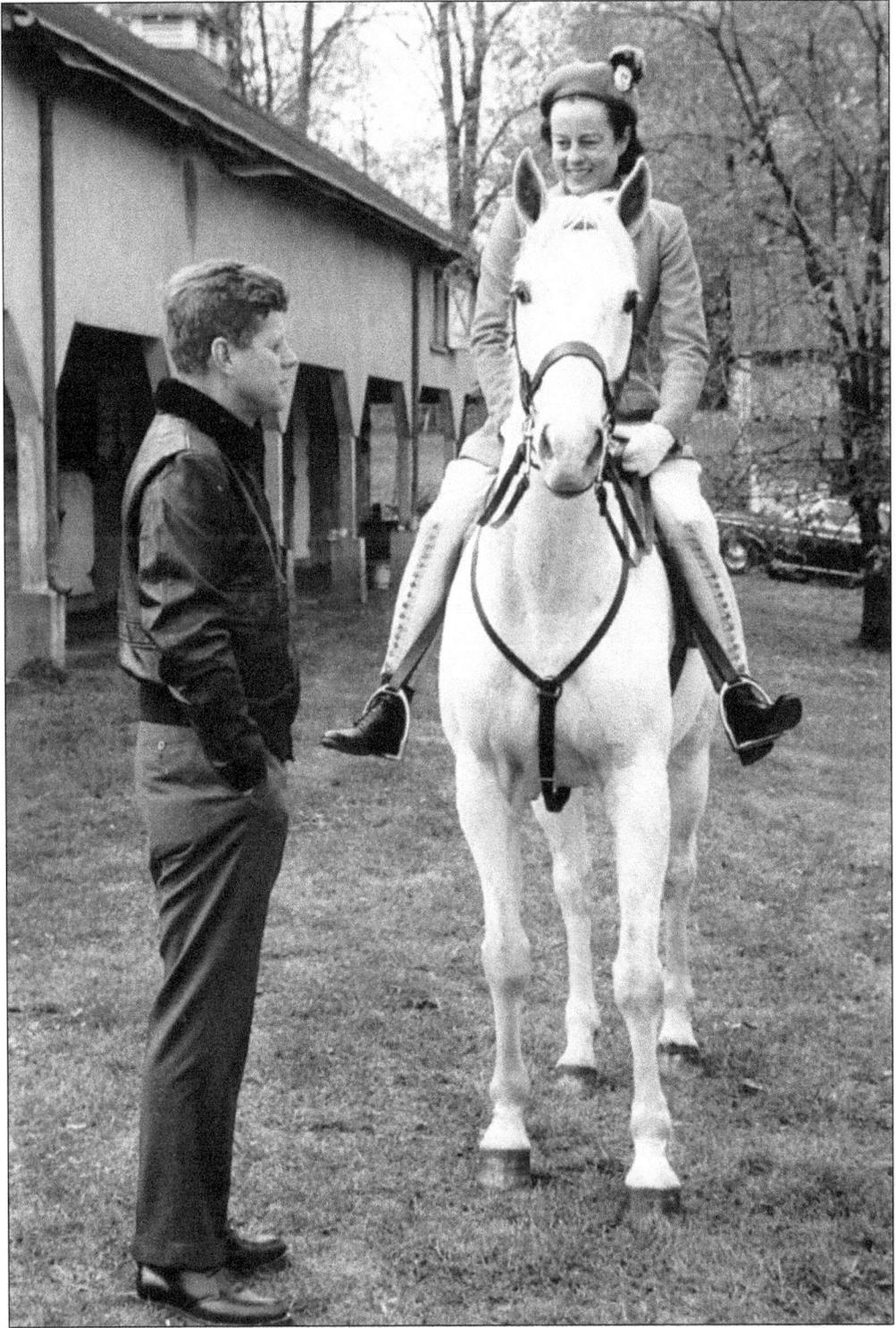

President Kennedy is pictured in Middleburg with Jane McClary and her horse. (The John F. Kennedy Library.)

Kennedy's presence as a weekend resident was credited with speeding up the desegregation of restaurants in Middleburg. The Kennedys were spending the weekend there when integration was achieved. The peaceful transition in Middleburg was accomplished by Kennedy's parish priest, Rev. Albert F. Pereira, who acted as a mediator. Father Pereira negotiated for integrated eating places in Middleburg after black residents threatened sit-in demonstrations during the president's visits to Glen-Ora. Father Pereira was asked to arbitrate the racial dispute by William McKay Jackson, head of the local chapter of the NAACP. There were also reports that the president heard a black servant from his farm had been refused lunch in town. The new integration policy passed its test when two black men were served at the lunch counters of the Tally Ho Pharmacy (shown here) and the Middleburg Pharmacy. (The Pink Box.)

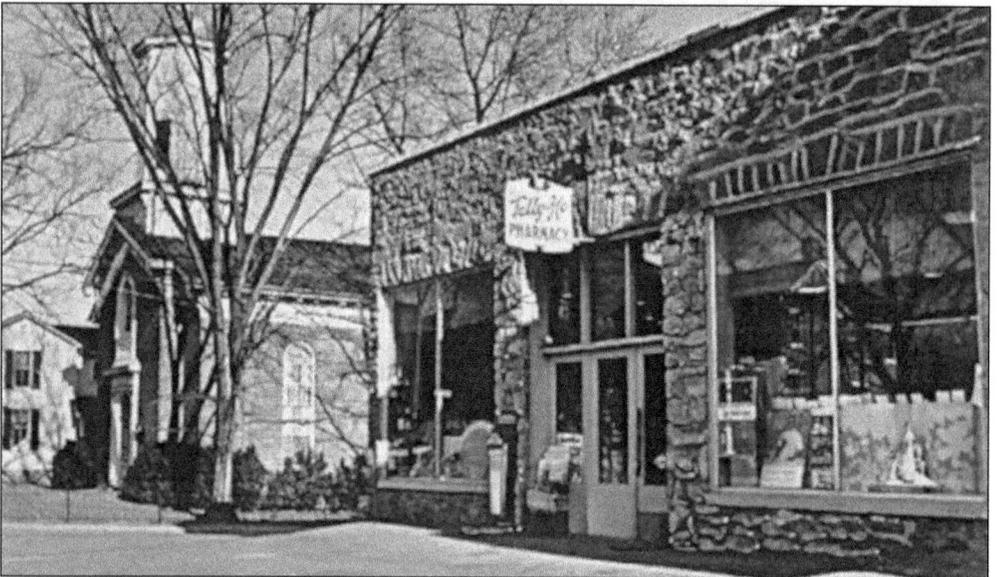

According to the April 10, 1961, *Rome News-Tribune*, "The new integration policy passed its first test Saturday when two young Negro men sat at the lunch counters of the Tally Ho Pharmacy and the Middleburg Pharmacy, and were served. The more elite restaurants also fell in line. Mrs. Nettie Michaelis, manager of the Red Fox Tavern, said that 'everyone will be served on the same basis' in its dining room. The proprietor of the Coach Stop, said: 'I've decided to go along. It would be fighting a futile battle not to serve them.' " The Tally Ho Pharmacy is seen here in 1963. (The Pink Box.)

Four

OFF TO THE RACES

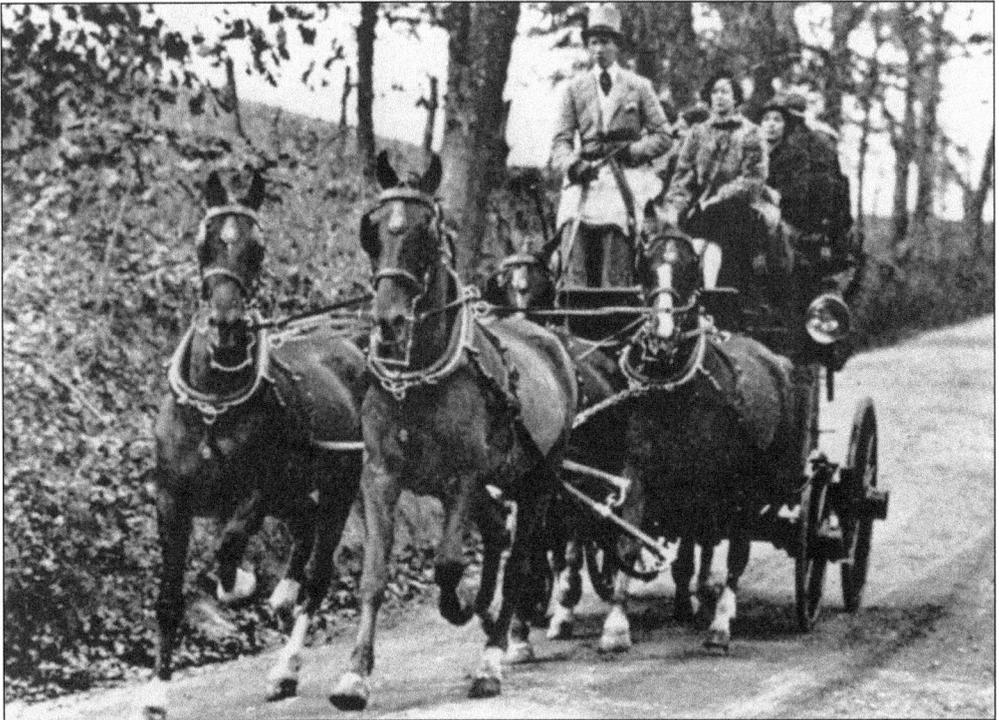

Horse racing, especially steeplechase and driving races, has been a big part of Middleburg life for generations. Here, around 1930, Tatine and Taylor Hardin come downhill toward Middleburg with their elegant team, heading to the race in their swanky coach. (The Pink Box.)

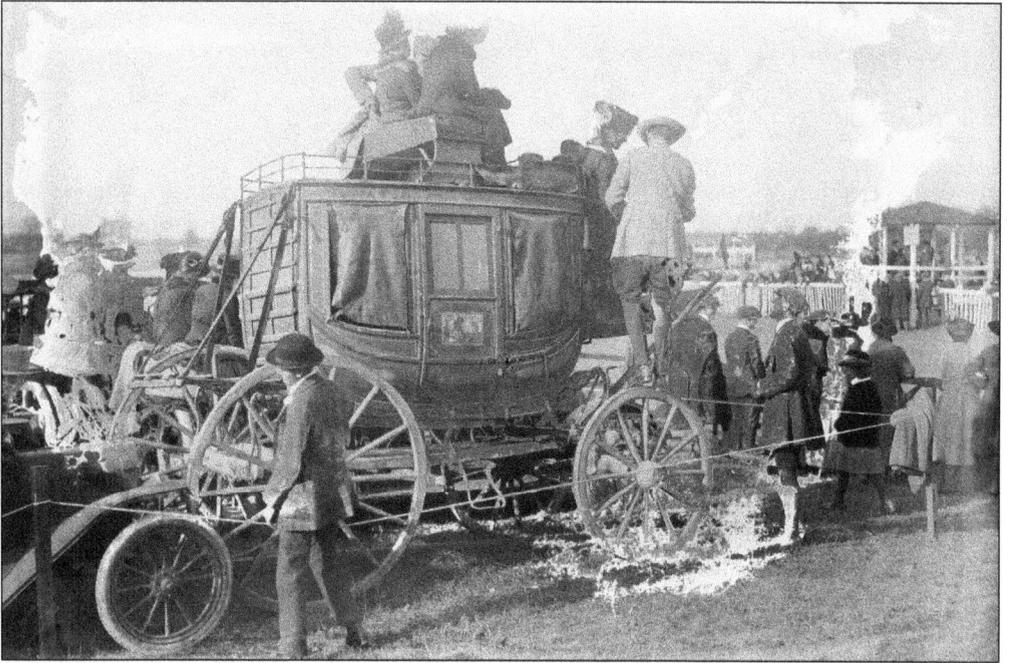

The first Middleburg race meet was organized in 1911 by Daniel Sands, who as master of the hounds for Middleburg Hunt, was faced with pacifying the farmers whose land they hunted. The landowners were growing weary of the thundering hooves and baying dogs disrupting their livestock or trampling their crops, so the races became an extended olive branch to the farmers. (Library of Congress.)

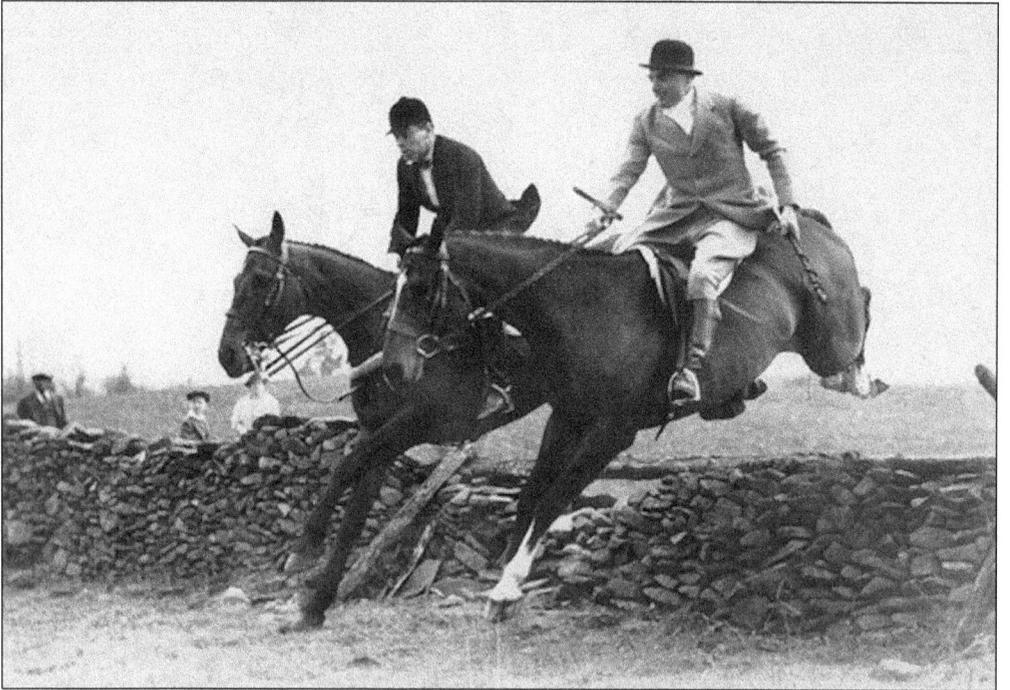

Horses clear the stone wall during an early Middleburg point-to-point race. (Library of Congress.)

The Middleburg Races at Glenwood Park began in 1911, after the land was donated by Daniel Sands, and became a very prestigious event. Here, hands prepare the course, which contained some intimidating obstacles. (Library of Congress.)

Daniel Sands, founder of the Middleburg Races, is shown here in 1914. (Library of Congress.)

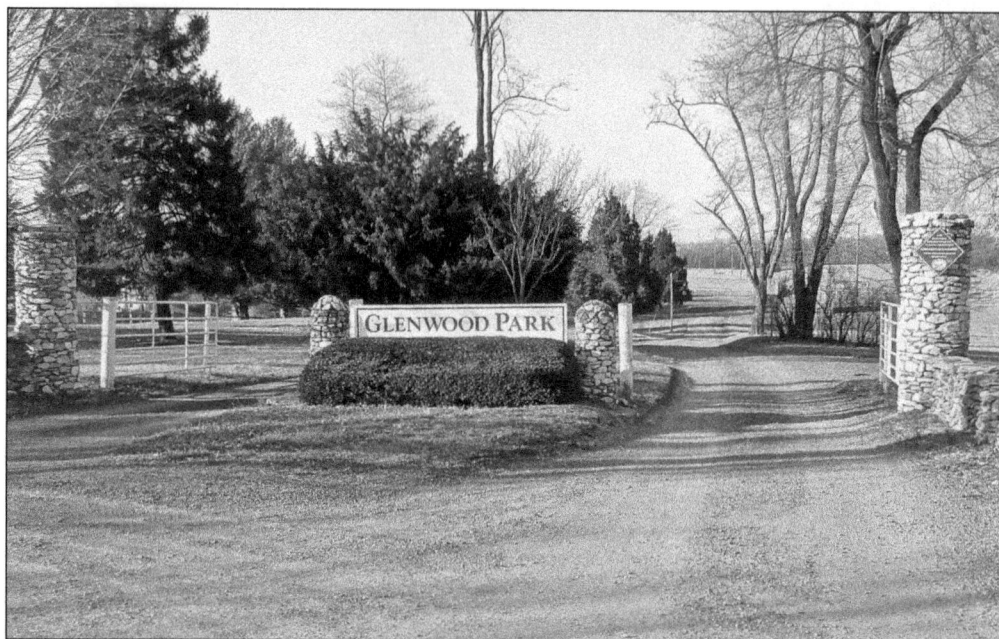

The Glenwood Park entrance (above) and vast steeplechase course (below) are seen here in the current day. (Both, photograph by Kate Brenner.)

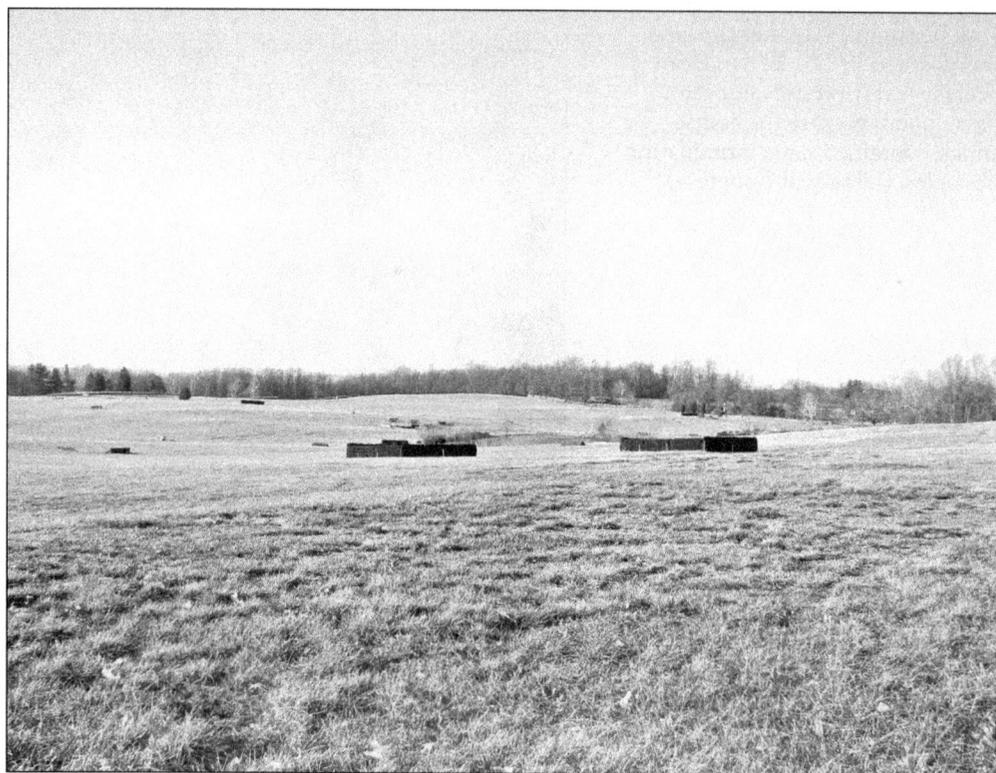

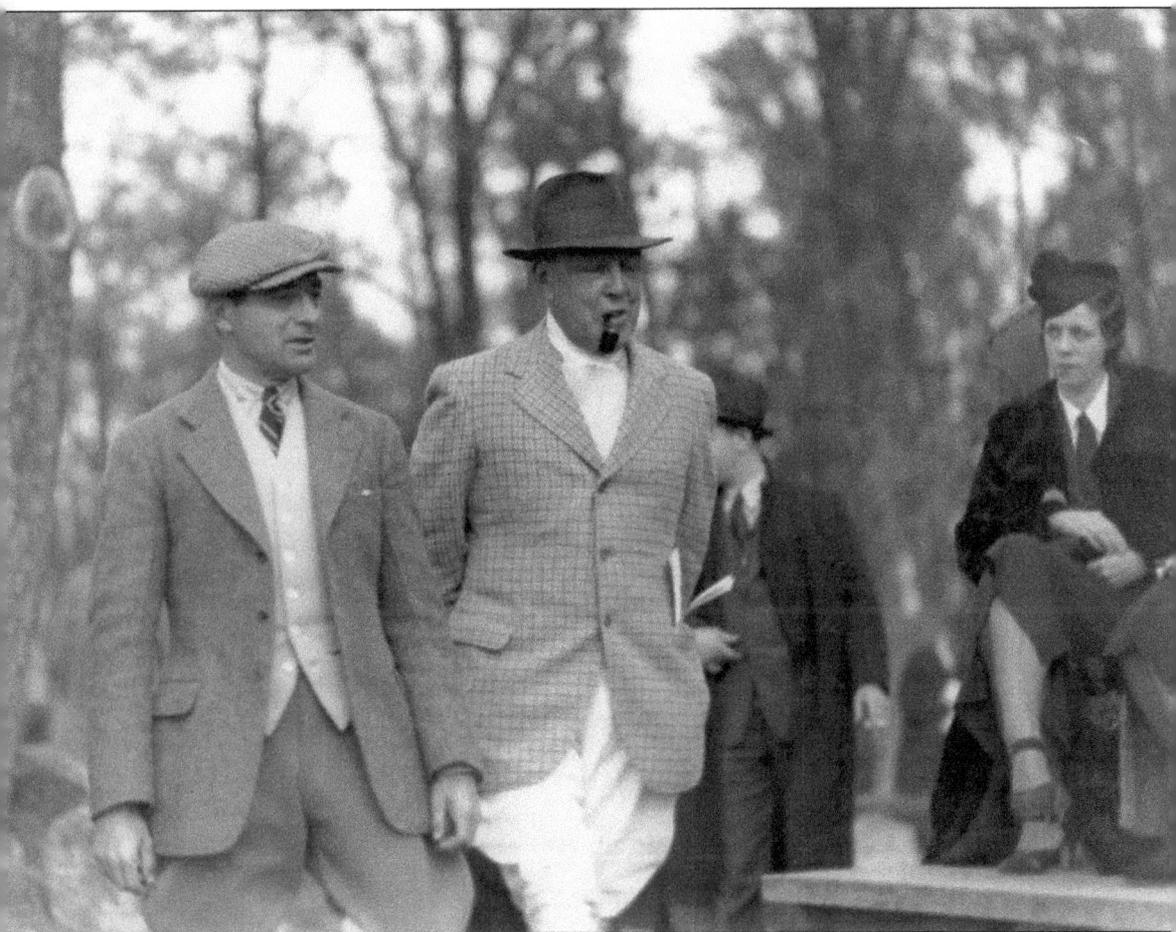

One of the best steeplechase riders in the 1920s and 1930s was Jack Skinner, a rider and trainer from Middleburg. He won the Virginia Gold Cup three times aboard a horse owned by Mrs. Sumner Pingree of Boston, to retire the second challenge trophy in 1933. Mrs. Pingree ultimately had a total of four Gold Cup wins, a record that stood until Saluter, owned by Mrs. Henry Stern of Richmond, swept to six consecutive wins from 1994 to 1999. Here, Dan Sands (left) and Jack Skinner look very distinguished as they stroll through Glenwood Park. (The Pink Box.)

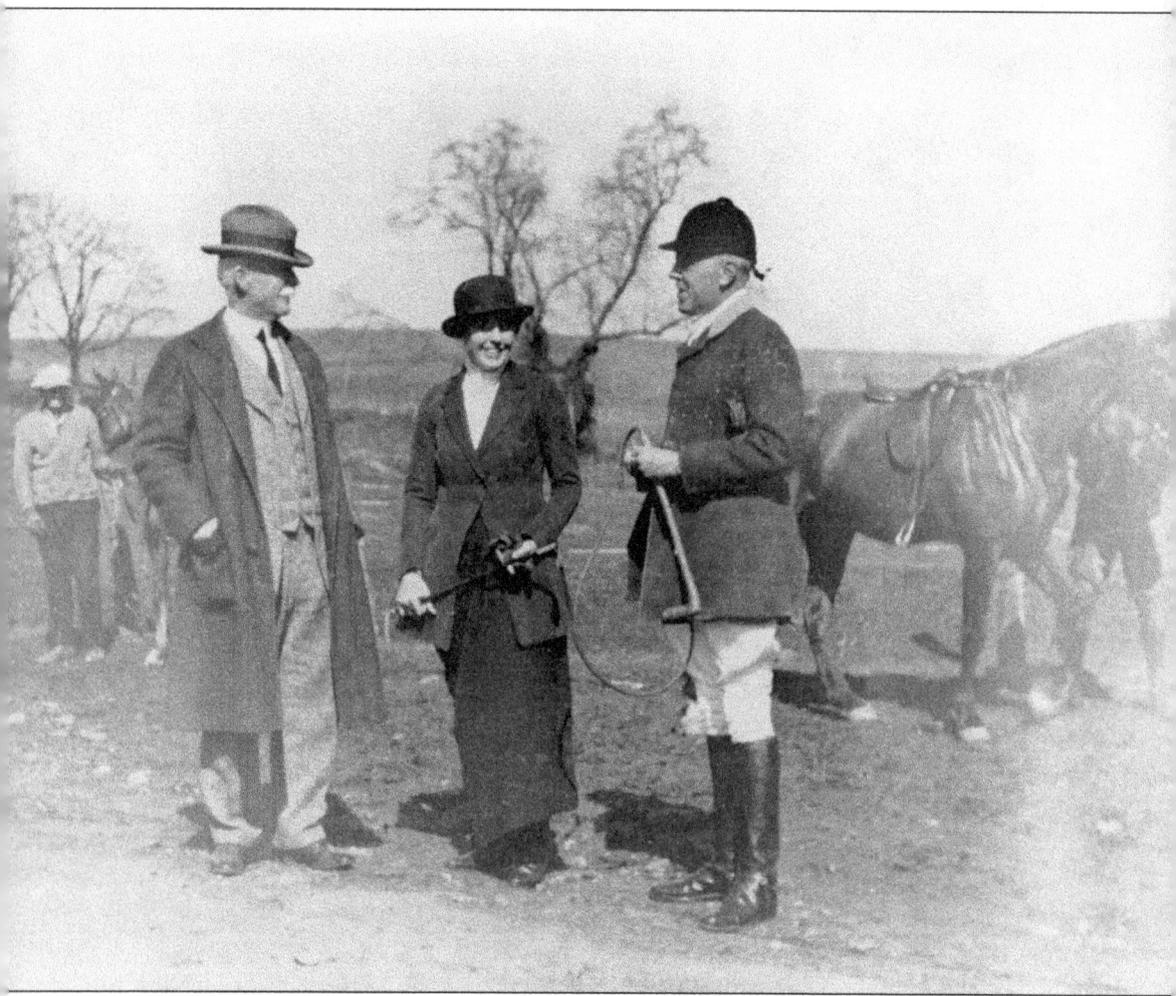

From left to right, S. Rogers Fred, Elizabeth Mitchell, and Daniel Sands are at a hunt meet around 1928. (Library of Congress.)

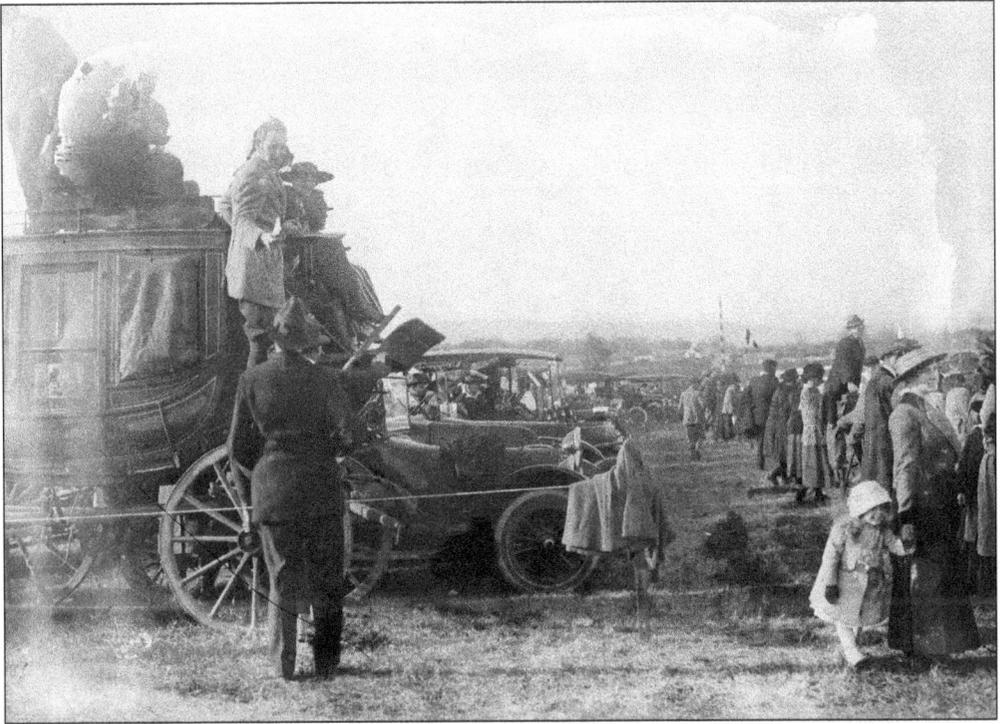

Racing continued through the decades under the tutelage of Daniel Sands. Such notables as Pres. John F. Kennedy even took in a race; the president breezed in and out of the paddock so fast that few even noticed him, but his wife was an avid race-goer. (Library of Congress.)

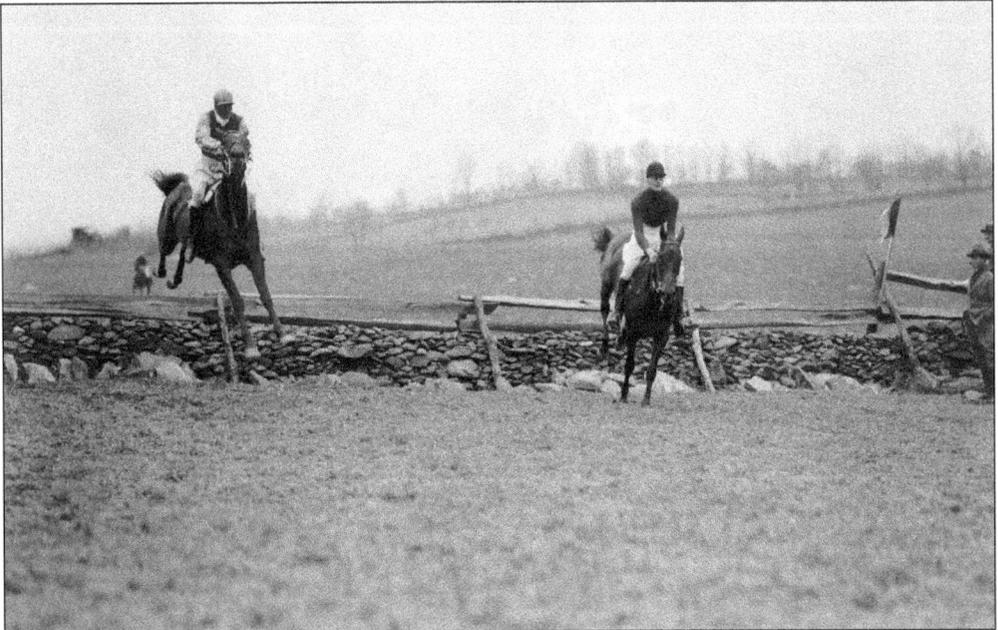

Point-to-point horse races, or steeplechases, were first run in Ireland. Church steeples were used as the beginning and end points of races because they were prominent landmarks to aim for and could be seen over great distances. (Library of Congress.)

Irish Laddie, owned by Katherine Hitt of Middleburg, won the first Gold Cup steeplechase event. Laddie was trained and ridden by Middleburg horseman Arthur White. In 1925, Hitt surprised the race organizers by twice repeating her win with different horses to retire the first Gold Cup. In all the years since, the prestigious cup has been retired only six more times, most recently by the great Saluter in 1998. Katherine Hitt is shown here in the 1920s with a young racehorse. (Library of Congress.)

A handsomely braided entry at the Gold Cup in 1941 looks out at the thousands of spectators lined up. (Library of Congress.)

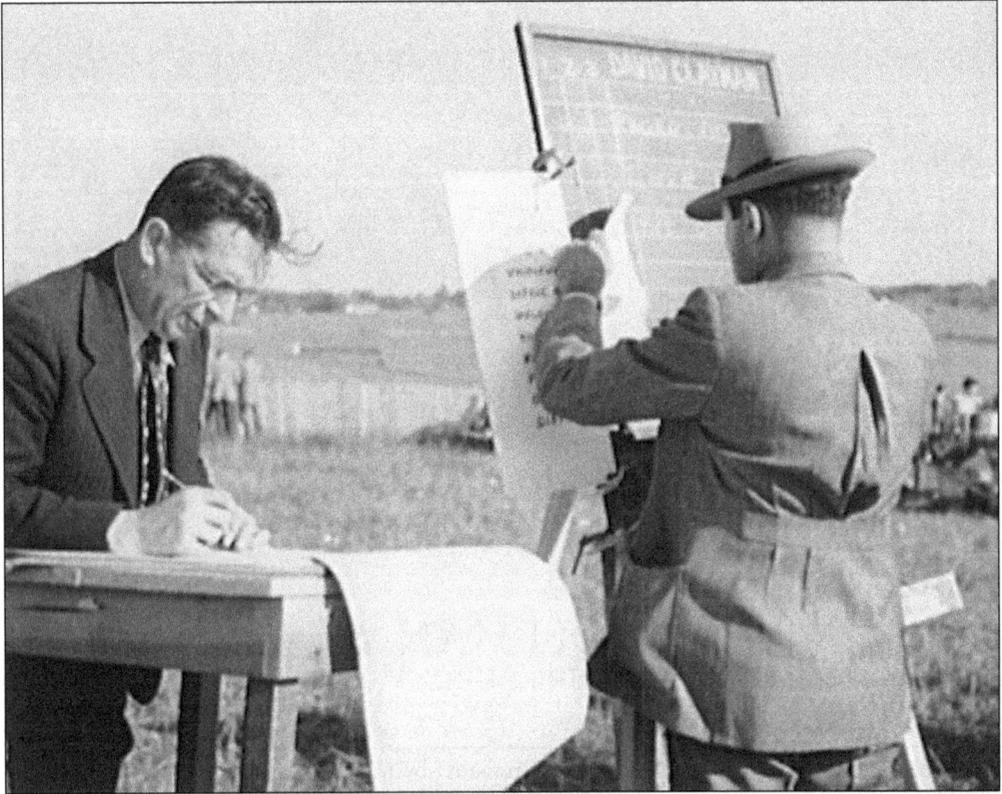

A bookie takes bets from a crude table at the race; gambling remains one of the main attractions at the races. (Library of Congress.)

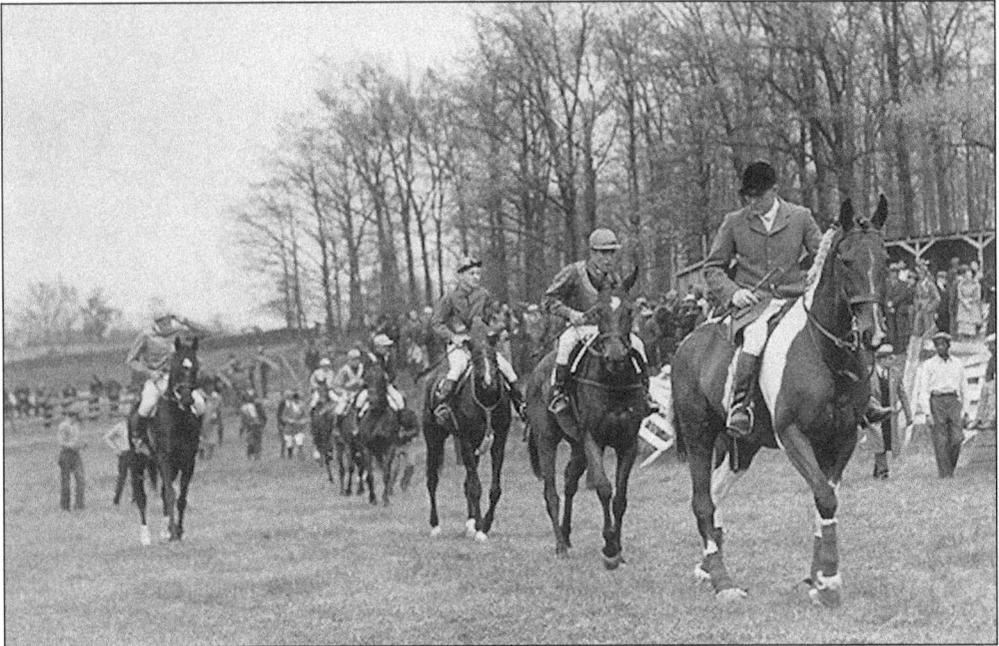

Thoroughbreds parade up to the post to line up for the race. (Library of Congress.)

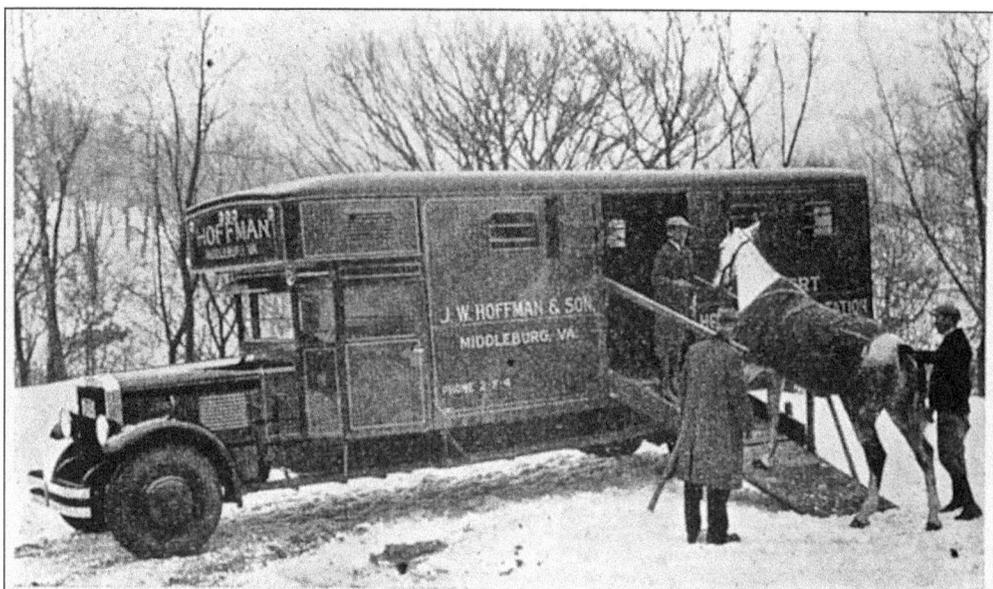

J. W. HOFFMAN & SON
MIDDLEBURG, VA.

Sun Beau Was Transported by One of Our Vans to His Home of Retirement

Sun Beau is transported to his "home of retirement" by J.W. Hoffman & Son of Middleburg. (The Pink Box.)

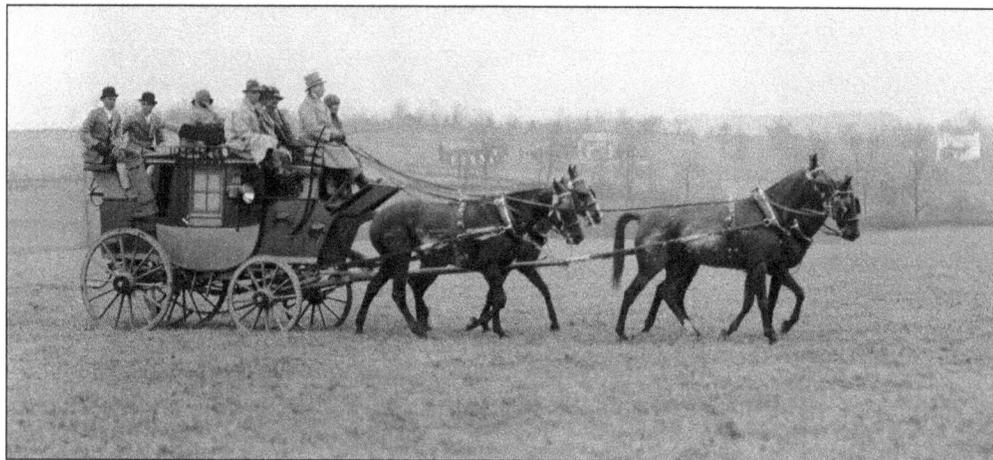

Middleburg owes its 20th-century renaissance to the advent of the Piedmont and Orange County Hunts. According to older residents, there was at first an uneasy alliance between the ex-patriot Northerners and the townspeople, for whom the Civil War was living memory. The sudden rise in the price of horses pleased those who traded them, but some farmers resented the Yankees paying higher wages than locals could afford. With the organization of the Middleburg Hunt in 1906, other well-known equestrians began to settle in and around the town, succeeding in making Middleburg a seat of international reputation for equestrians. Their activity brought investment capital for new construction and for the preservation of Middleburg's historic architecture. An upscale coach carries guests to the Middleburg Hunt Cup in 1926. (Library of Congress.)

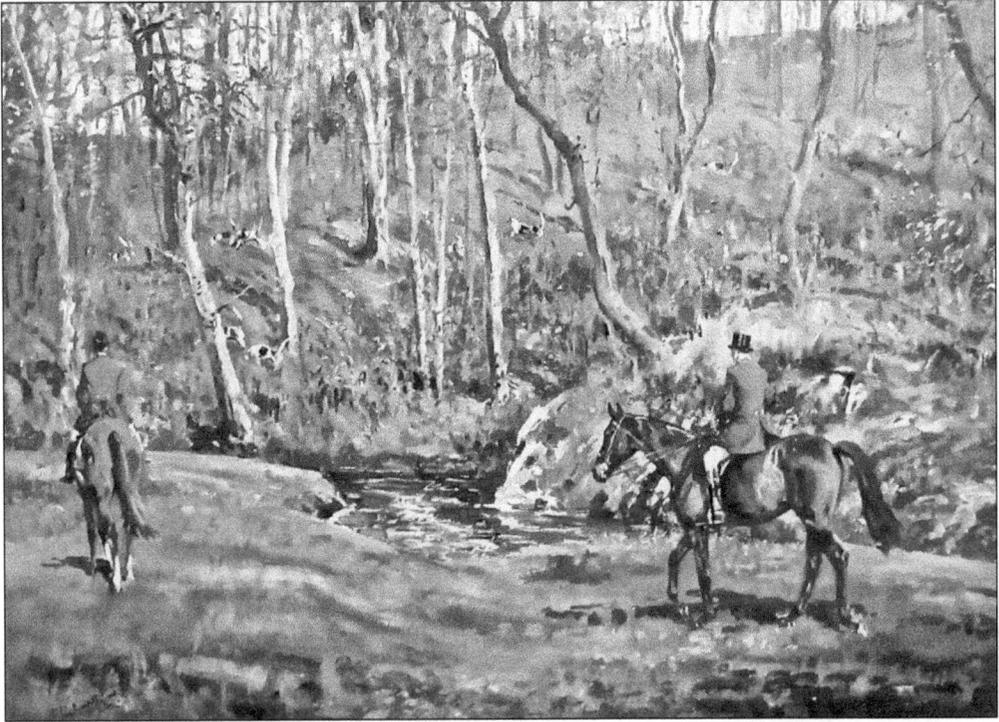

This 1950 painting by Michael Lynne shows Fredrick Warburg, a wealthy Middleburg descendant of the German Warburg bankers, joining the hunt over Goose Creek. This painting is on display at the National Sporting Library and Museum in Middleburg. The Middleburg Hunt was believed to have originated in a dispute between two foxhunters, Henry Higginson and Harry Worcester Smith. Both believed in the superiority of their hounds, and they aimed to prove themselves by declaring the Great Hound Match of 1905. The match endured for two weeks, earning impressive newspaper publicity and christening Middleburg as "the axis of the Hunt Country of America." (Photograph by Laura Troy.)

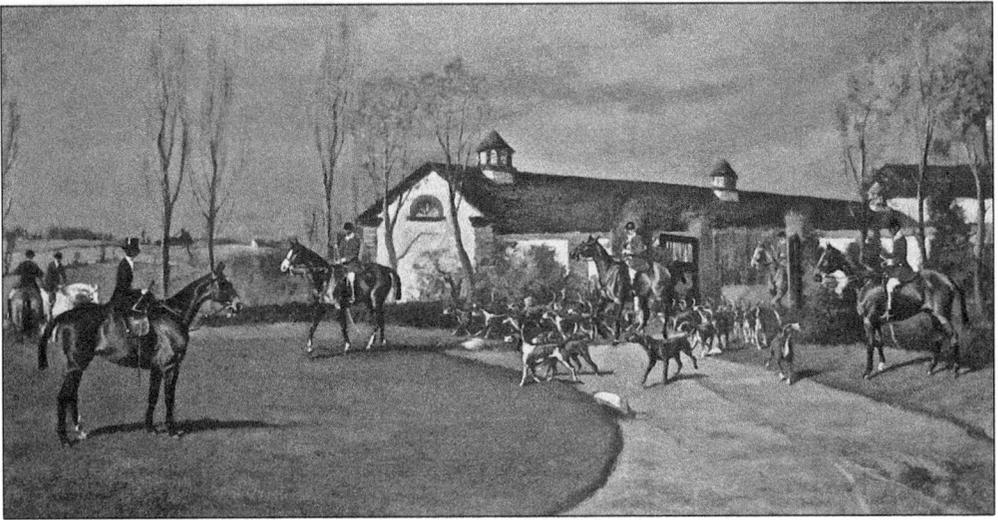

The Middleburg Hunt is depicted leaving in a 1919 painting by Franklin Brooke Voss displayed at the National Sporting Library and Museum. (Photograph by Laura Troy.)

Middleburg hounds catch a ride. (The Pink Box.)

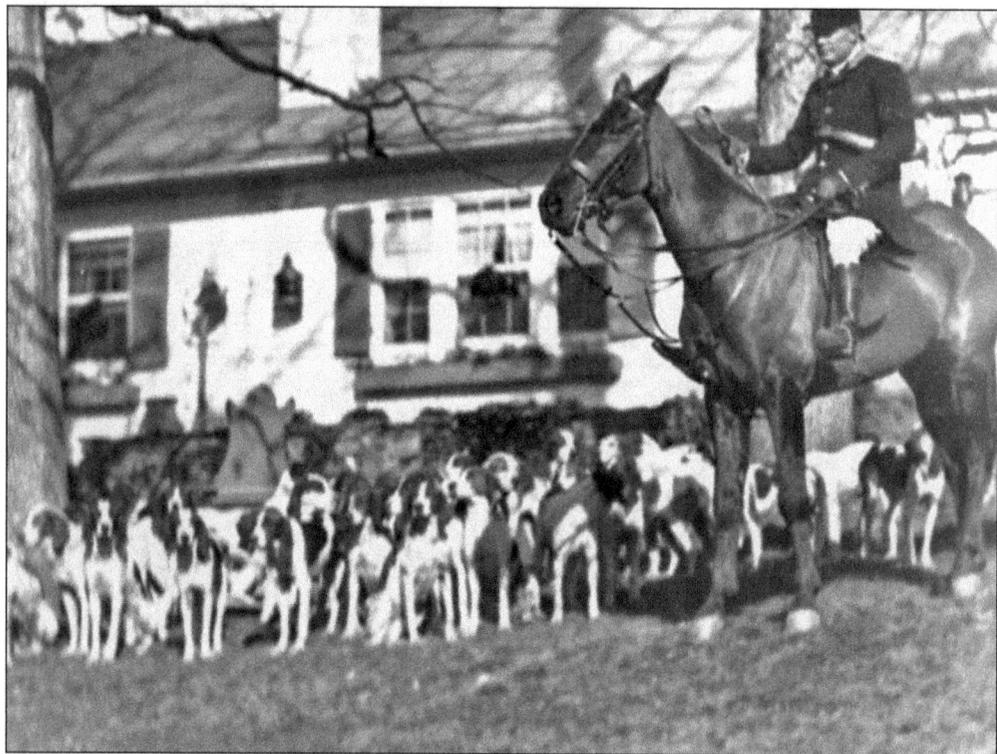

The Middleburg hounds are seen here at The Shelter, owned by Amory S. Perkins at Mount Olive Farm. (Library of Virginia.)

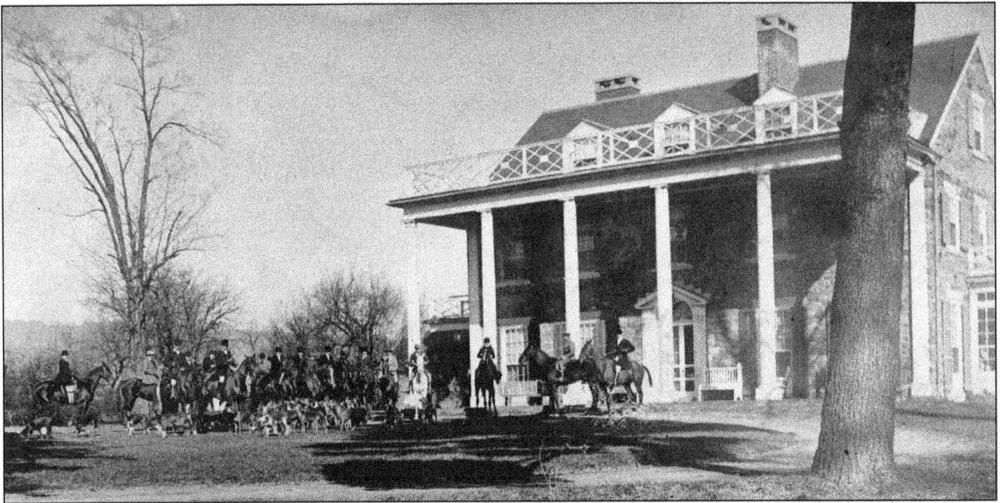

The Great Hound Match of 1905 was recounted by the hound blog *Full Cry*: "Harry Worcester Smith called on American foxhunting authorities to widen their breed standards to include the emerging American type of foxhound. At that point, the English hound—bigger and heavier—was the foxhound breed standard, but Smith led the charge to include the leaner, racier American type of hound that was being bred mostly in the deep South, Virginia, Tennessee, and Kentucky as a legitimate and approved standard. His argument was founded mainly on his strong belief that, while the English hounds were still dominant in the hound show ring, the lighter-boned American hounds were better at catching foxes." (Library of Congress.)

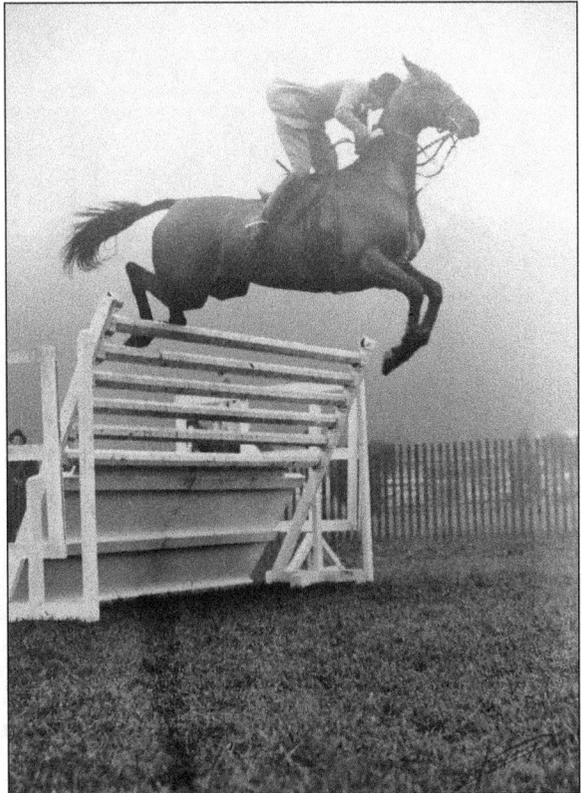

All the spectators probably held their breath during this awkward, gravity-defying jump. A relatively new sport, show jumping was popularized after the British Inclosure Acts were implemented in 1750, bringing fencing and boundaries between the lands of wealthy owners. Those who wanted to pursue the fox on horseback now had to breed horses with the ability to jump these obstacles. (National Sporting Library and Museum.)

This old foxhound was photographed between 1890 and 1910. (Library of Congress.)

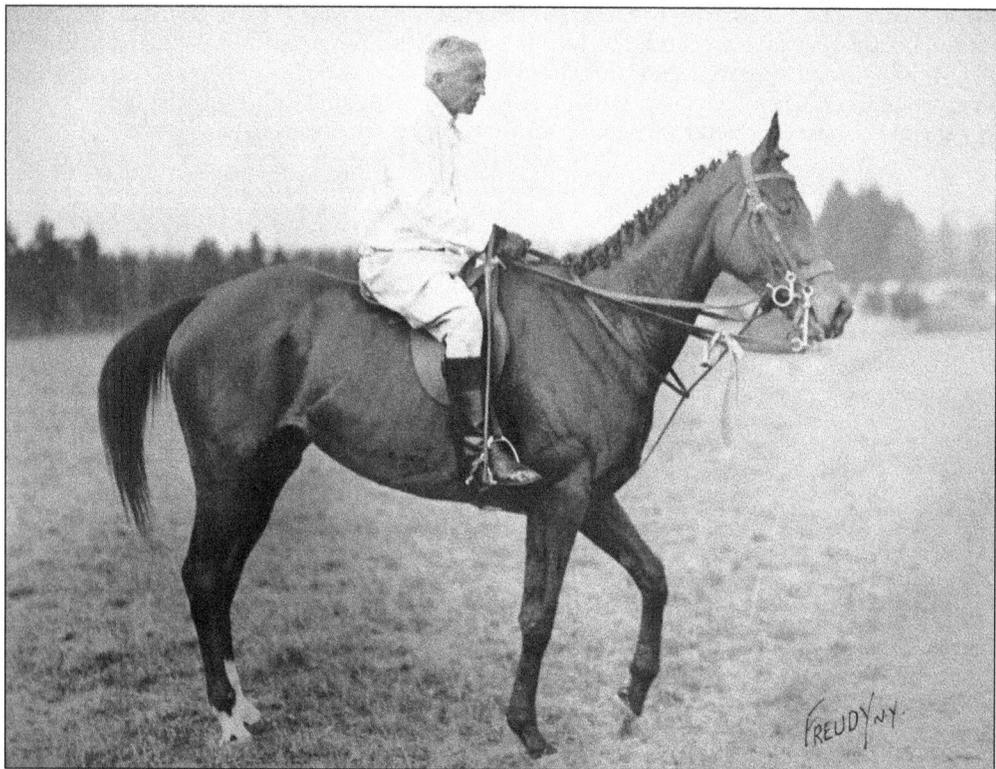

The Great Hound Match of 1905 took place on November 1, 1905. The months leading up to the match were marked by acrimonious public exchanges between Higginson, Smith, and their various pro-English or pro-American supporters as well as by breathless press accounts of the two packs, their breeding and facilities, and the larger debate over which type of hound was indeed best for pursuing the American fox. Shown on horseback is Harry Worchester Smith. (National Sporting Library and Museum.)

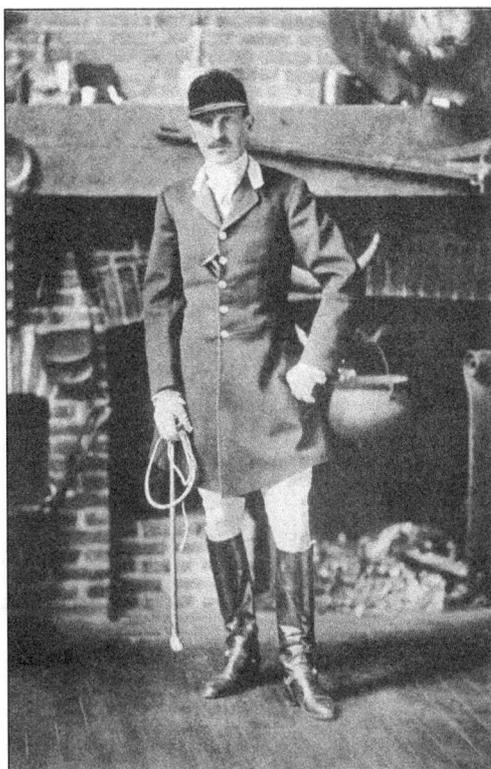

Henry Higginson (right) of the Middlesex
Hunt and Harry Worcester Smith (dressed
elegantly below) were the cofounding
competitors of the Great Hound Match.
(Right, National Sporting Library
and Museum; below, Nancy Lee.)

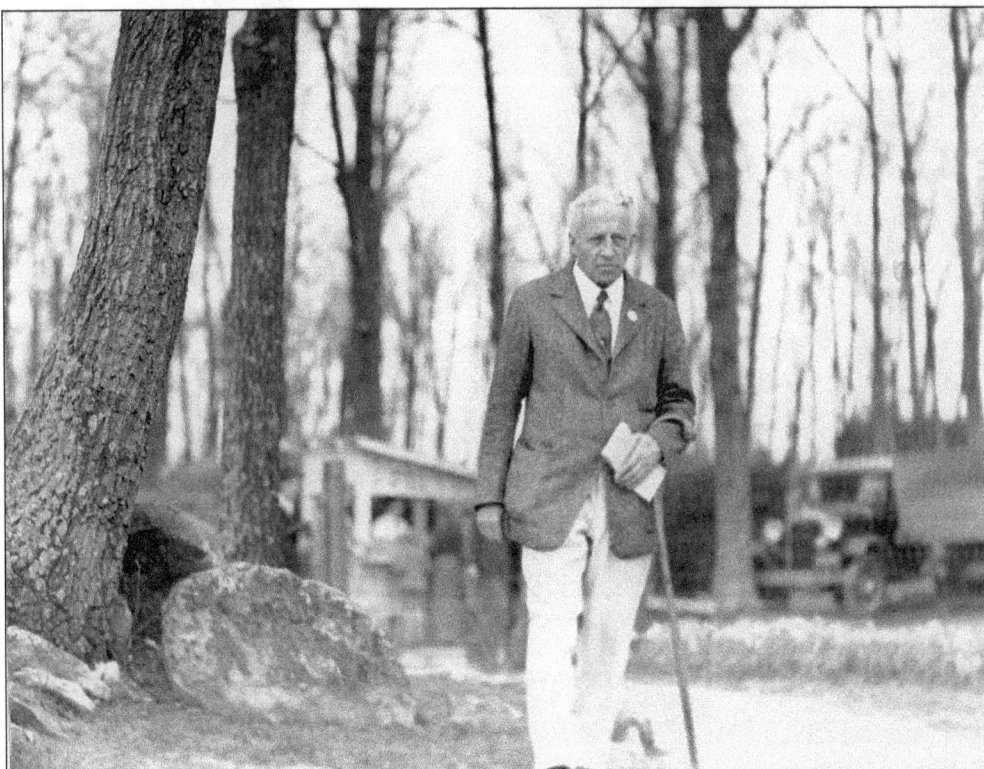

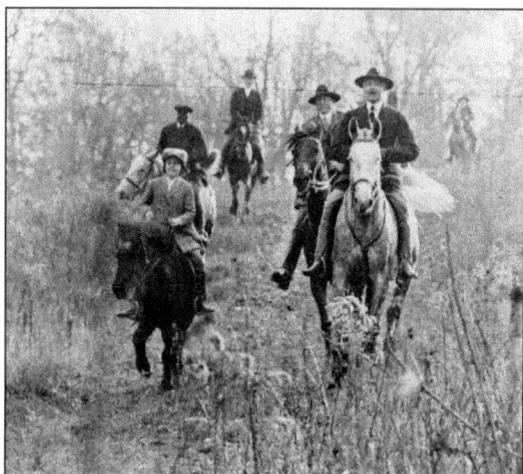

The Great Hound Match started off with tremendous fanfare. A local newspaper reported that 100 horses had been imported to the Middleburg area so that riders from up and down the East Coast could ride behind the Grafton and the Middlesex packs as they attempted, once and for all, to settle the question of whether English or American hounds were superior for hunting the American red fox. During this break, the score was essentially even, with no clear winner in the book yet. But word was out: the Great Hound Match of 1905 was providing some of the best sport foxhunting America had ever seen. (Library of Congress.)

Established 1890 Edited by Samuel Walter Taylor Price, 15 cents

Copyright, 1904, by Rider and Driver Publishing Co., New York.

Vol. XXIX New York and Chicago, March 4, 1905 No. 23

See Text Inside of $1,000 Match between American and English Bred Fox Hounds—Mr. Harry W. Smith, of Worcester, having accepted the challenge of Mr. A. Henry Higginson, of Boston.

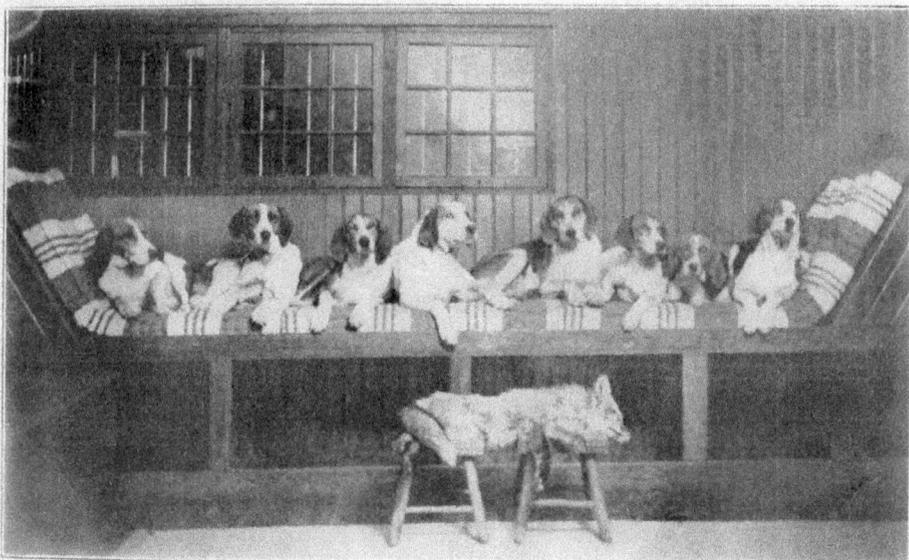

GRAFTON HUNT CLUB'S AMERICAN FOX HOUNDS

When Smith and his Grafton hounds were proclaimed winners of the match, Higginson wrote that he was "*perfectly* satisfied with the work of my hounds," adding, "Messrs. Movius, Maddux and McEachran gave the decision to the Grafton, and it would be most discourteous to them for me to make any statements as to how their decision agreed with anything I may or may not think." In the photograph, the Grafton Hunt Club's foxhounds bask in their glory after a long day of hunting and making headlines. (National Sporting Library and Museum.)

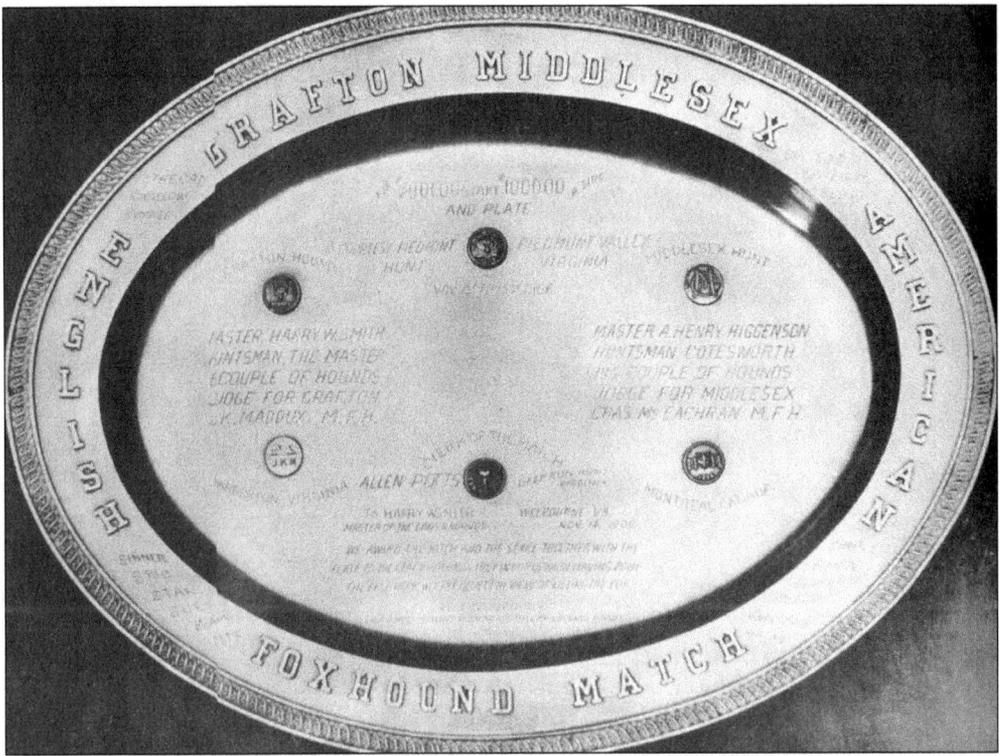

The debate over English versus American hounds continued long after the Great Hound Match of 1905. Fox-catching has given way to fox-chasing as the goal of the hunt, and with development and the coyote's new predominance as game in many territories, packs have been prompted to reassess their hound programs. So what, if anything, did the Great Hound Match of 1905 accomplish? It raised Virginia's profile as the nation's most fashionable place to hunt and helped the sport grow there. Among the people drawn to the Middleburg area by the hound match was Joseph B. Thomas, who built a state-of-the-art kennel at Huntland here and went on to write the wonderful *Hounds and Hunting through the Ages*. The 1905 trophy seen here has gone missing through the years. (National Sporting Library and Museum.)

Three generations in the family class at the Middleburg Hunt are shown here. From left to right are Harry Worcester Smith, Cromptom Smith, Mrs. Cromptom Smith, and young Tommy Smith, who later became the first American to ride and win the English Grand National on an American-owned horse. (Nancy Lee.)

The Montreal Hunt, established in 1826, was the first North American foxhound club. The Piedmont Foxhounds were established in 1840 in Virginia, making it the first US Foxhound Club. Both of these clubs are still in existence today. Records indicate that while the earliest politicians were settling matters of policy, on at least one occasion, matters of state took a back seat when a hunt coursed past the White House and the politicians interrupted the proceedings to mount their horses and join the chase. The Piedmont Hunt is seen above in 1921 and below with their beagles in 1914. (Library of Congress.)

Five

MIDDLEBURG THROUGH THE YEARS

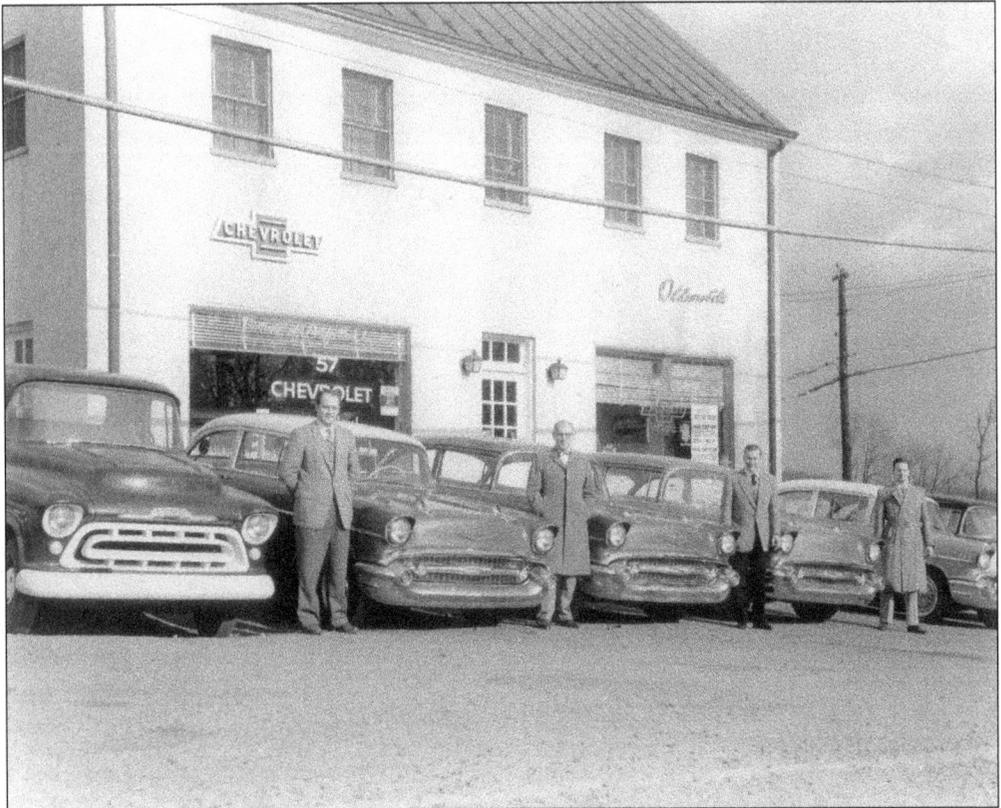

At one time, Middleburg had several car dealerships. (Tyler Gore.)

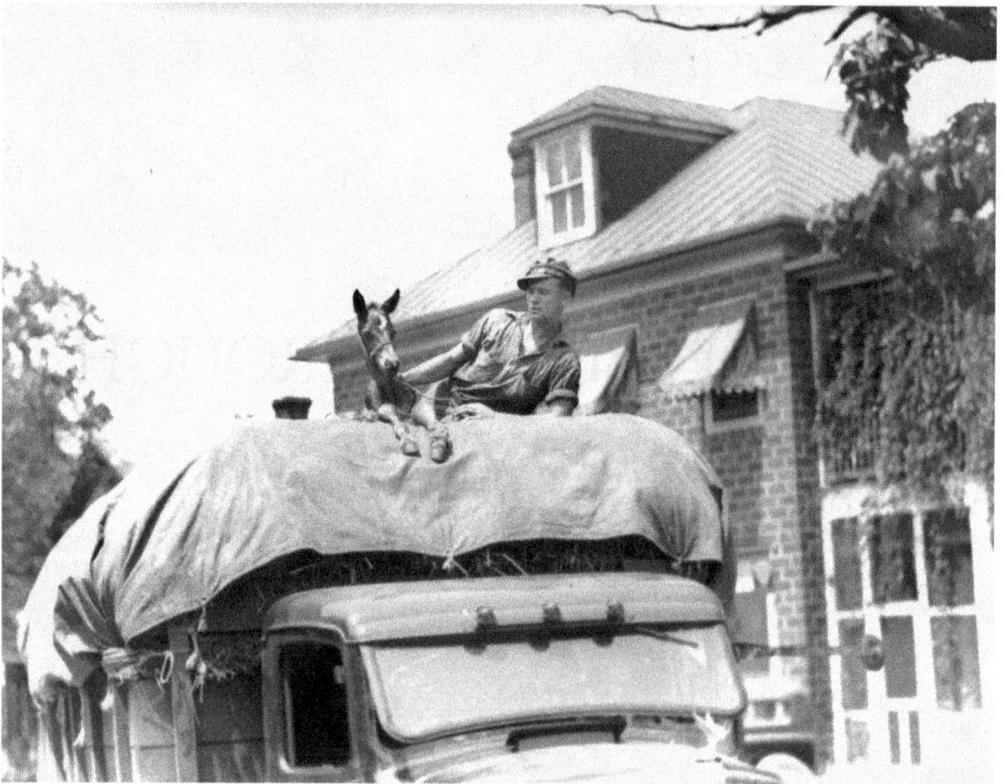

This image of human and equine hitchhikers atop a truck on Main Street in the 1930s captures the essence of the equestrian community. (The Pink Box.)

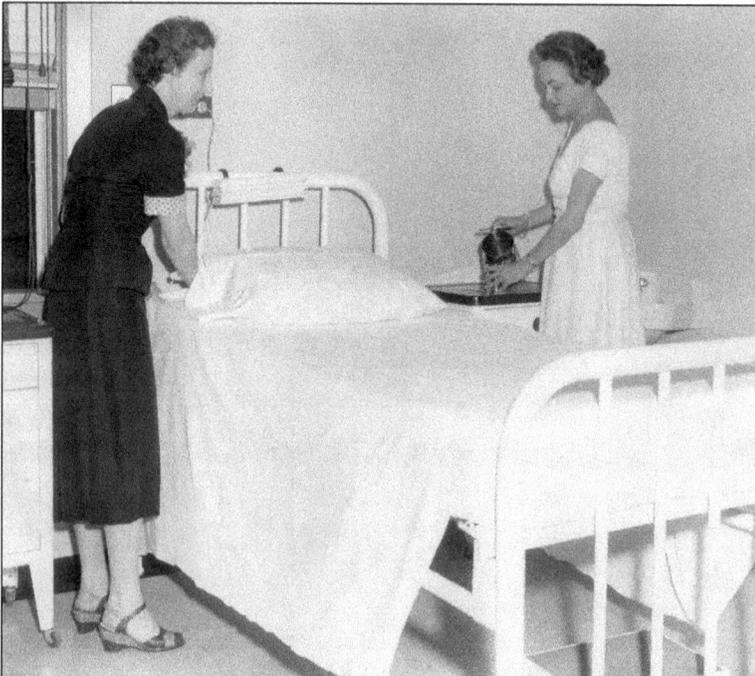

In the mid-20th century, women came to the Birthing Inn to have their babies. They stayed overnight for a cost $3–5. Shown are head nurse Virginia Williams (left) and nurse Mable Waddell. (Tyler Gore.)

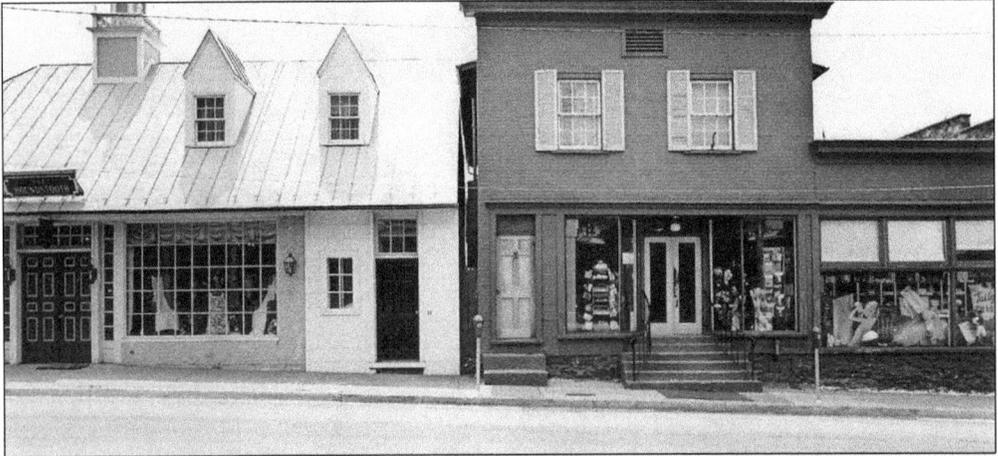

These Middleburg storefronts from the 1960s are just beyond the single traffic light. (The Pink Box.)

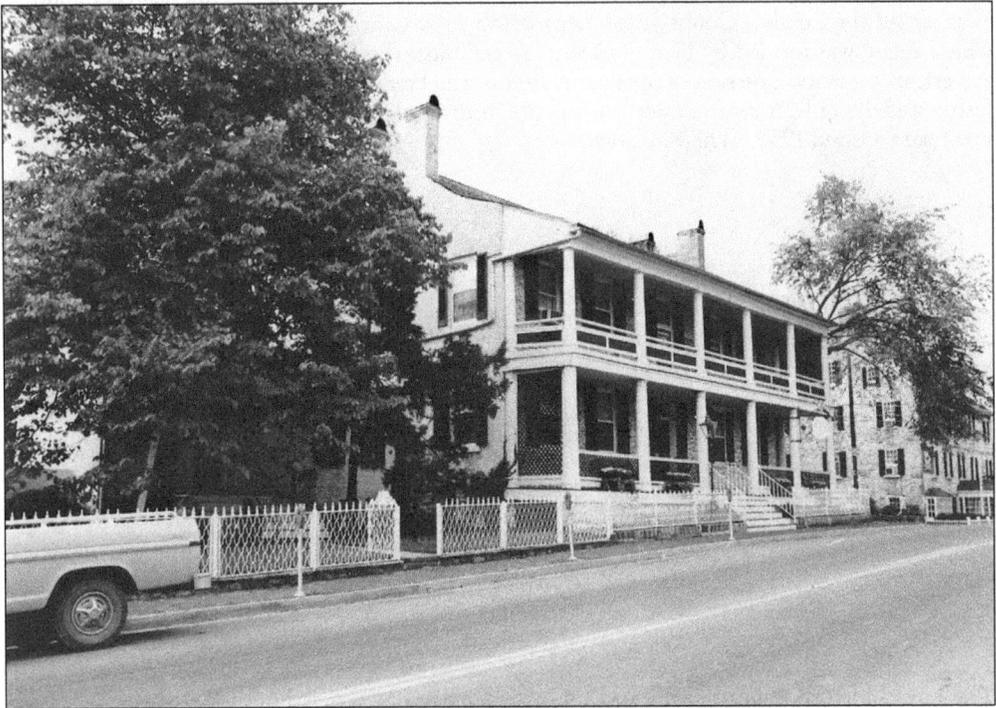

In the 1970s, the Noble House still had its two-story porches, and across the street the Red Fox Inn was flourishing. (The Pink Box.)

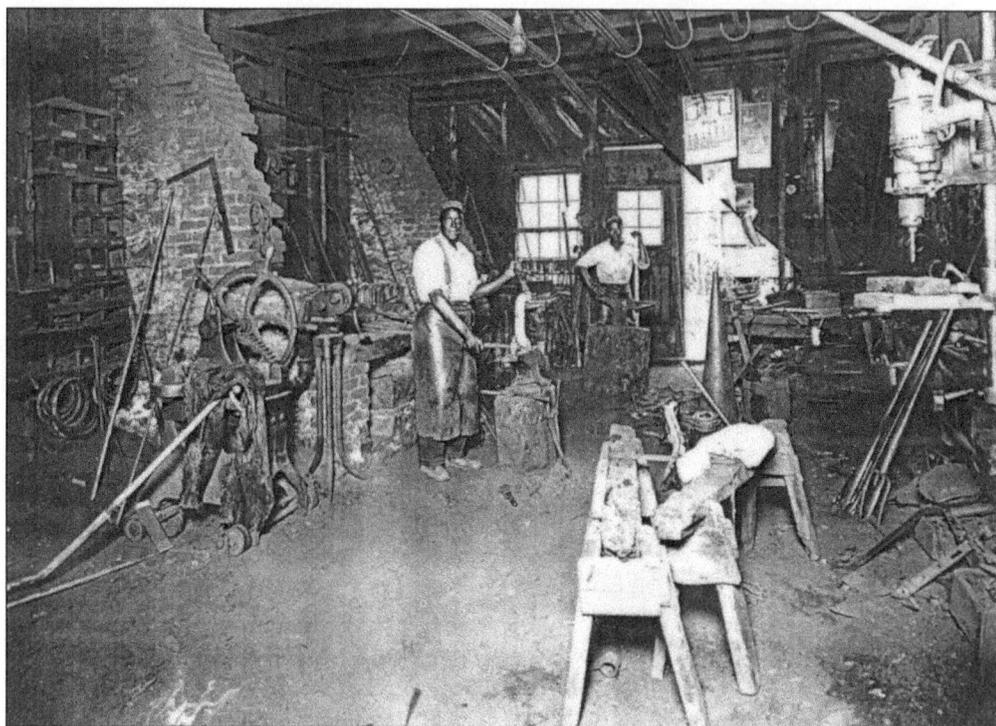

John Wesley Wanzer and Charles Fisher pose in their blacksmith shop. Wanzer, Middleburg's last blacksmith, retired shortly before his death in 1957. A leader of the African American community, Wanzer led the Loudon County-wide League from 1938 until his death. The Loudon County-wide League was formed by black residents to establish the first secondary school for African American students. The school opened in 1941 as the Frederick Douglass High School. Charles Fisher was the only African American to vote in town elections in the 1930s. The photograph was taken around 1930. (The Pink Box.)

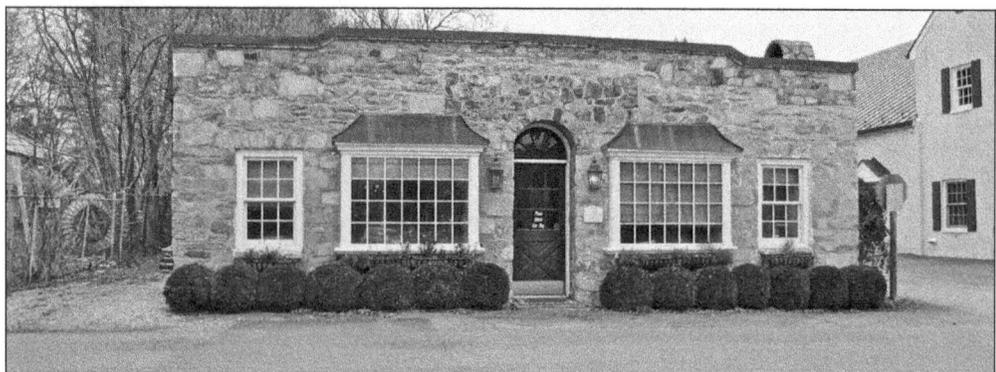

The blacksmith shop burned in 1934 and was replaced by a new building. It became a body shop, and later the police chief built go-carts here. Today, it is an office building. (Photograph by Laura Troy.)

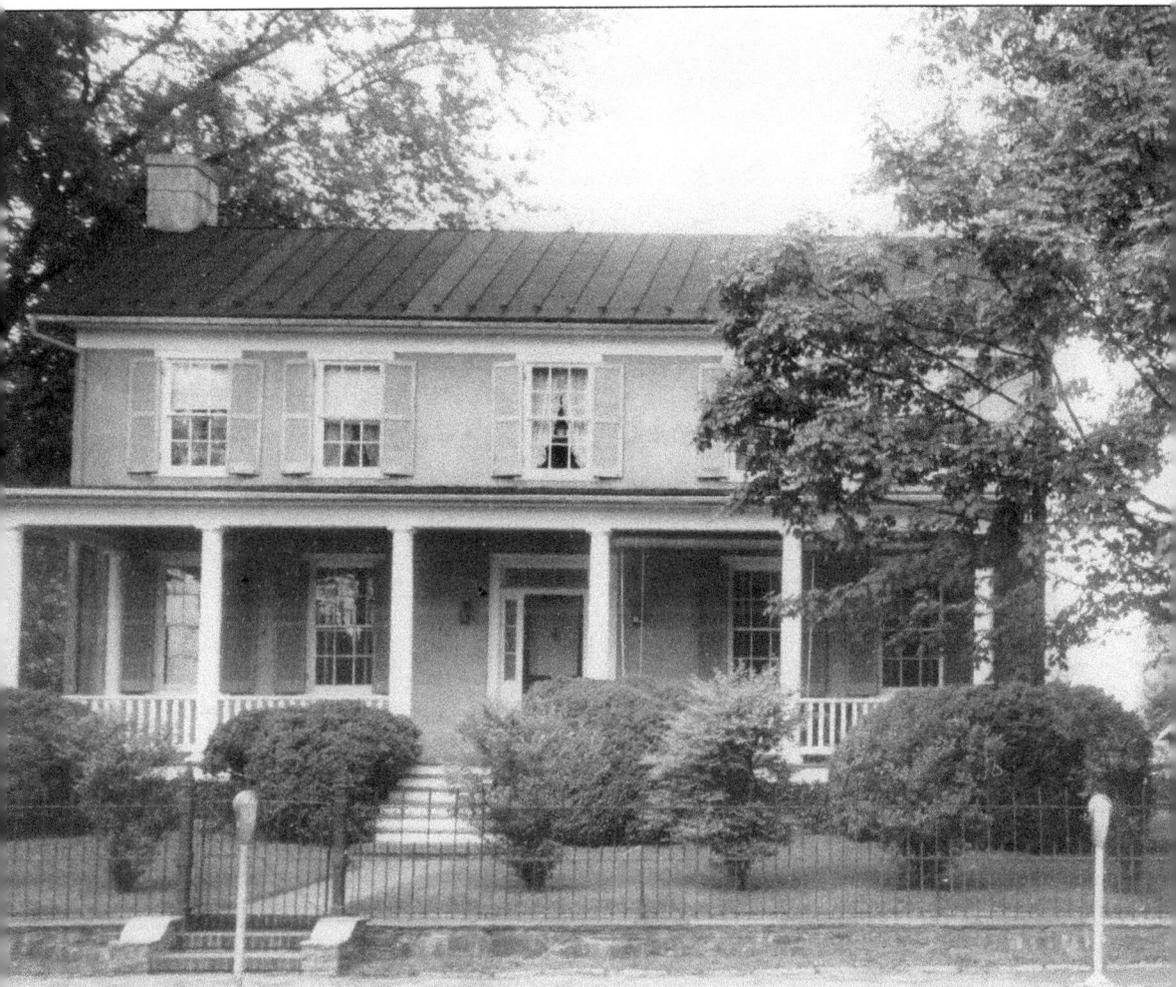

The home of Dr. Spitler is shown in 1962. It was torn down to make way for the Safeway. (Tyler Gore.)

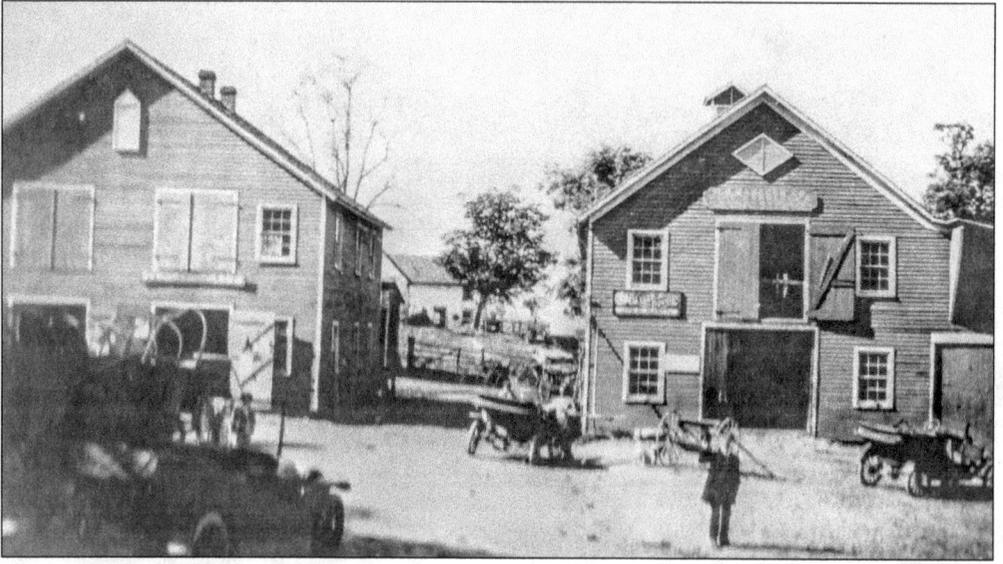

The sign above the door to the building on the right reads, "H.H. Babcock Co. Fine Carriages." A top-of-the-line Babcock buggy sold for about $180. Joe Martin was probably the town's most popular businessman, with a reputation of being good for a loan. He would always say, "I love Middleburg, and I love baseball." In the background stands the Shades, one of Leven Powell's homes. The buggy shop burned with the blacksmith shop, and on its site today is Mosby's Tavern. (The Pink Box.)

Mosby's Tavern once served as a General Motors Shop. (Photograph by Laura Troy.)

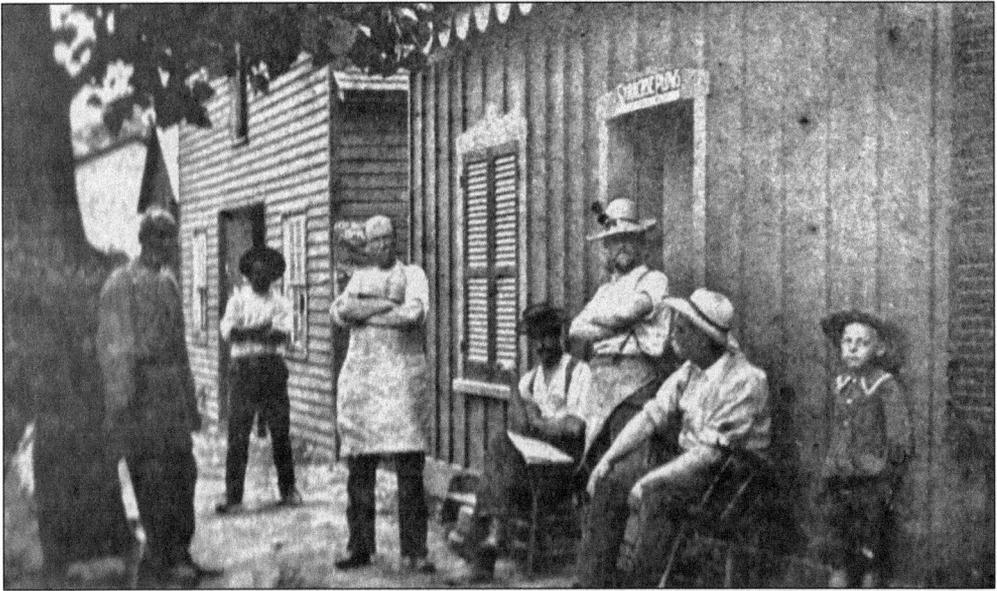

Town craftsmen pose in front of Joseph Martin's office, which also housed the Benton Tombstone Carving Shop, before it moved to the back street in 1906. In the background is Martin's first livery stable. At left is Samuel Atwood (with folded arms and apron), who drove the Leesburg stage, and harness maker Will Keeler. Seated with the black hat is blacksmith Billy Mitchell, who worked for Martin; standing with the white hat is Otto Riedl, a German leather worker who worked for Keeler; Joseph Martin is seated with the white hat; and the boy is Atwood's son Howard. These structures were torn down with the buildings of Samuel Preston Luck's garage in 1918. This part of Middleburg was transformed in the late 1920s into stores owned by Samuel Preston Luck and H. Rozier Dulany Jr., whose building became the New York Café. (The Pink Box.)

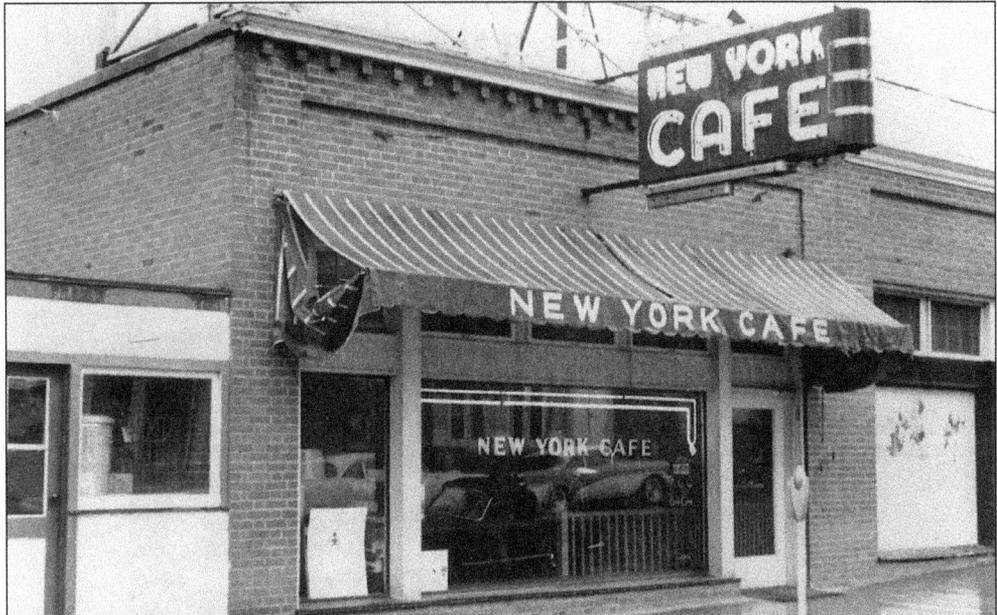

The New York Café is seen here in the late 1920s. It was the Coach Stop restaurant after that and is now the Lou Lou dress shop. (The Pink Box.)

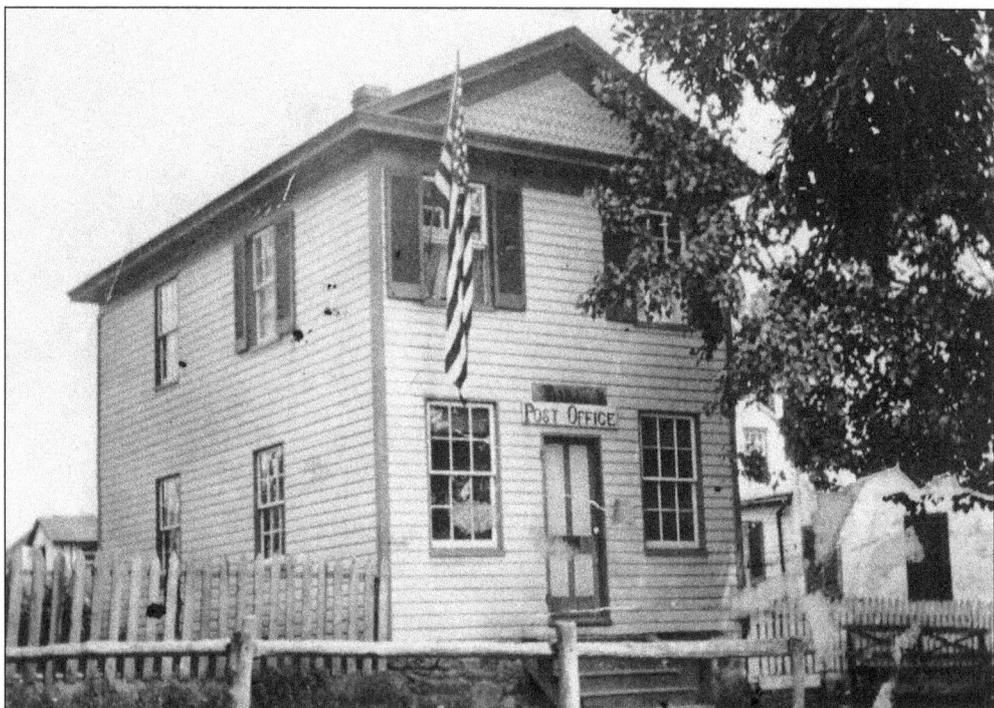

Along the westerly stretch of the Route 50 corridor, Middleburg was the first town to boast a post office. It was opened on October 2, 1797, the same day postal authorities approved the Fauquier Court House post office. The town's official post office name was Middleburgh, with the final "h" holding on for nearly a century. In the 1830s, Leesburg's postmaster regularly made more than $400 a year, Middleburg's and Warrenton's postmasters made more than $300, and Upperville's postmaster made more than $200. The postmasters of Aldie and Waterford averaged about $100 a year. The building now holds retail stores and a coffee shop (below). (Above, The Pink Box; below, photograph by Kate Brenner.)

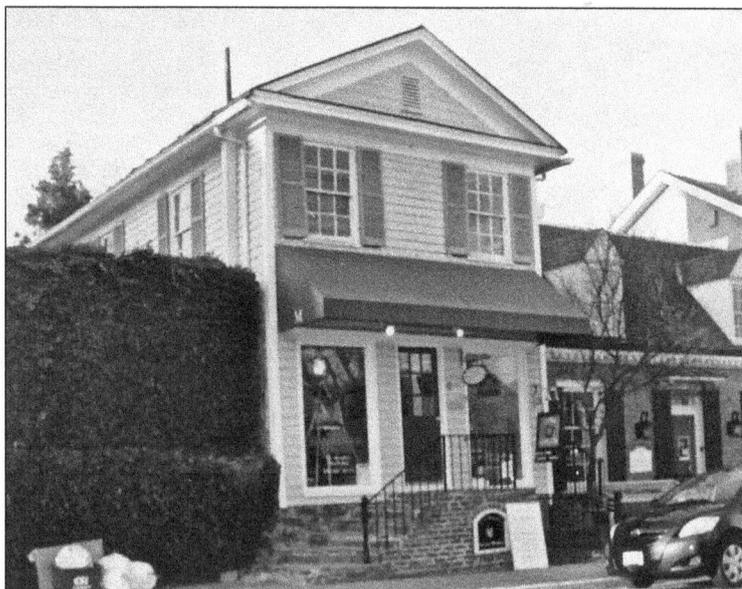

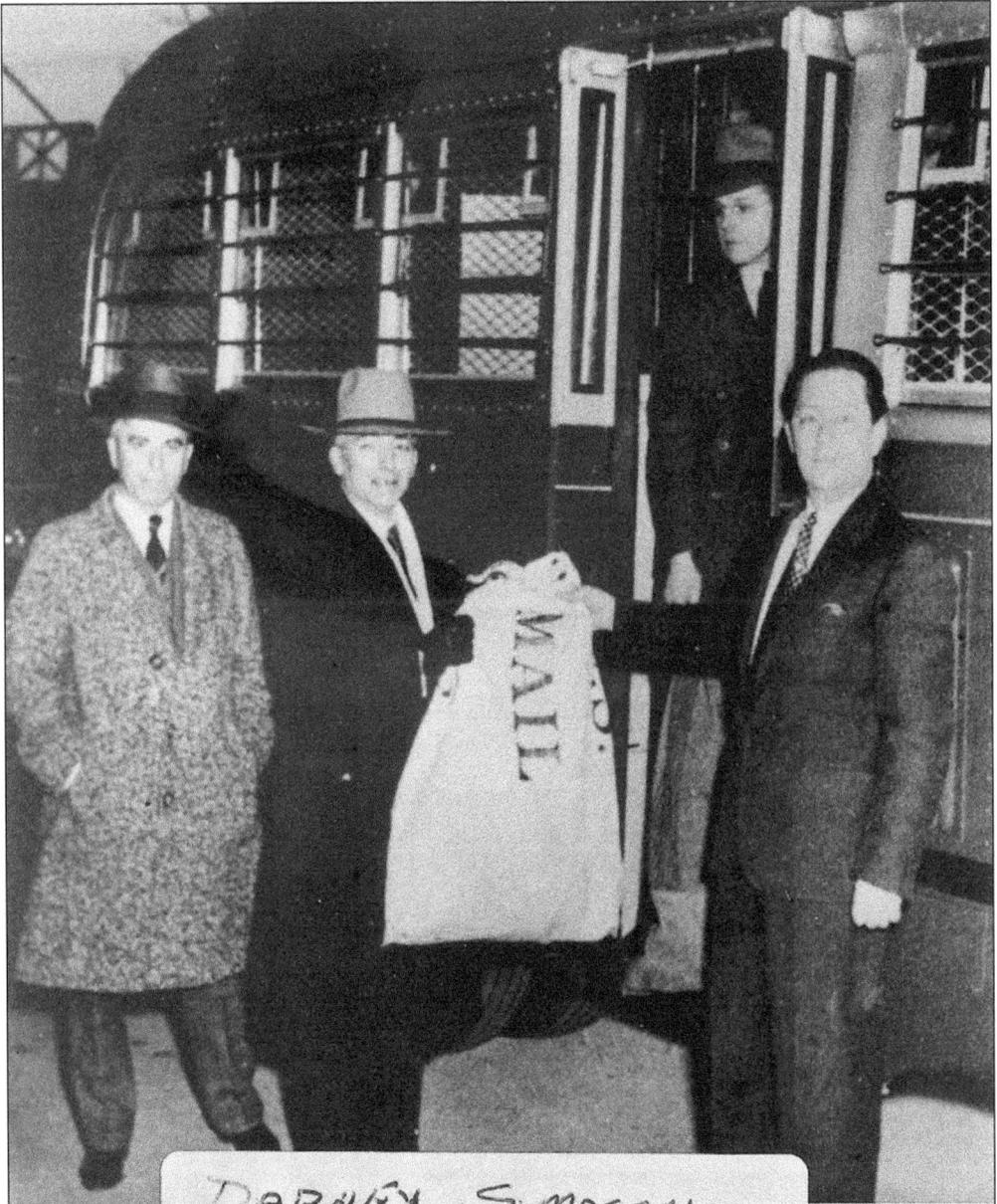

Dabney Simpson, the Middleburg postmaster, accepts mail from the US mobile post office in 1941. (The Pink Box.)

The Anna Duffey House was home to the Duffey family for two centuries. Edward Duffey, a former Confederate soldier, ran the newsstand and jewelry store across the street. He is famed for being the last person to fire a shot at the Battle Of Gettysburg in 1863, a claim which was substantiated in writing by General Longstreet. (Photograph by Laura Troy.)

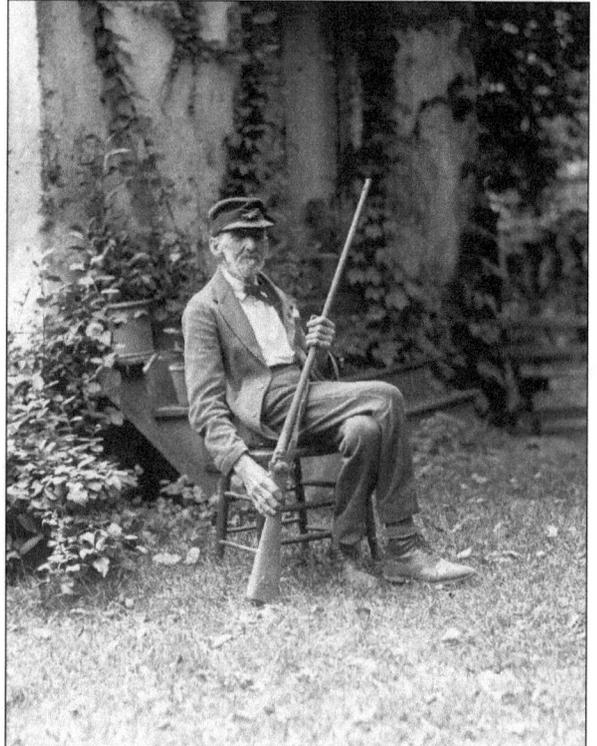

Edward Duffey sits with his rifle in 1925. (Library of Congress.)

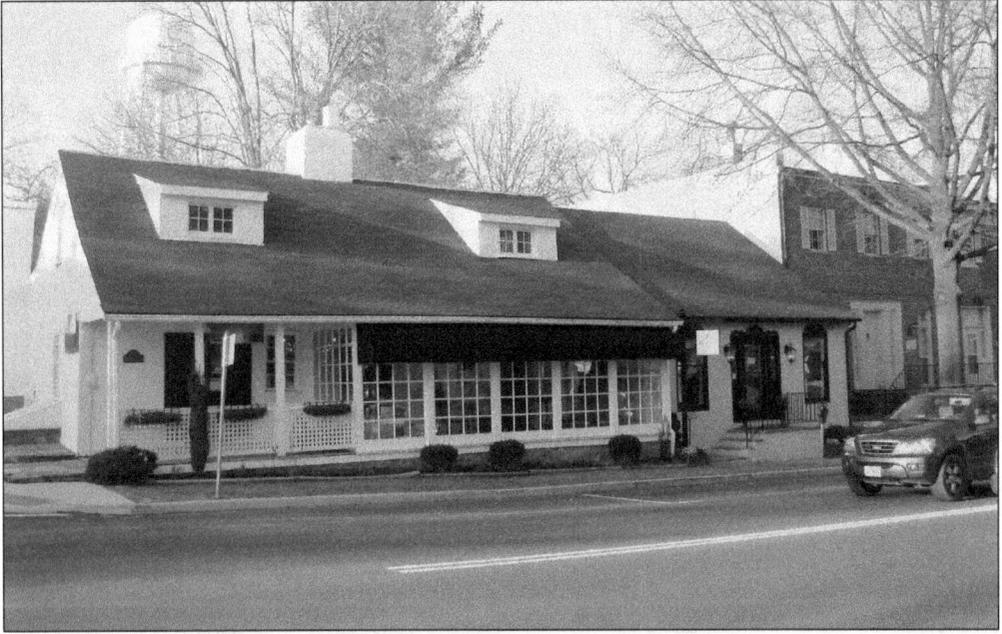

The Moran House, purchased by Samuel Henderson in 1796, contains two log units that were part of the original construction, making it one of the oldest homes in town. Its location on Washington Street made it ideal for commercial use, and it has housed everything from a tin shop to a tearoom. (Photograph by Kate Brenner.)

The Wright House is one of the oldest documented residences in Middleburg. The home was built around 1793 by Josiah Dillon, one of the original land purchasers of Leven Powell's plots. Today, it houses the restaurant The French Hound, popular with Middleburg residents and visitors alike. (Photograph by Kate Brenner.)

The southeast corner of Washington and Madison Streets is seen here in 1928. The building was J. Walter Cochran's general store, where the Middleburg Bank first stood and where today's Home Farm Store is located. William Zeigler purchased acreage from J. Walter Cochran, a successful businessman in town, to expand historic Burrland Farm, now known as Hickory Tree Farm. (The Pink Box.)

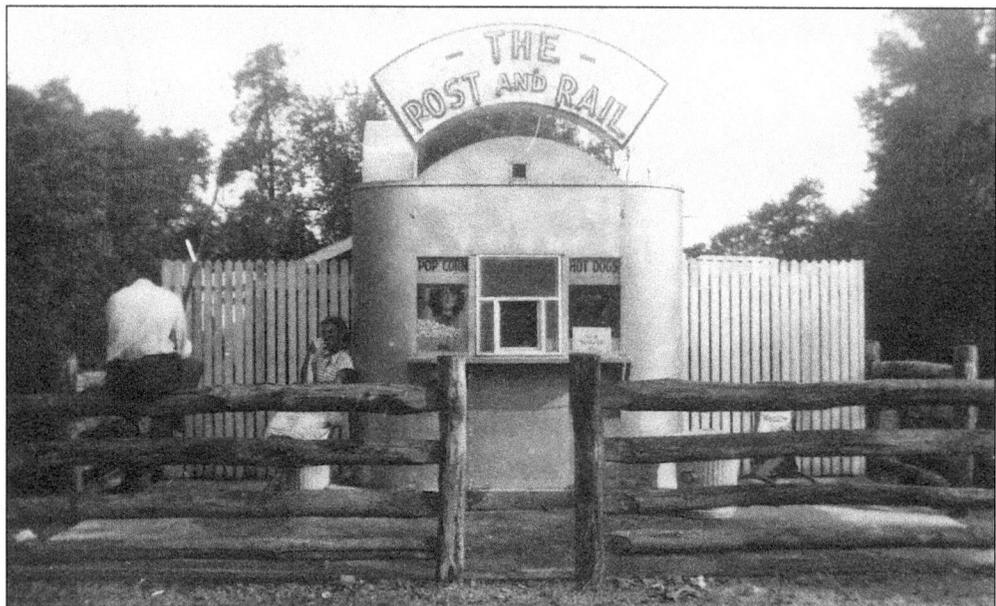

Charles Cushman called his restaurant, The Post and Rail, a "midget kitchen" or "miracle kitchen." It was built in late 1947, its metal house the twin of Leesburg's still thriving Mighty Midget Kitchen. The Post and Rail served up deep fried food; hamburgers cost 25¢, hot dogs were 15¢, and the jukebox played for a nickel. It closed in 1956 and was razed to make room for the Middleburg National Bank building. (The Pink Box.)

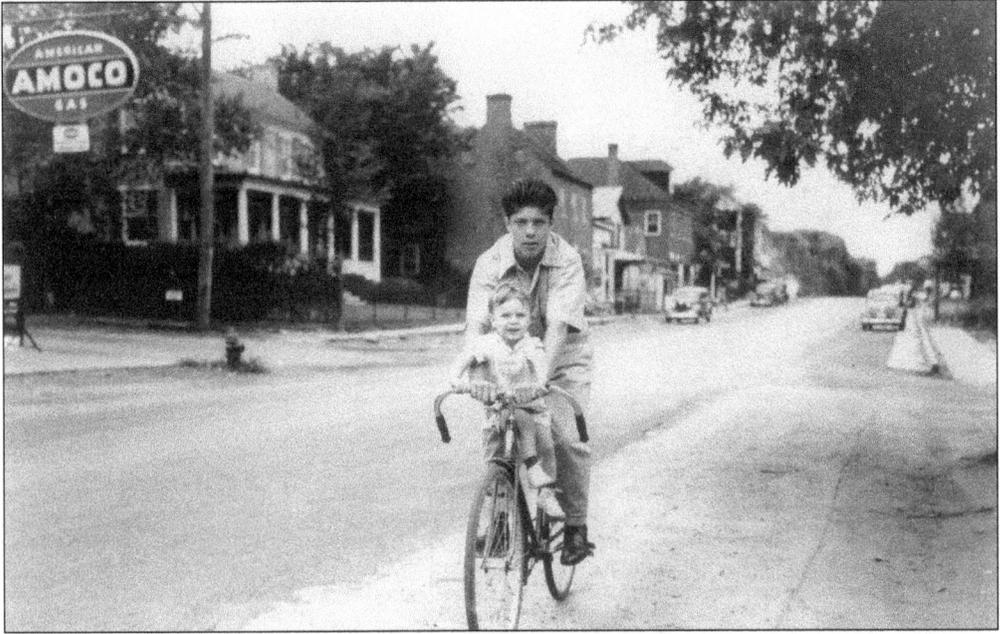

Thomas Darling and his son ride down Washington Street in 1939. Curbs were just being installed on the main street. (Tyler Gore.)

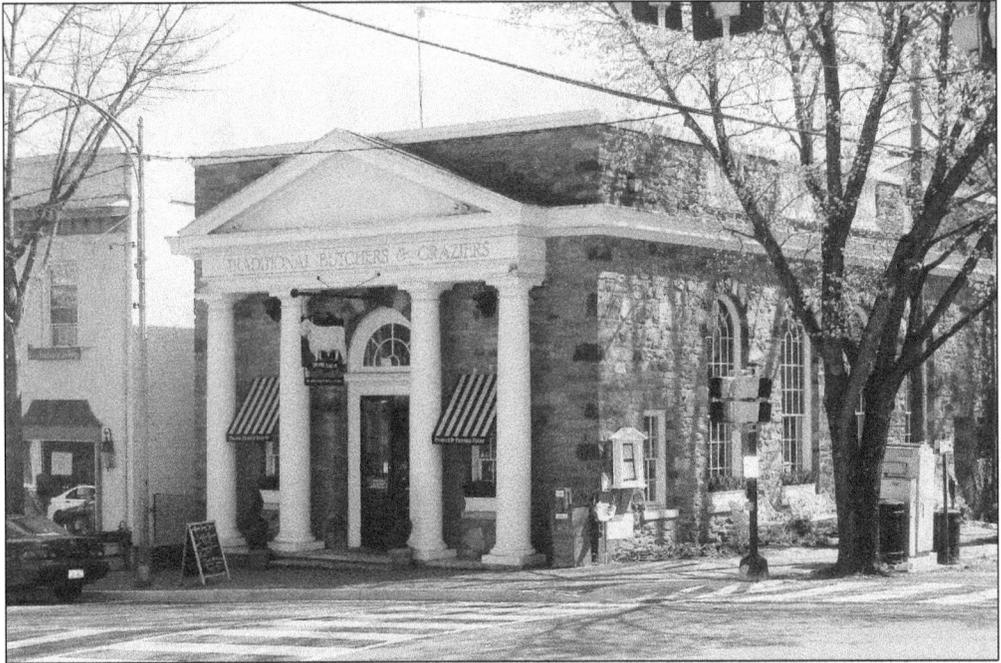

An imposing symbol of Middleburg's resurgence from its 19th-century developmental stall was the completion in 1924 of the Middleburg National Bank by Will Hall. Both as a depository and as a lender for the financing of homes, farms, livestock, automobiles, farm equipment, and small businesses, the bank has performed essential services for the town and its inhabitants. The original bank building is now the Home Farm Store, the retail outlet for Ayshire Farm's organic meat. (Home Farm Store.)

A previous manager of the Home Farm Store, which was also a charcuterie, was especially attracted to the bank vaults in the basement of the building, using them as a storage locker to ferment artisan meats, such as pancetta and salami. (Photograph by Kate Brenner.)

The inside of the building has old belt-and-pulley ceiling fans and two-story Palladian windows made of original glass. (Photograph by Kate Brenner.)

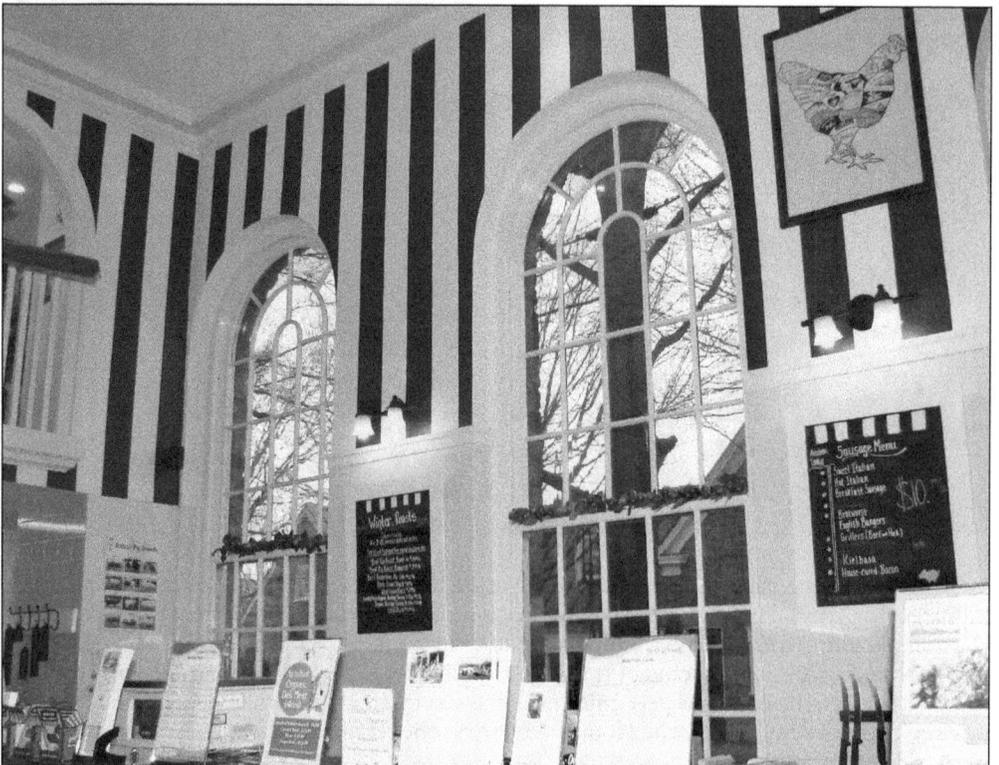

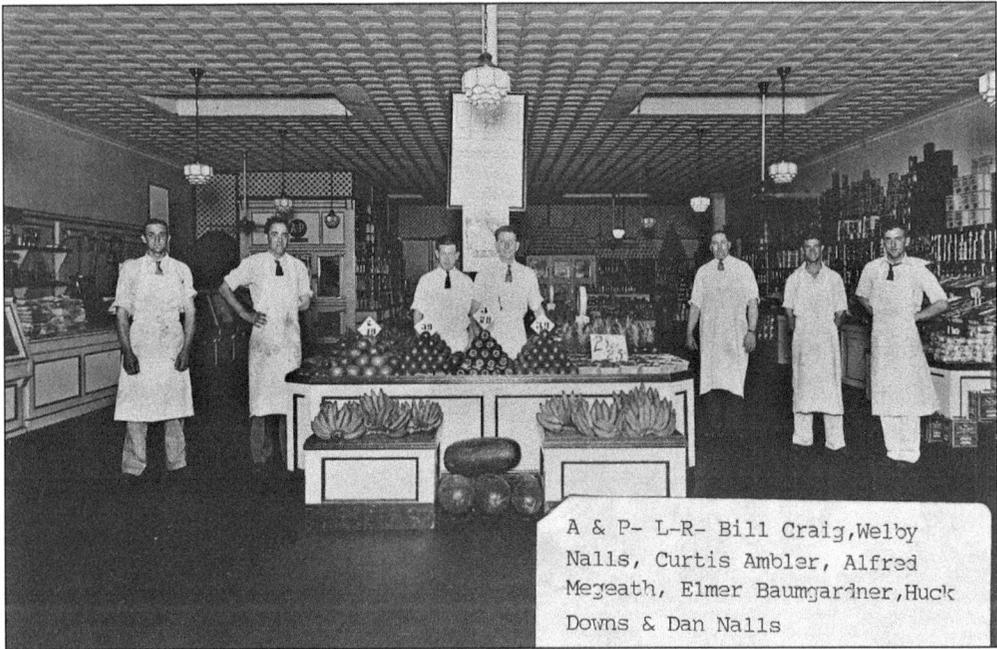

A & P- L-R- Bill Craig,Welby
Nalls, Curtis Ambler, Alfred
Megeath, Elmer Baumgardner,Huck
Downs & Dan Nalls

The Middleburg A&P is seen here in 1939. Shown from left to right are Bill Craig, Welby Nalls, Curtis Ambler, Alfred Megeath, Elmer Baumgardner, Huck Downs, and Dan Nalls. (The Pink Box.)

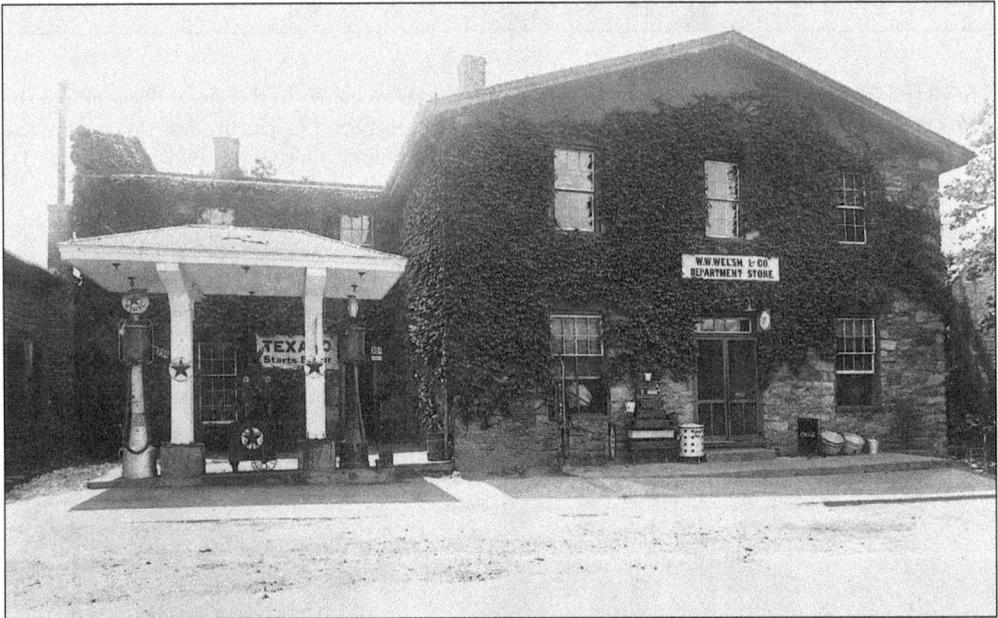

Another sign of the new age was the construction of Middleburg's first service station in 1924, next to the W.W. Welch five and dime. A true vehicle of change, the automobile greatly weakened the ties binding the town and countryside in close interdependence since the early 19th century. Chain stores eventually supplanted the old country stores, and residents from a much wider area began to come to Middleburg to shop. The new mobility also enabled neighborhood and town residents to shop and work as far away as Winchester and Washington, DC. (The Pink Box.)

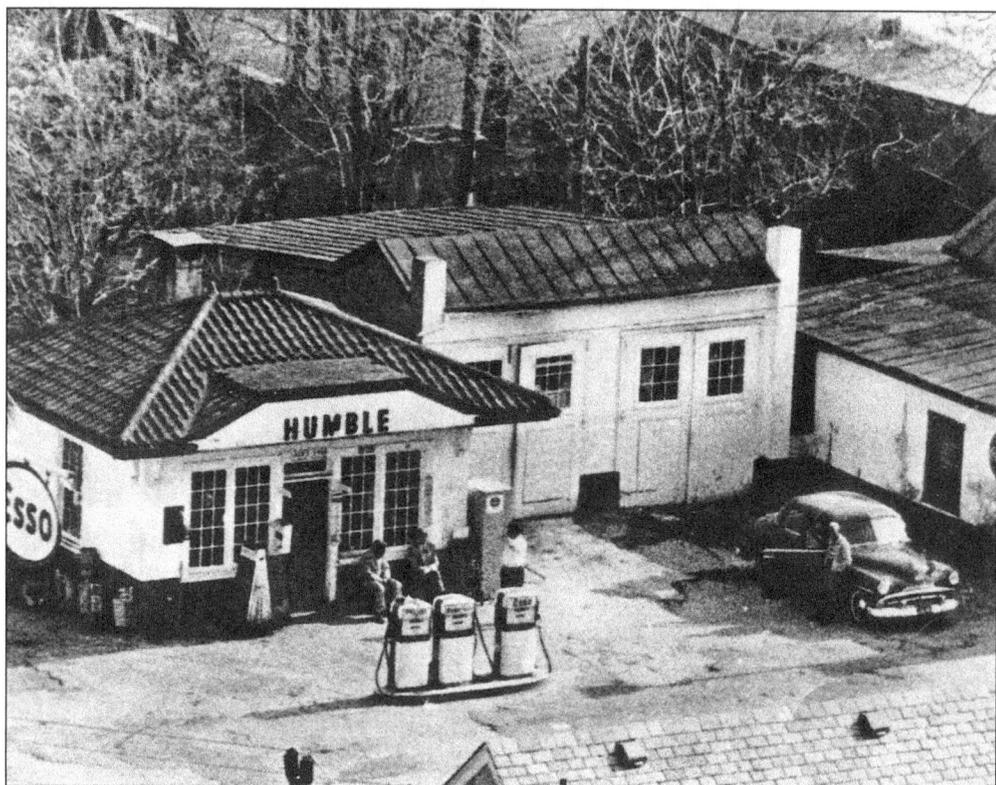

The old Esso station (above) has been converted into the shops below. In the above photograph, the men gathered outside the gas station were there to play bluegrass. The picture was taken from the top of Middleburg's water tower. (Above, The Pink Box; below, photograph by Kate Brenner.)

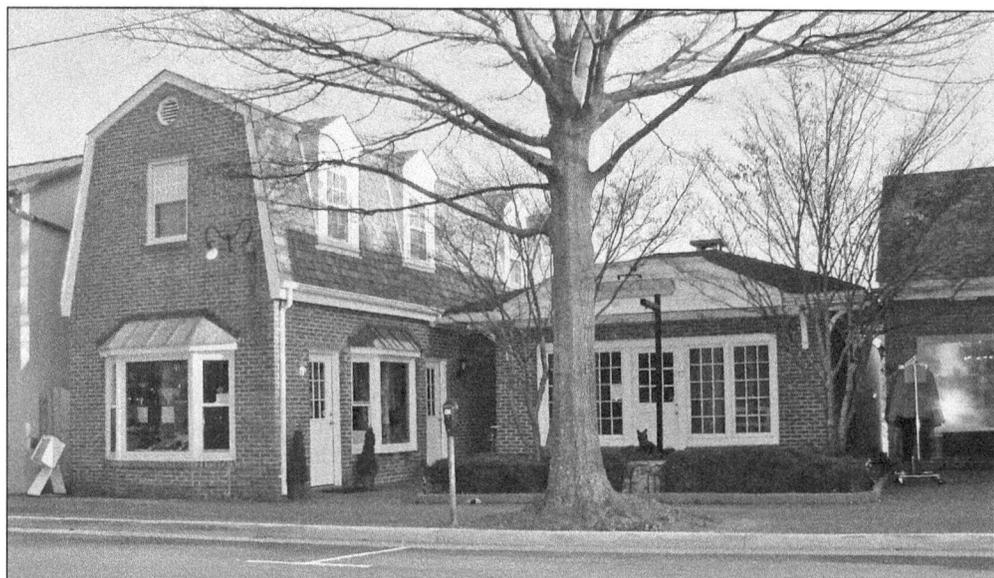

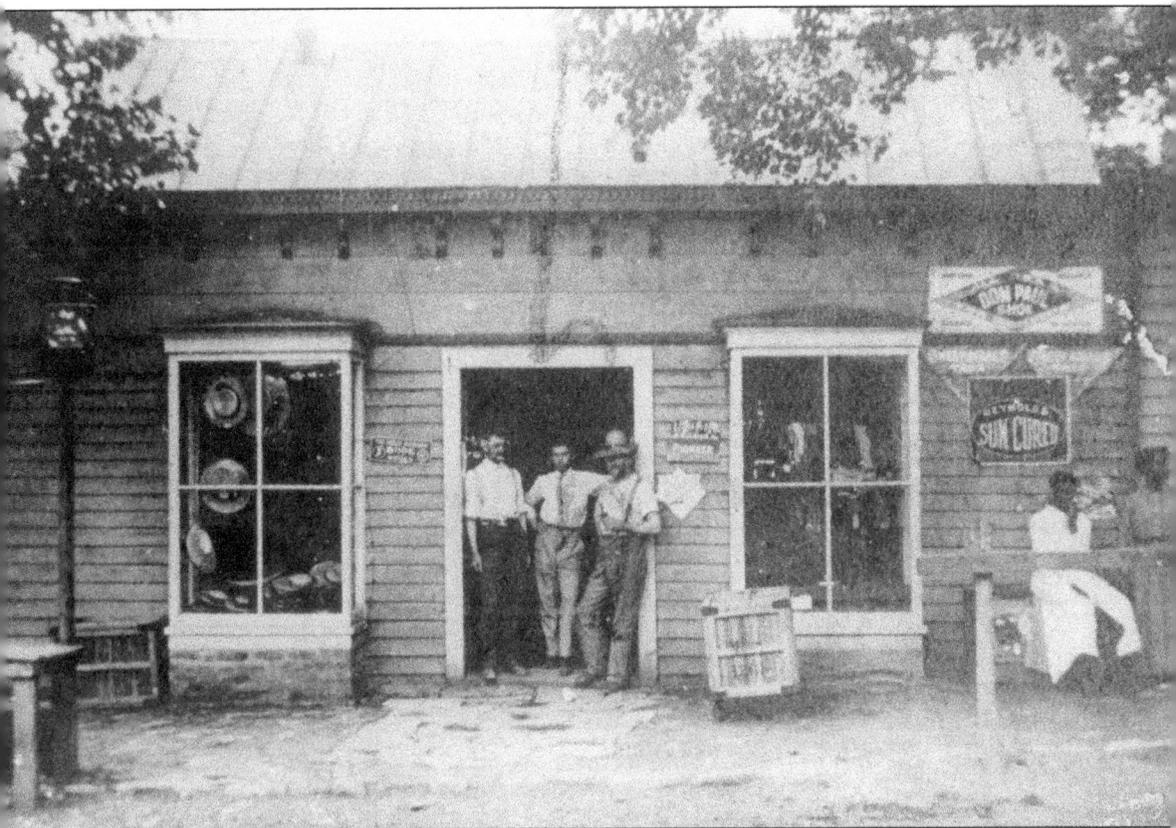

J. Walter Cochran's Christmas store was one of his two auxiliary shops, the other being an ice cream parlor on West Madison Street. These buildings were razed in 1937 to make way for the Stevenson Block, now a bevy of shops. From left to right are J. Walter Cochran, the owner; an unidentified clerk; saddle maker Otto Reidl; and Annie Minniefield. In the off-season, the shop sold a lot of candy, with a sour ball always free for the asking. Note the coal oil lamp at left. (The Pink Box.)

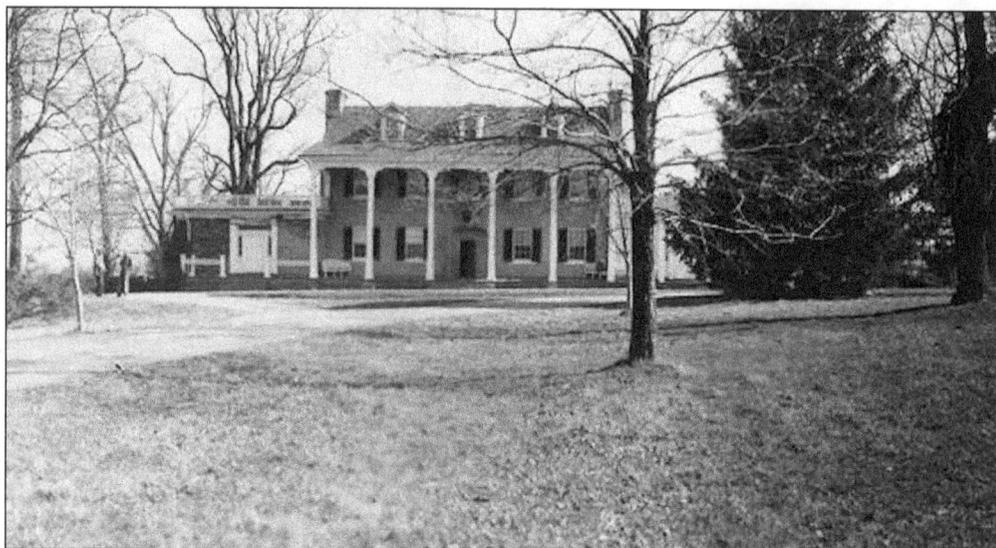

In 1861, Richard H. Dulany raised and personally equipped a company of mounted troops and left his ancestral home, Welbourne, to follow the secessionist course set by his native Virginia. Welbourne, seen here in 1938, is a lavish home and estate nestled near the foot of the Blue Ridge Mountains outside of Middleburg. Between forays, Col. John Mosby and his valiant rangers were frequent visitors to the safe haven Welbourne provided. (Library of Virginia.)

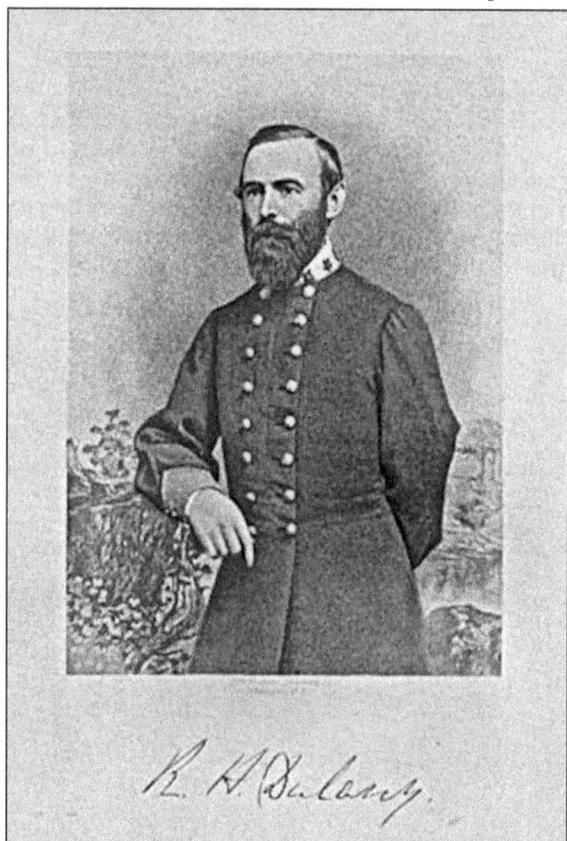

Dulany, who eventually rose to the rank of colonel of the 7th Virginia Cavalry and was in temporary command of the famed Laurel Brigade, left behind five children and a large extended family when he went to war. Even though it was difficult to subject his children to the possible loss of their father after their mother had died in 1858, Richard felt that honor and duty demanded that he serve his state. (Library of Congress.)

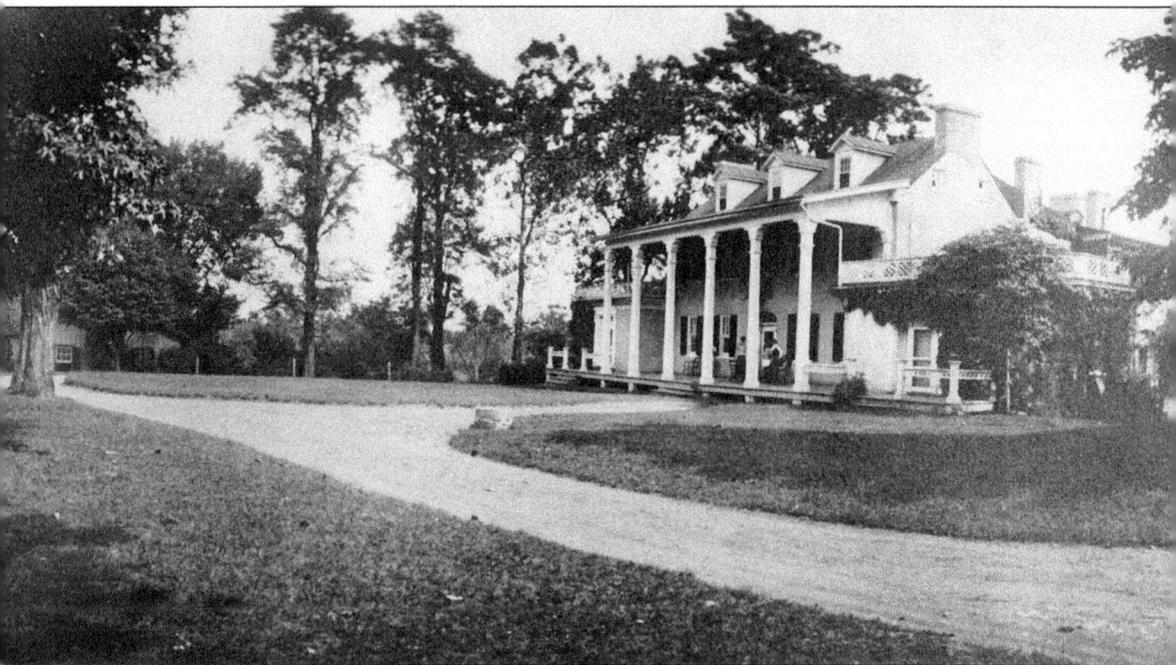

The Dulanys resided first at Old Welbourne until it burned down in a fire in the 19th century. They then moved to the present Welbourne, where their descendants, now in the eighth generation, still live today. Col. Richard Dulany is best known in the equestrian world for founding the Upperville Colt & Horse Show in 1853, the longest running horse show in America. He also founded the Piedmont Hunt in 1840, one of the oldest foxhunting organizations in North America. (Library of Congress.)

A Civil War reenactment is seen here at Welbourne. The house is listed in the National Register of Historic Places. In 2009, *In the Shadow of the Enemy: The Civil War Journal of Ida Powell Dulany* was published. It is a compelling and elegantly written account of life during the Civil War in this part of Virginia. In it, Dulany writes of a battle in her backyard: "Mamma was alarmed and took the children in the cellar, but I was spell bound on the balcony. The artillery on both sides kept up a constant roaring, while the reports of the small arms, the shouts of the men, the cries of the wounded, and the flash of the firing, made a scene terrible to me, and every now and then a horse with empty saddle ran terrified by the house, telling the sad tale of his rider's fall." (The Pink Box.)

The Jeb Stuart Room at the Red Fox Inn is named for the wartime meetings held there by the famous Confederate general. It now hosts busy lunch and dinner services within the polished original wood-paneled walls, with a cozy fireplace in the winter months. (Photograph by Laura Troy.)

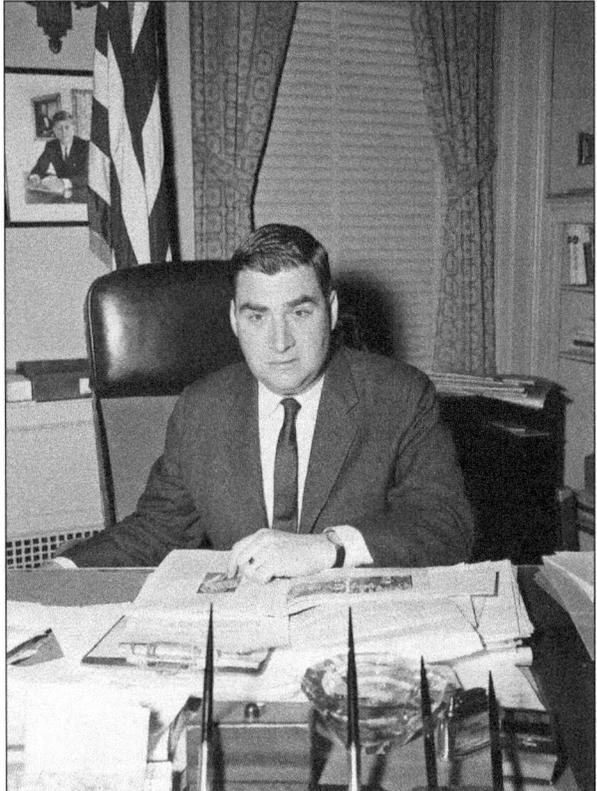

In the early 18th century, the Red Fox Inn was known as Chinn's Ordinary. A local newspaper described it as: "All the rooms [are] comfortable and well-furnished. The subscriber's bar is well-appointed with choice liquors." During the Civil War, it served as headquarters for Mosby and Jeb Stuart. In the room later named the Jeb Stuart Room, tactics were discussed by the famous generals, while downstairs the rooms served as a hospital for the ailing wounded. The tavern serves drinks on what was an operating slab for the surgeon under General Stuart's command. It is billed as the "oldest original inn in America." A century later, President Kennedy's press secretary, Pierre Salinger, seen here, held press conferences here. (Photograph by Laura Troy.)

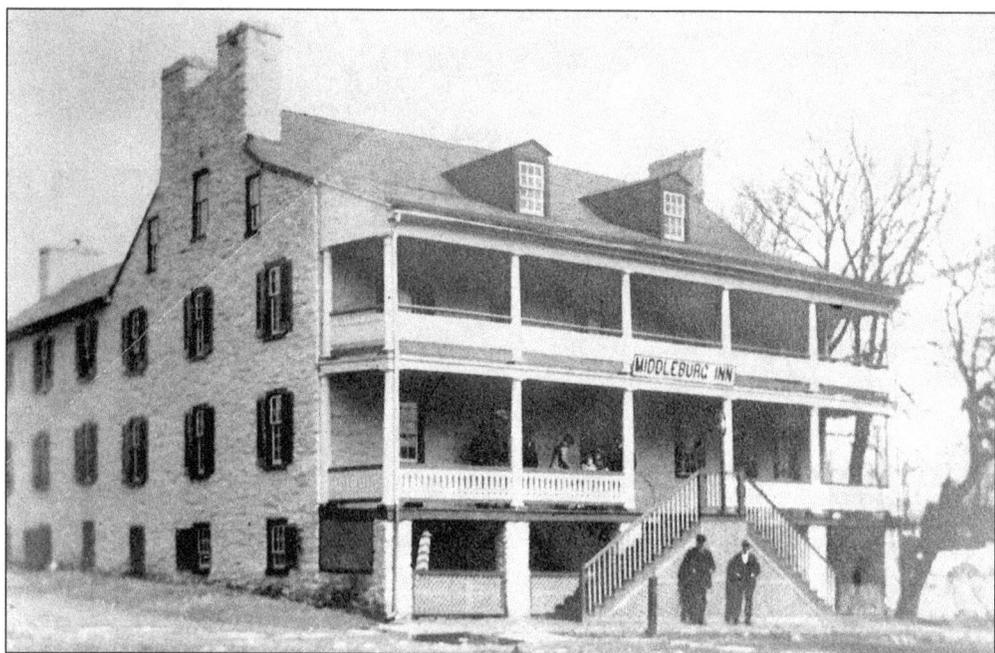

The Red Fox Inn is seen above in 1897, when it was known as the Middleburg Inn. As Chinn's Ordinary, it was the focal point for the area's social and economic activities. It served as both a hospital and a headquarters for the Confederate army. It was saved from the wrecking ball in 1937. The double staircases are gone now, as are the porches, but the inn itself remains a centerpiece of the village. (The Pink Box.)

On Oatlands Road near Middleburg stands this stone and stucco building, erected in 1854 as Loudoun and Mechanical Institute. Its three founders were prominent county agrarian scientists. On June 17, 1863, Mosby and his Rangers were resting here and observed the dust clouds from the ferocious Battle of Aldie taking place nearby. Unfortunately, America's first agricultural college, Loudoun A&M, failed to thrive and folded. In 1916, the school building and property became the headquarters of the National Beagle Club, and today the annual beagle trials are held here. In 1982, it was listed in the National Register of Historic Places. (Photograph by Kate Brenner.)

The Leith name is often associated with American independence and Confederate heroism. In 1768, Jamie Leith came to the Virginia frontier and purchased 640 acres, which would become the Goodstone Inn estate. Jamie shared his good fortune in agriculture with the Continental Army, acting as their supplier during the Revolutionary War. Leith's grandsons fought for the South—two with Mosby's Rangers and one with General Stuart. They even found themselves fighting on their own doorstep, as several skirmishes occurred on the Goodstone Inn property. The inn is now the site of many weddings and layovers for visiting equestrians and their mounts. (Photograph by Laura Troy.)

The old dairy at the Goodstone Inn from its days as the prominent Goodstone Dairy is still in good order. The dairy operated into the 1960s. (Photograph by Laura Troy.)

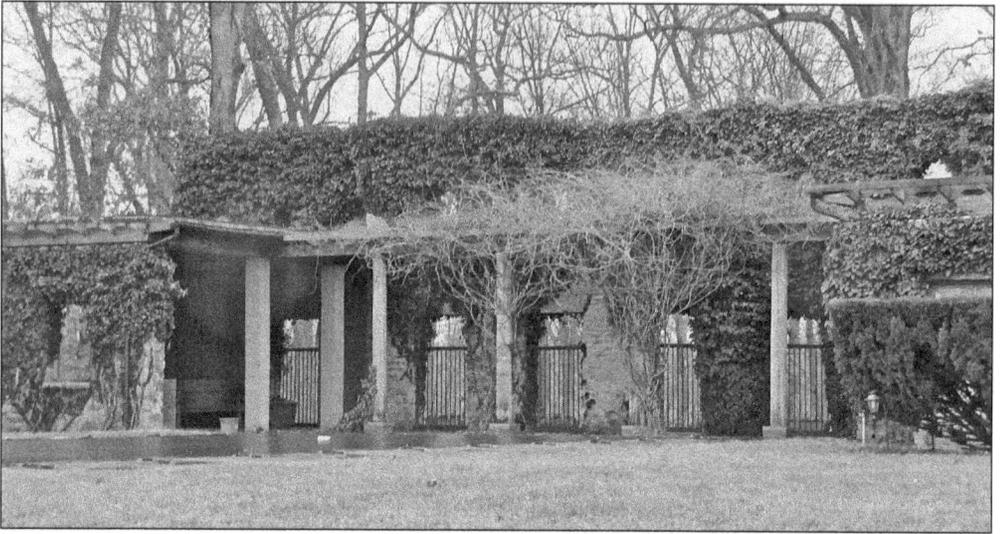

In 1915, the Leith land was sold to the Goodwin family, who built a large stone house—now the site of the pool—and named the property Goodstone, later creating the dairy. (Photograph by Laura Troy.)

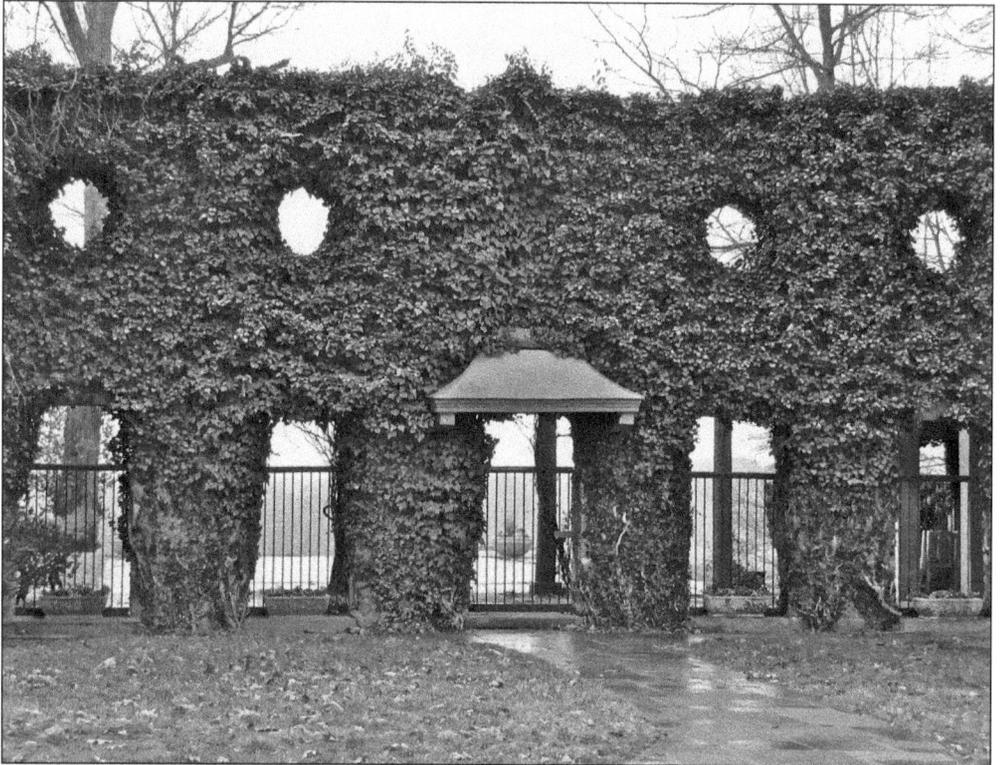

The Warburg family, part of an esteemed financial dynasty and known for their influence on the fictional character "Daddy Warbucks," bought the property in 1939. Frederick Warburg was known as the "father of the Federal Reserve" for contributing to its foundation. He and his wife, Wilma, maintained the facade of the Goodstone mansion as a backdrop for this concrete heated pool built around 1948. (Photograph by Laura Troy.)

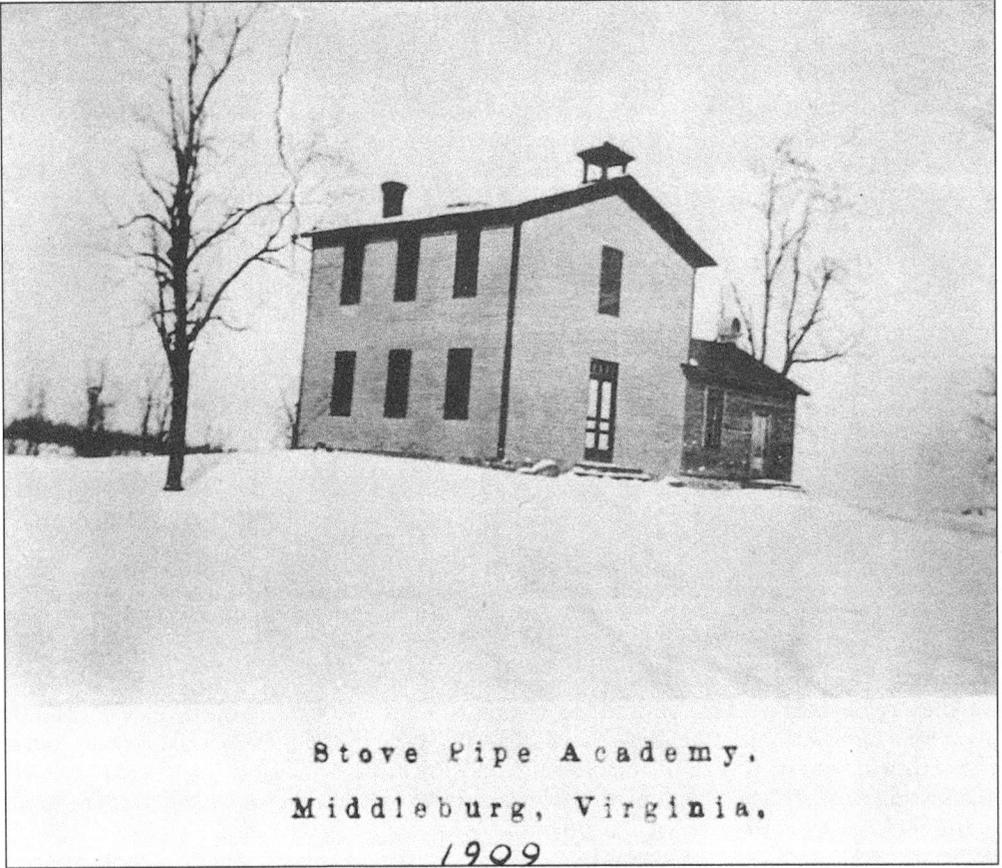

Stove Pipe Academy,

Middleburg, Virginia,

1909

A stovepipe academy is a term for a school that refers to itself by an aggrandized name to attract students but whose status is belied by the metal stovepipe sticking out from the roof. The early public schools at Aldie and Middleburg were called stovepipe academies, and the original Middleburg Academy is seen here in 1909. The stove was probably well stocked on this chilly day in Middleburg. (The Pink Box.)

The Middleburg Academy closed almost a century ago, and the building is now a private residence with added wings and a brick chimney. (Photograph by Kate Brenner.)

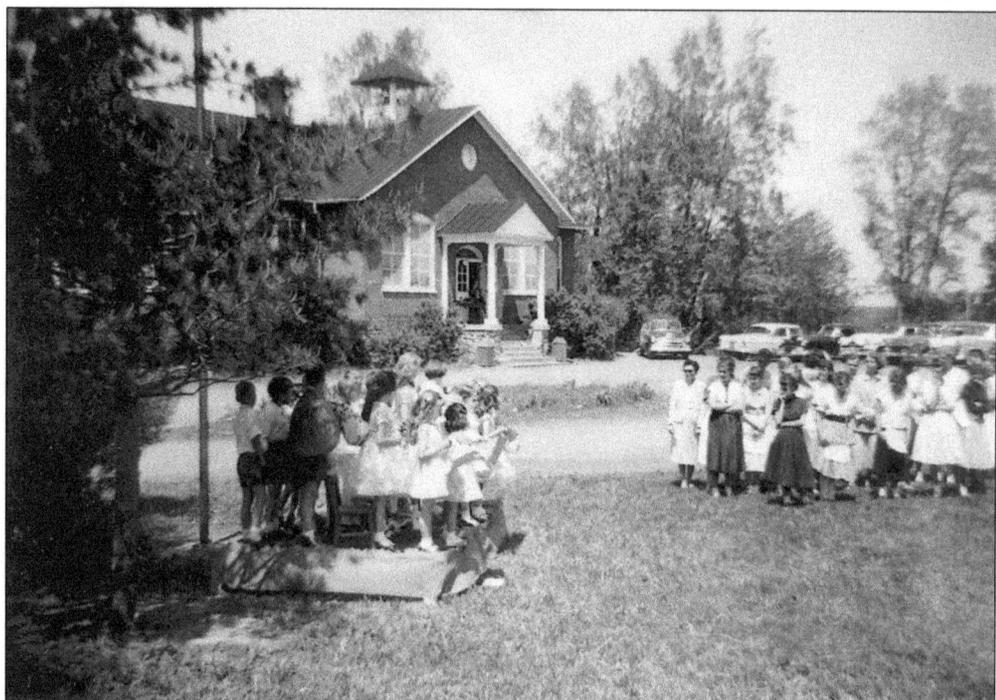

Middleburg Elementary was converted to a brick building in 1910 and opened a year later. It underwent renovations and additions in the 1920s and again in the 1960s but is still in use and is one of the oldest schools in the commonwealth. In 1967, Loudoun County integrated its schools and several African Americans enrolled. Here, children join in a May Day celebration outside of the brick school in the 1950s. (The Pink Box.)

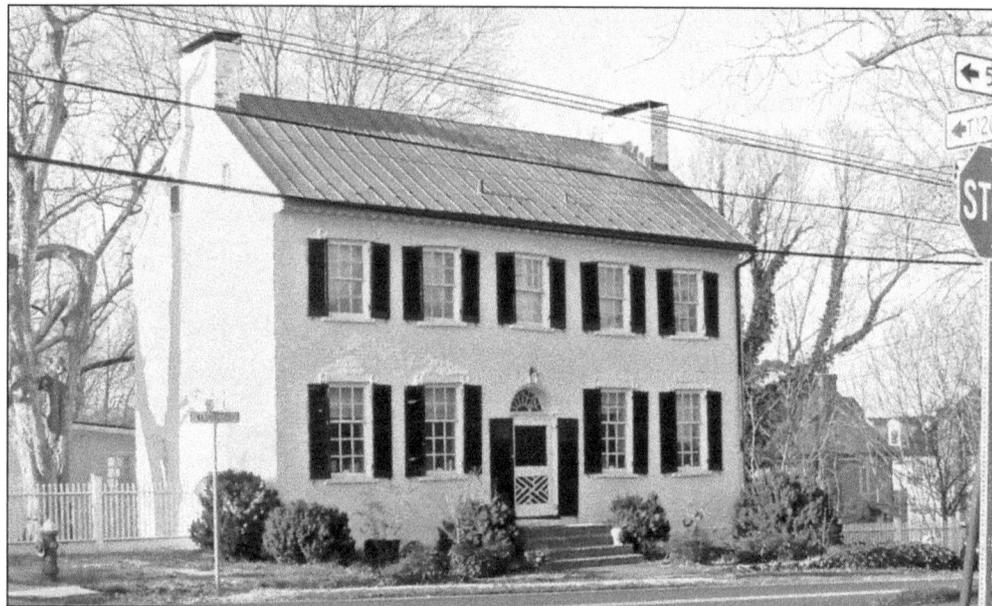

Enos Newton, the second owner of this 1817 home, was the first headmaster of the Middleburg Academy. Richard Dawson, minister of the Shiloh Baptist Church, owned it in 1889, when members of his congregation laid the bricks for the sidewalk in front. (Photograph by Kate Brenner.)

Charlotte Haxall Noland founded Foxcroft School in 1914 at the age of 32. She dreamed that her own school would be one that "girls would want to come to and hate to leave because they loved it." Charlotte's father, Cuthbert Powell Noland, was a direct descendant of Middleburg founder Leven Powell. (Library of Congress.)

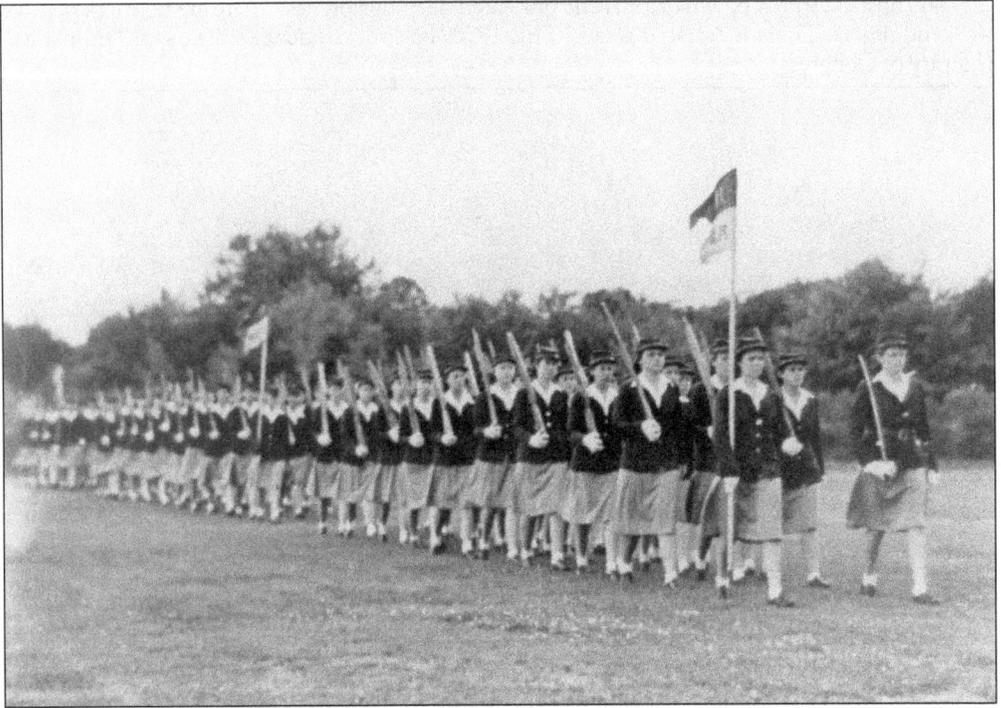

This Foxcroft training drill in 1947 was an example of Charlotte Noland's program, which intended to train and expose young women to wartime disciplines. (The Pink Box.)

As reported by *Sports Illustrated* in November 1963, "Foxcroft girls lead a sheltered but Spartan life—no lipstick, sturdy brown oxfords and unheated sleeping porches. There are no fripperies like weekend proms. There is riding instead." This 1950s Foxcroft student studies, sans "fripperies." (Library of Congress.)

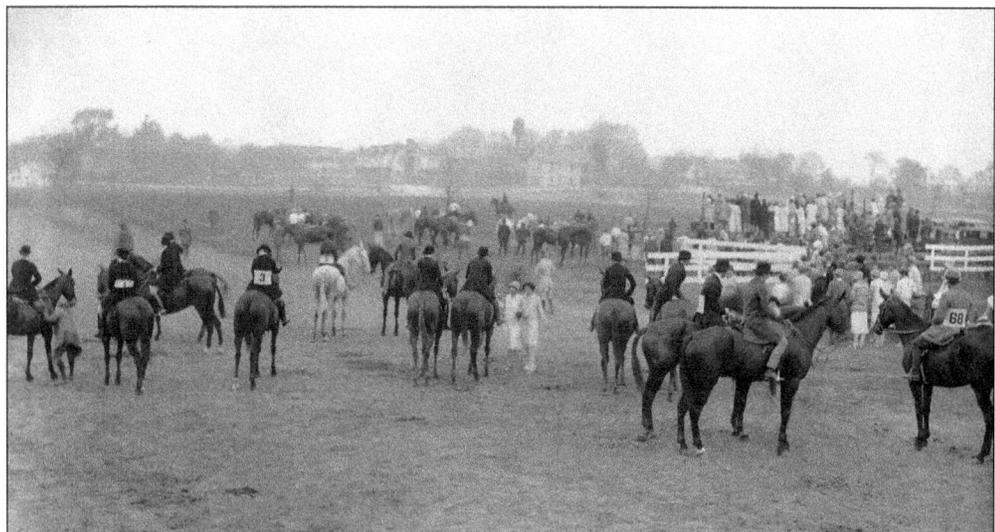

Charlotte Noland believed that involvement in the social service exposed her girls to "a cross section of the country and a part of life they have never seen before. It is impossible to tell the good that contact with these children does for Foxcroft and Foxcroft does for them." Foxcroft teaches girls college preparatory academics as well as competitive horsemanship, values aligned with the foxhunting culture of Middleburg. (Library of Congress.)

One of the many beautiful buildings at Foxcroft School is seen above. The school was visited by the Duke and Duchess of Windsor in 1942, and the visit was described by the *Free Lance Star* thusly: "All that day people flocked here, as word got out that the Duke and Duchess of Windsor would go through Middleburg to spend the week-end at Foxcroft to call on Miss Charlotte Haxall Noland. When they arrived, the lawn was flooded in lights and all the colored servants stood at one side to get a peep of the visitors." At right, Mrs. Sterling Larrabee (left) stands with the Duchess and Duke of Windsor during their visit. (Above, Library of Congress; right, The Pink Box.)

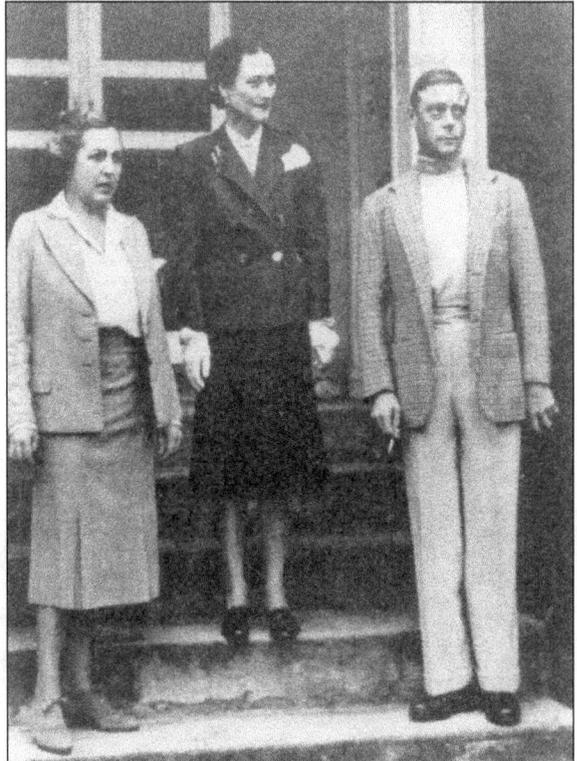

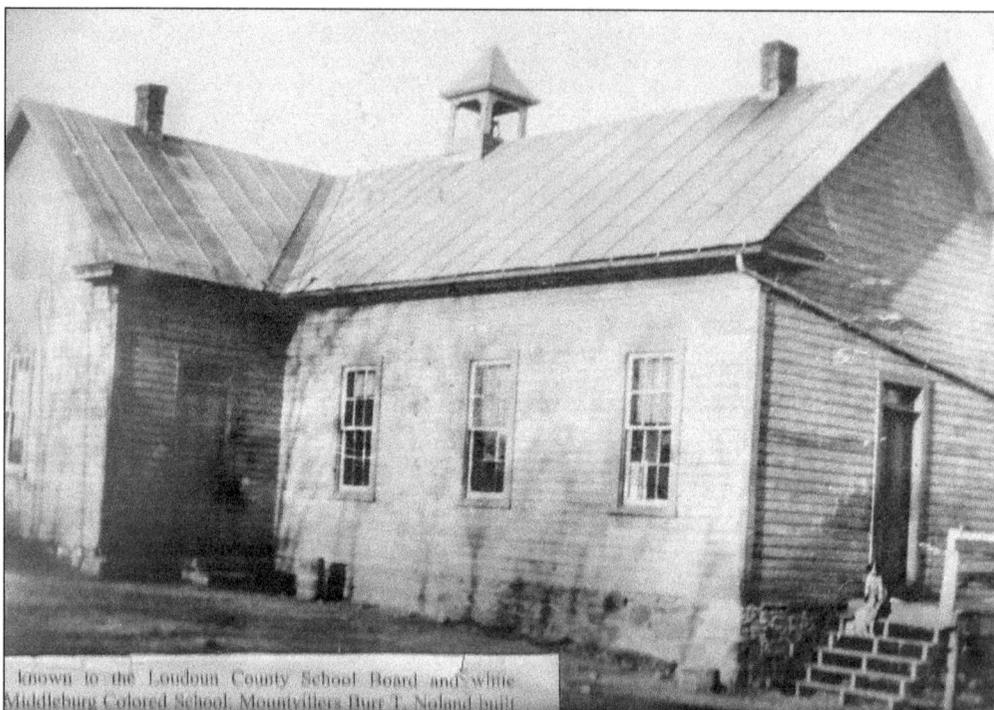

known to the Loudoun County School Board and white
Middleburg Colored School. Mountvillers Burr T. Noland built

In the 19th century, the Grant School was known to the Loudoun County School Board and white Middleburg as Middleburg's colored school. Burr T. Noland built the two-room schoolhouse in 1888. The school was named for its principal, Oliver C. Grant, a Pennsylvanian restaurateur who died at age 61 in 1908. The Grant School closed in 1948 but was stuccoed and remodeled and became the Marshall Street Community Center for the town's black community. The current building is seen below. (Above, The Pink Box; below, photograph by Kate Brenner.)

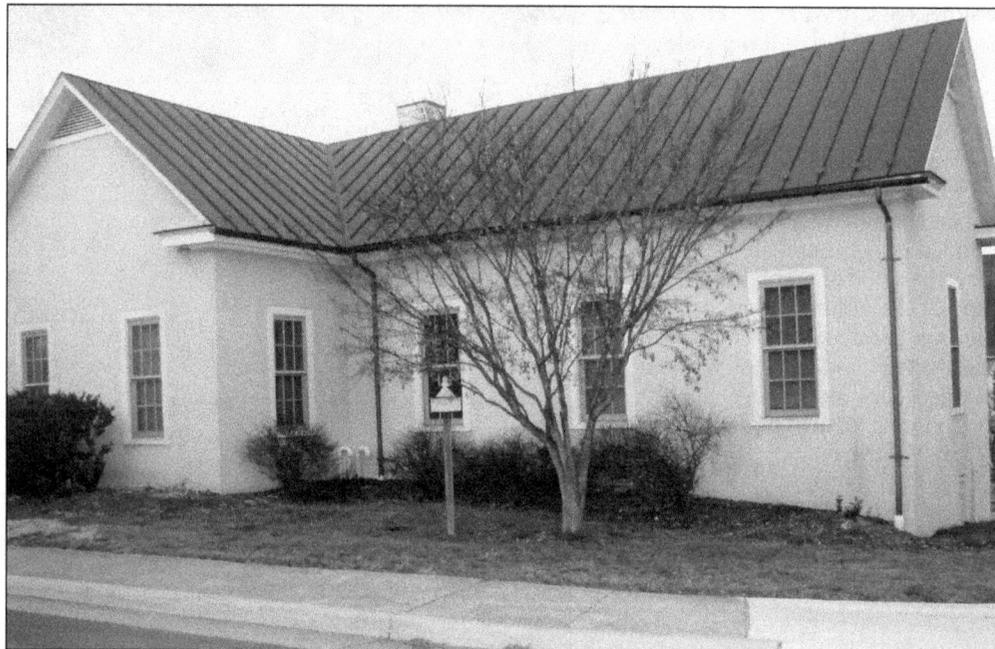

120

Townspeople congregate on the front steps of the Middleburg Community Center's grand facade in recent times. (Photograph by Kate Brenner.)

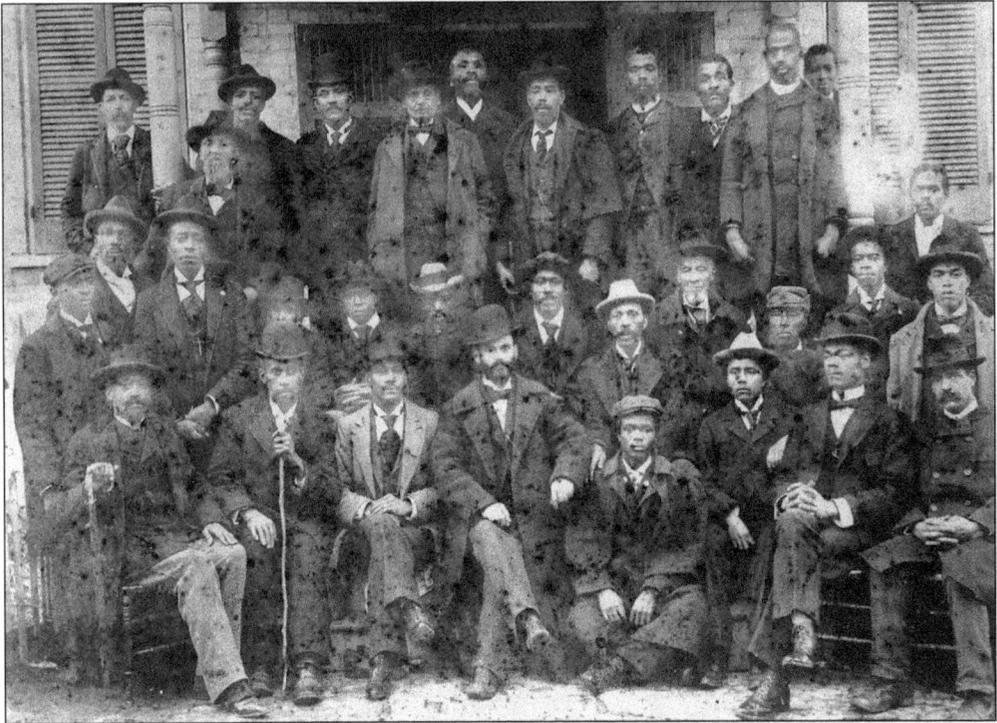

In this iconic picture, the black men of Middleburg pose in front of Rev. Richard Porter Dawson's fine home at the northeast corner of Jay and Washington Streets around 1895. (The Pink Box.)

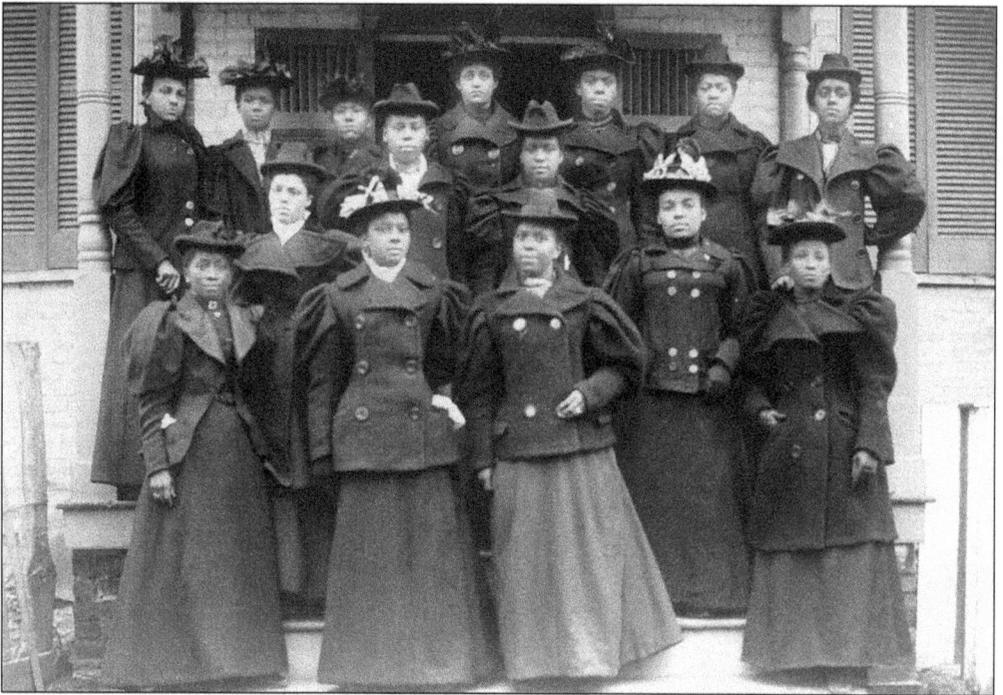
The black women of Middleburg take their turn posing in front of Reverend Dawson's house. (The Pink Box.)

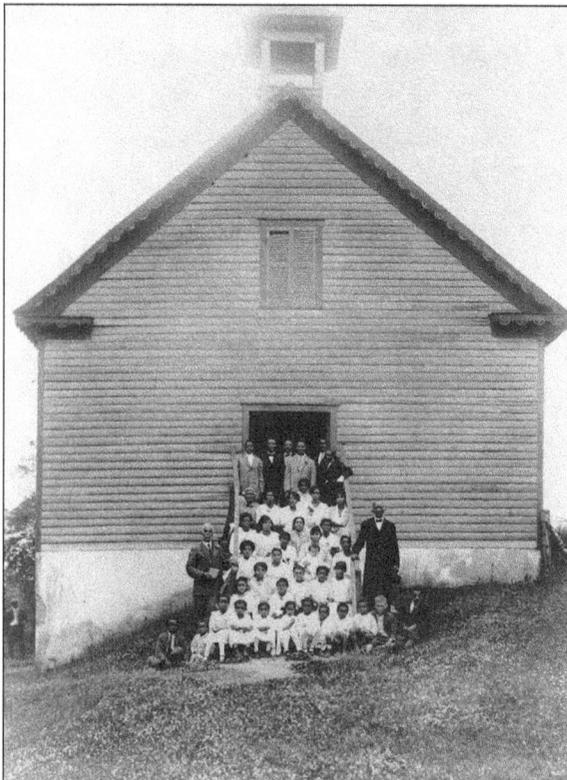

In 1866, Leland Warring, influenced by a great Christian movement in Virginia, felt himself called by God to preach and soon saw a need for a Baptist church in Middleburg, which he organized as the Shiloh Baptist Church in 1867 with only eight members. The tiny congregation's Sunday school classes posed on the steps of the original wooden structure, which was used until 1913 when the members constructed a new place of worship. (The Pink Box.)

The current Shiloh Baptist Church is seen here. (Photograph by Kate Brenner.)

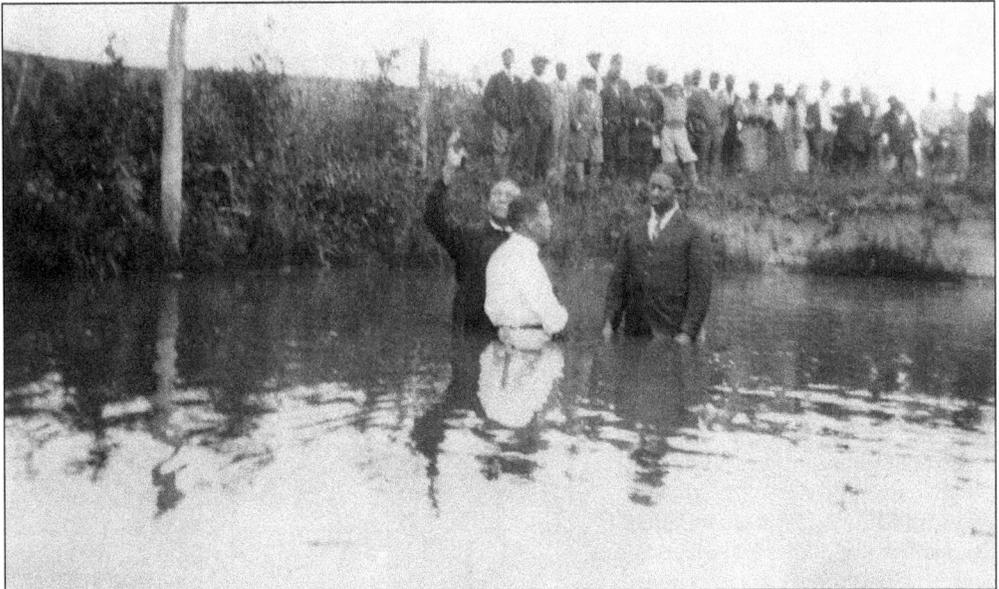
Shiloh Baptist Church minister George W. Coleman and deacon Lawrence Dade baptize in the fishing hole, a pool in Wankopian Branch Creek just east of town, around 1920. The Sunday baptisms were a fixture through the 1930s, attracting hundreds of people. (The Pink Box.)

St. Stephen's Catholic Church was built in 1963 to accommodate the Kennedys. Before their arrival, Mass was held in the community center. John and Jacqueline Kennedy worshipped here numerous times before his assassination later that year. (Photograph by Laura Troy.)

The 1829 Asbury Methodist Church is the oldest building still standing in Middleburg. The stone and stucco, two-story church features semicircular-headed front windows and an enclosed square belfry atop its steeply pitched gable roof. The church has been owned by an African American congregation since 1864. (Laura Troy.)

Middleburg Baptist Church was built in 1847 on land given to the town by Burr Powell. During the first half of the 19th century, the building was known as the Free Church because it was used by all different Christian groups in Middleburg. By 1847, all congregations except the Baptists and Presbyterians had built churches of their own. These two denominations continued to share the use of the Free Church until the late 1880s, when the Baptists became the sole worshippers here. The stark, two-story, end-gable building features two front entrances, one for men and one for women. There are also side entrances—one for black men, the other for black women. Note the carriage steps still visible against the stone wall. (Photograph by Kate Brenner.)

In 1857, the Methodists built Middleburg Methodist Church on the corner of Washington and Pendleton Streets, on the first lot conveyed by Leven Powell after he founded Middleburg. The original purchaser was Jacob Stely, a blacksmith, but by the 1850s, the lot was vacant. Completed after the Civil War, this elegant brick church has a bracketed cornice, classically inspired portal surround, semicircular-headed windows, and an octagonal framed belfry with a spire. During the war, the churchyard was covered with the bodies of wounded soldiers. Catherine Broun, the wife of the storekeeper and a member of the congregation, remarked that the beautiful new church had become a scene of horror, overflowing with the injured, a terrible stench, and their cries of pain. (Photograph by Laura Troy.)

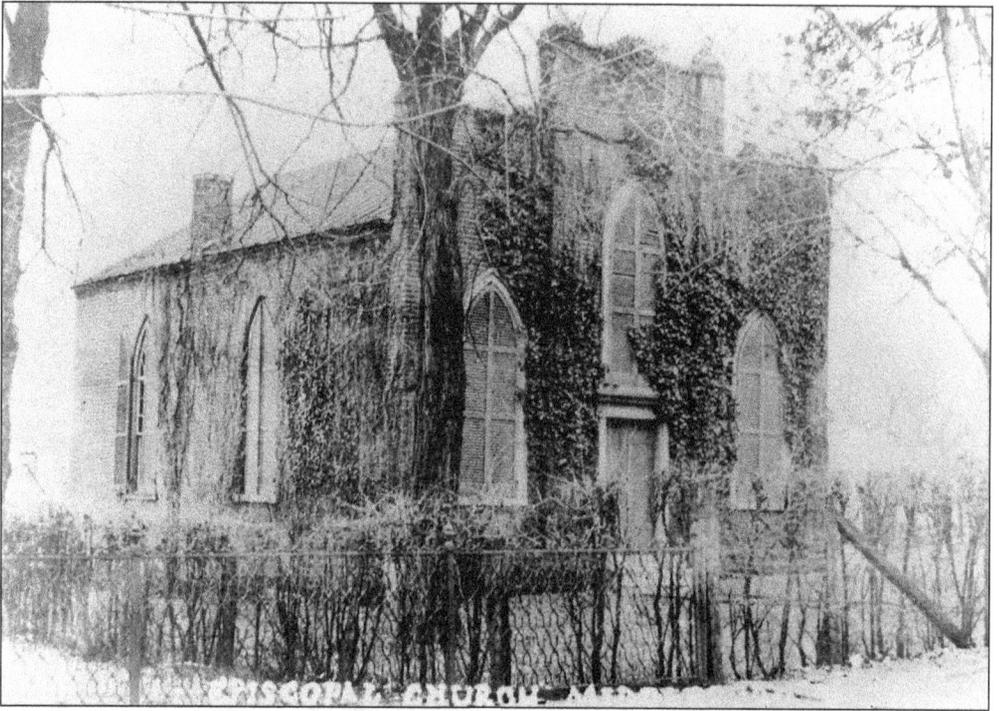

On July 21, 1843, Bishop John Johns consecrated Emmanuel, an elegant brick church in the Gothic Revival style with buttresses and large multi-paned pointed-arch windows. Senior warden Asa Rogers, an original trustee, became a Confederate brigadier general in 1861. In 1856, an adjacent building was purchased for use as a parsonage. After the war, the Bentons, their fellow parishioners the Nolands, and others successfully fought the Freedmen's Bureau's attempts to expropriate their allegedly abandoned lands. Church enlargement finally began in 1926, prompted by the gift of a large pipe organ from a wealthy New Yorker whose daughter had attended Foxcroft. Emmanuel celebrated Middleburg founder Leven Powell's 200th birthday in 1937, installing a large stone tablet inside the church. The church celebrated its centennial on May 23, 1943. (The Pink Box.)

The interior of the Episcopal Church on Washington Street has bright light shining through the rose windows. Enlargement of the church was undertaken in 1926, fifty years after debate began on this issue. Throughout its history, Emmanuel has played an important role in the life of Middleburg. (Photograph by Laura Troy.)

126

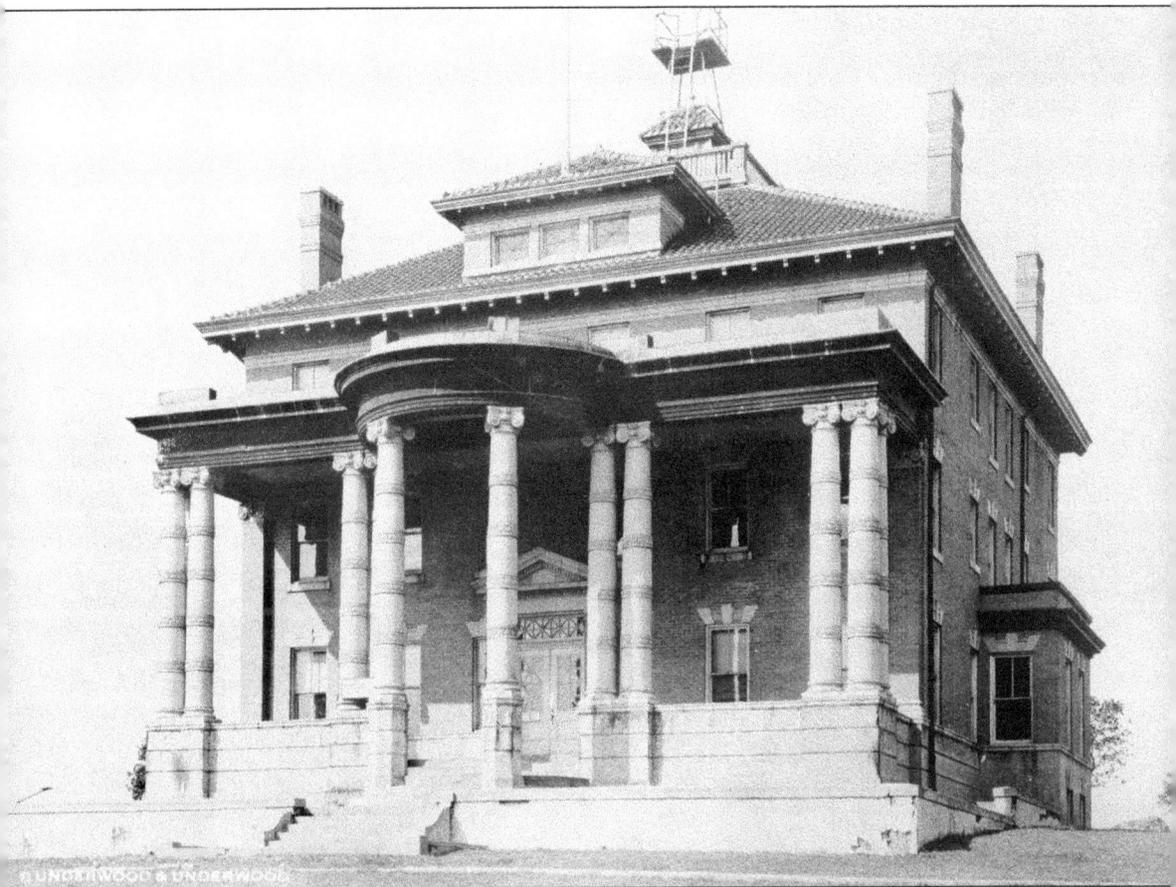

Mount Weather is a civilian command facility on a mountaintop in Bluemont. It is a control station for the FEMA National Radio System, connecting most public safety agencies and the US military. It was originally a weather station in the late 1800s, and the underground facility was completed in 1959. The aboveground area is about 434 acres, and Area B, the underground component, is said to be 600,000 square feet. It has been claimed that following the September 11, 2001, attacks, most of the congressional leadership was evacuated to Mount Weather. If one watches closely, sometimes helicopters fly right into the mountain and a huge door opens at the last second. The station has been a cause of local gossip since its construction in the 1940s. The administration and observation building at Mount Weather is seen here in 1928. (Library of Congress.)

Visit us at
arcadiapublishing.com

www.ingramcontent.com/pod-product-compliance
Lightning Source LLC
Chambersburg PA
CBHW050656110426
42813CB00007B/2027

* 9 7 8 1 5 3 1 6 6 2 8 3 7 *